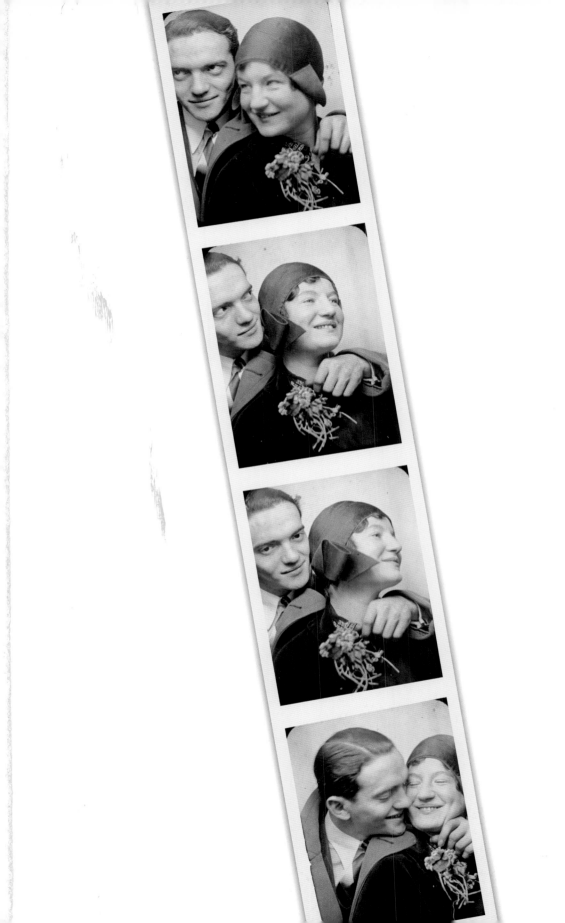

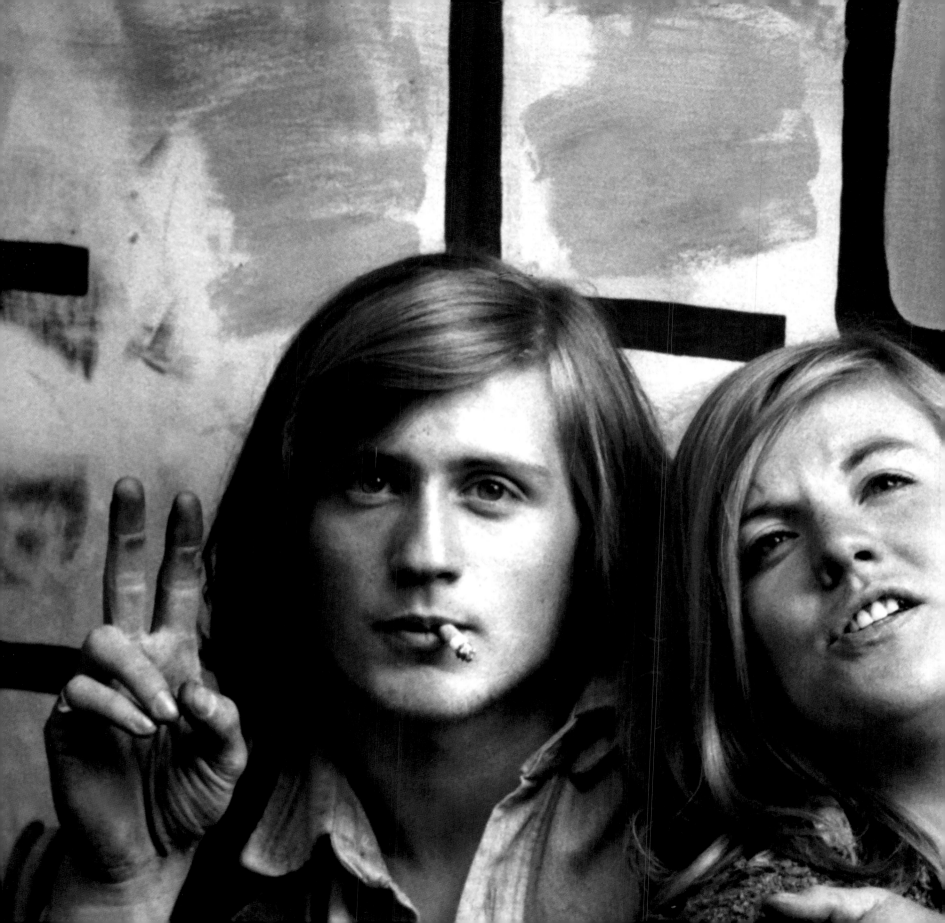

FERDINAND PROTZMAN

NATIONAL GEOGRAPHIC

WASHINGTON, D.C.

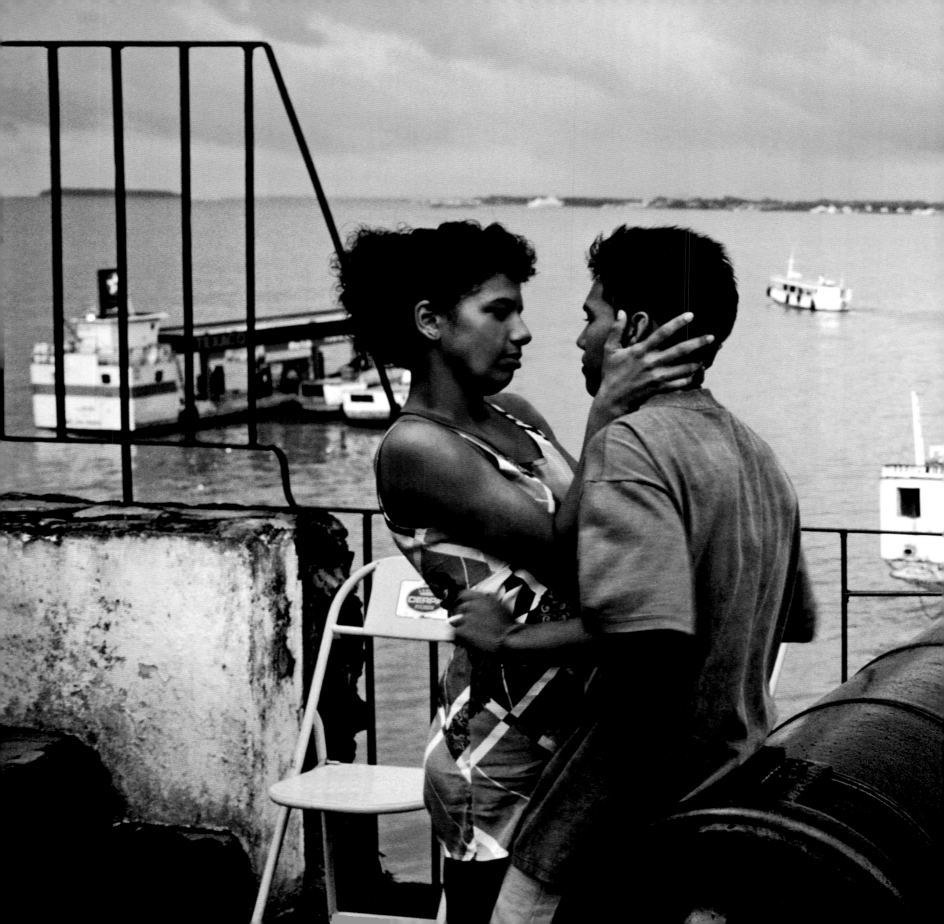

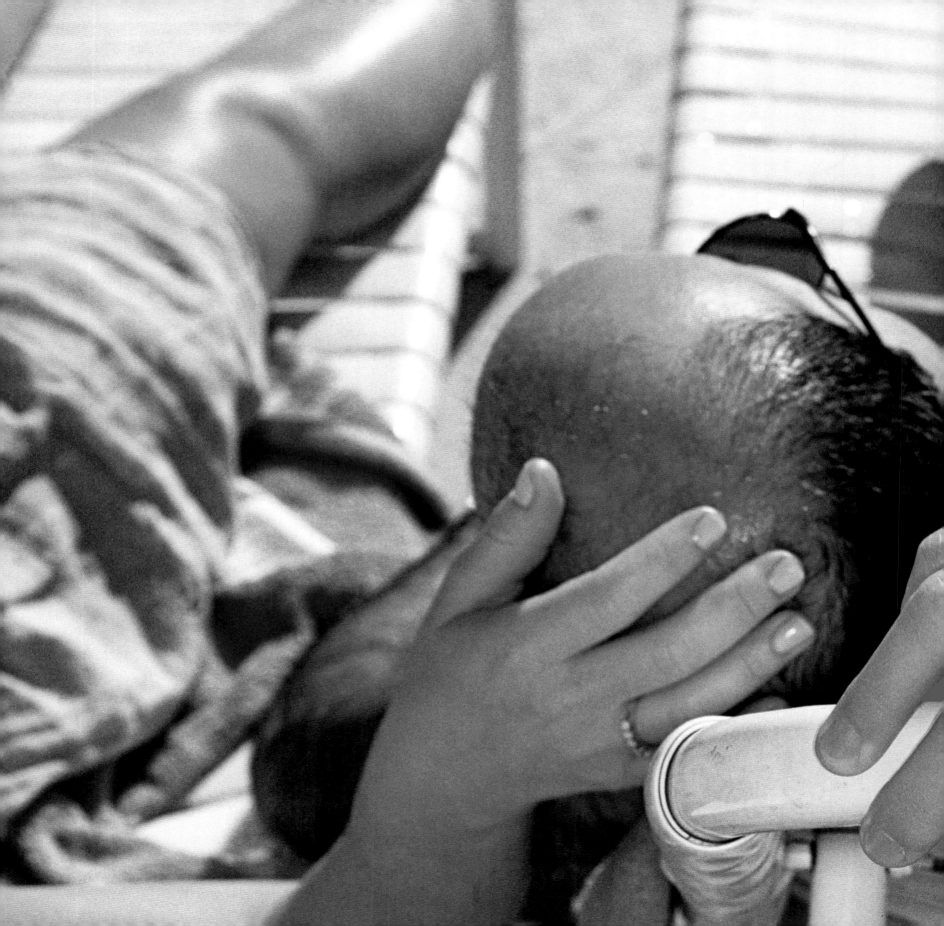

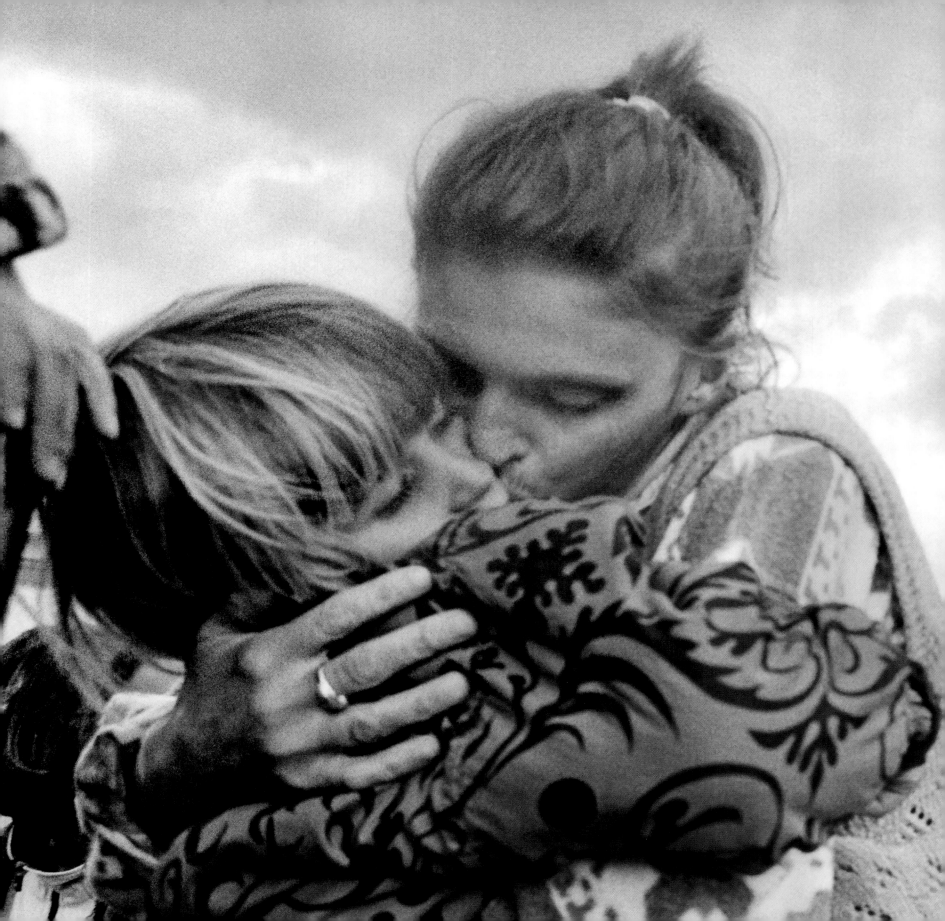

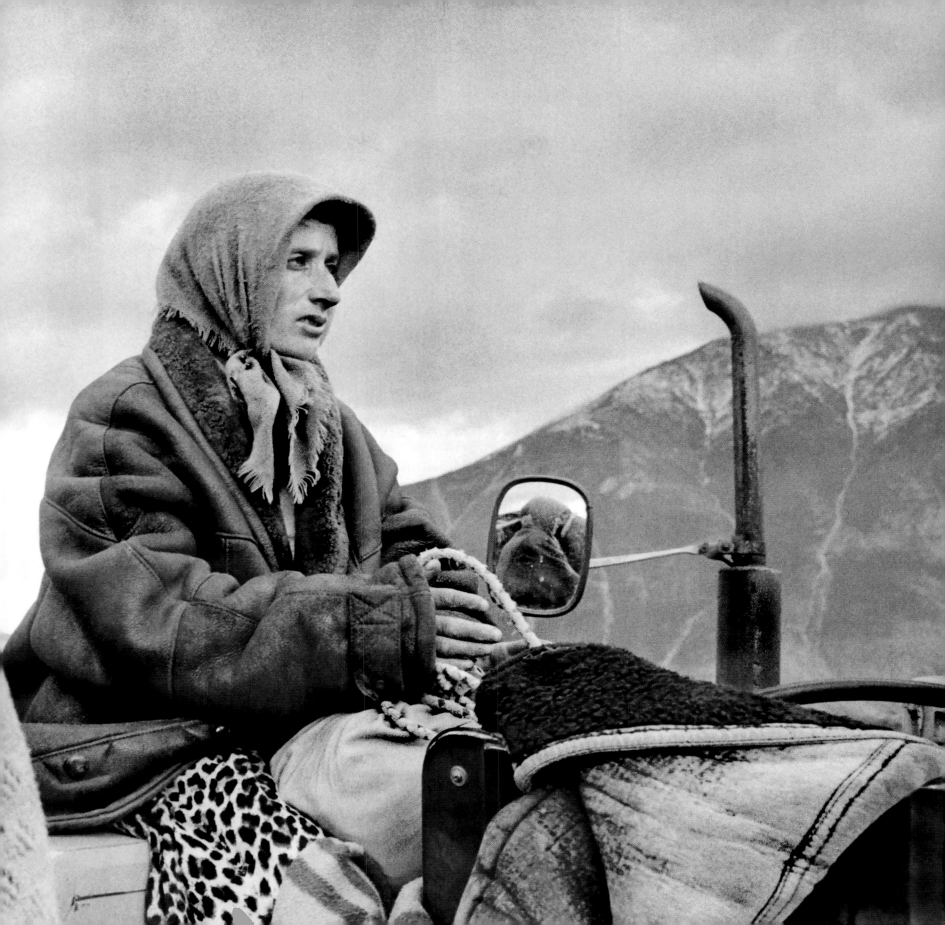

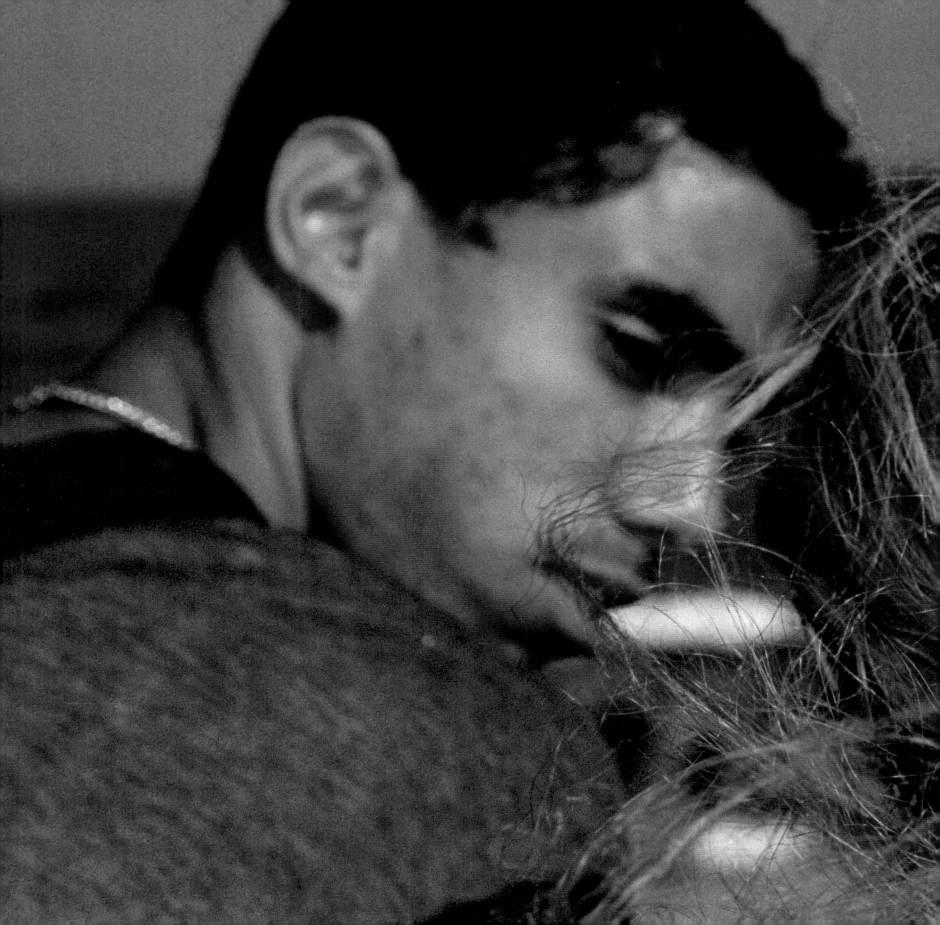

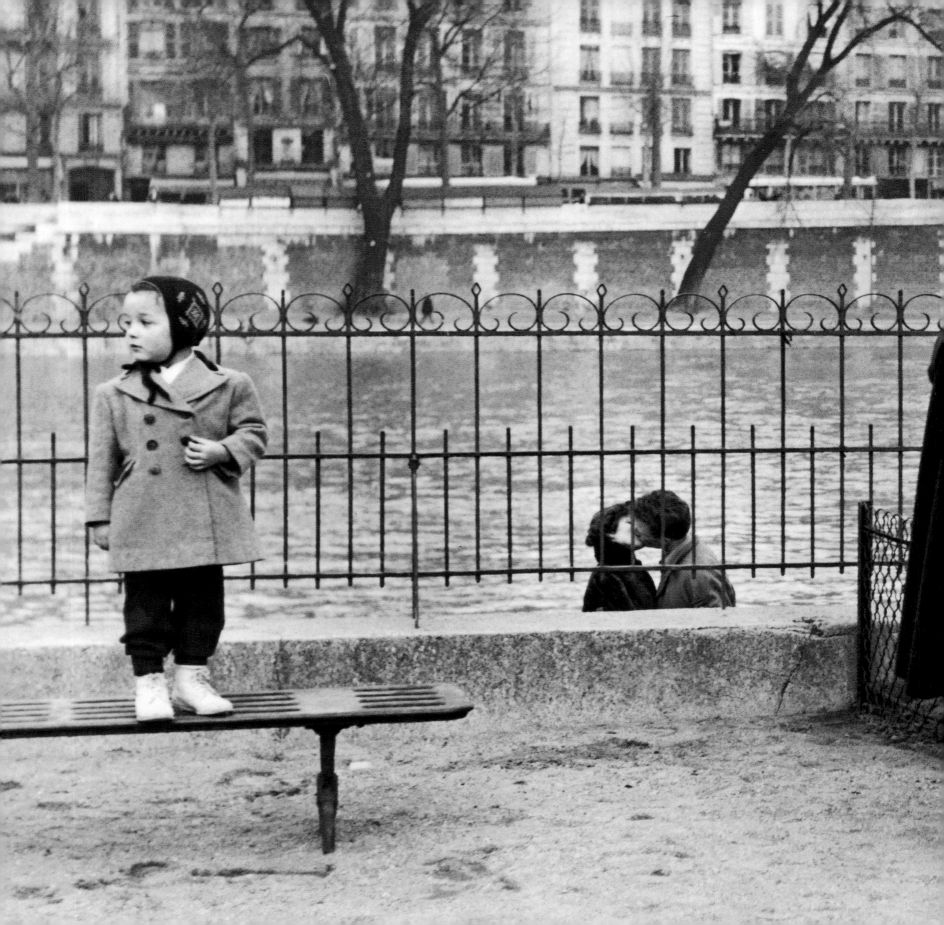

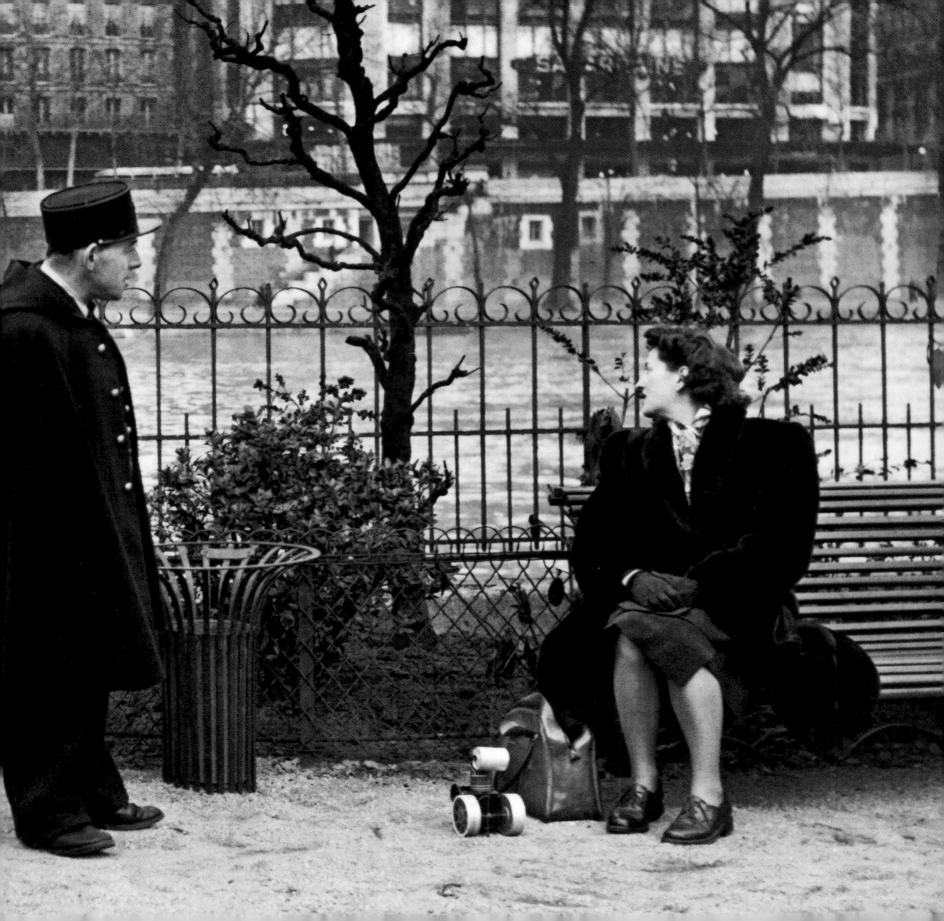

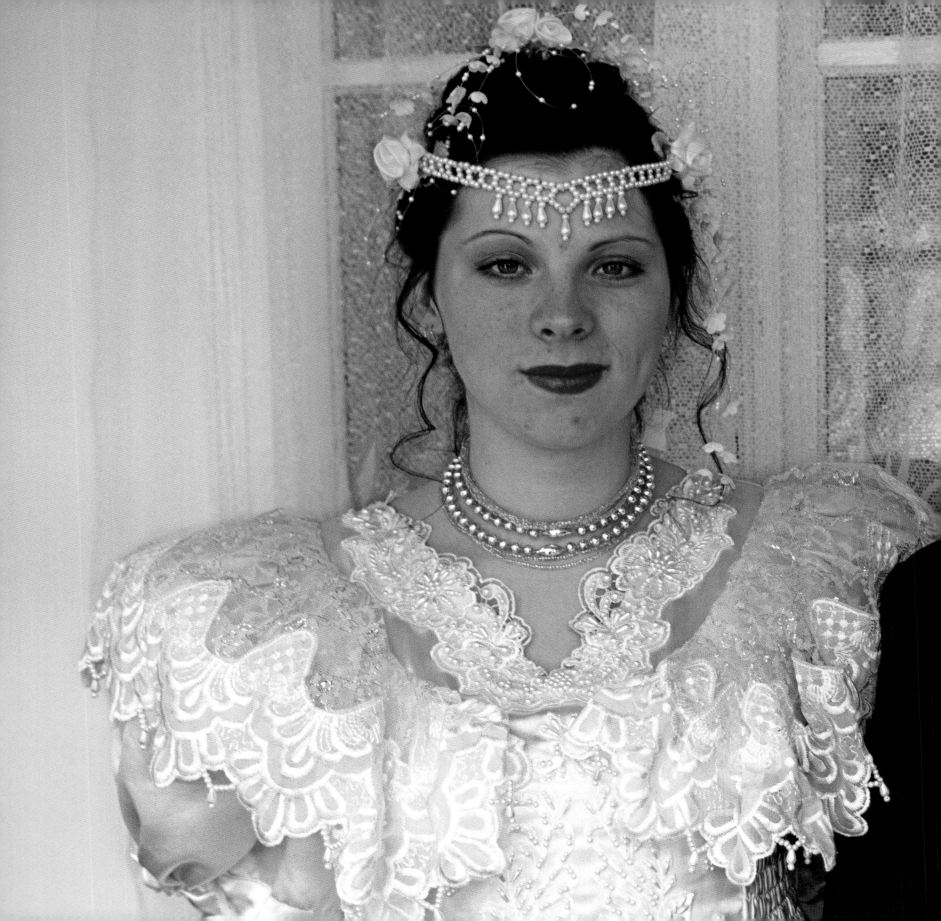

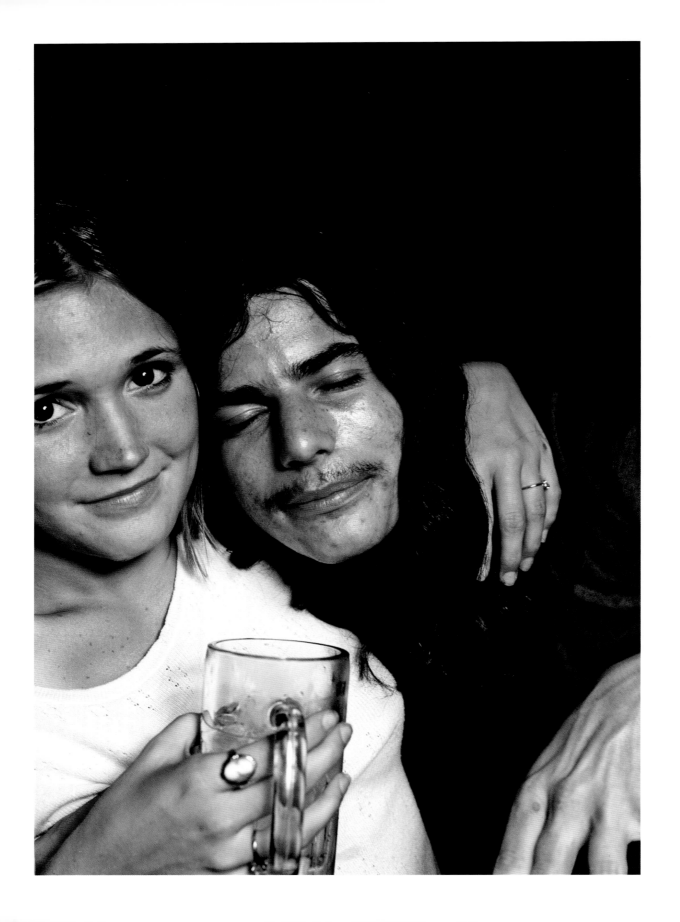

OPPOSITE: **WILLIAM EGGLESTON** I U.S.A. I Untitled I PREVIOUS PAGES: 1 **BABBETTE HINES** I U.S.A. I Photobooth shots;

2–3 **BERT GLINN** I Chicago, Illinois, 1968 I Protestors outside the convention hall; 4–5 **ALEX WEBB** I Brazil, 1993 ; 6–7 **MARTIN PARR** I Florida, 1997;

8–9 **TOM STODDART** I Albania, 1999 I A family from Kosovo is reunited; 10–11 **MARTIN PARR** I Havana, Cuba, 2000;

12–13 **ROBERT DOISNEAU** I Paris, France, 1950 I Vert-Galant public garden; 14–15 **TOMASZ TOMASZEWSKI** I Setetpataka, Romania I Csango couple on their wedding day

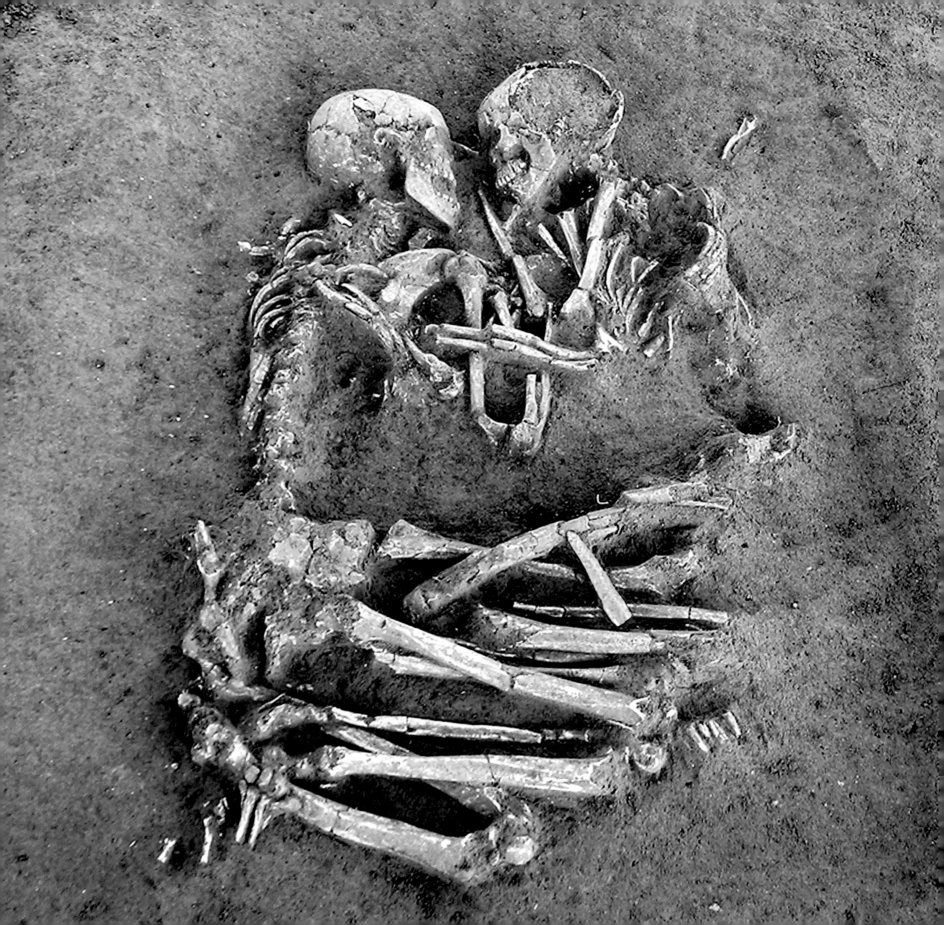

INTRODUCTION |

Love is a driving force of human existence, the root of our survival as a species, a common denominator of every culture, race, and religion, existing wherever people live. Politicians may govern nations but love rules everyone, with or without our consent, exercising immense power to bring goodness and joy, evil and sorrow, and everything in between, sometimes all at once. Love touches us from before we are born until we die. So great is love's reach that its absence can be felt as acutely as its presence.

That primal power makes love an obvious subject for artistic expression. And love has indeed been exalted, examined, explored, and deplored ad infinitum in almost every imaginable medium of expression. Yet the subject remains fresh because love is not only universal, but intriguing and amorphous. Despite its universal nature and the countless words, pictures, and music devoted to it, no one knows exactly what love is.

Because each of us experiences love as an individual, because it is so personal and subjective, because we love so many things, in so many ways—God, our families, our friends, ourselves, our pets, our possessions, and our pleasures—coming up with a concise, catch-all definition is impossible. Compared to love in air-gulping, pulse-pounding, palm-sweating life, all definitions of the word seem formal and inadequate. No one ever looks into the eyes of another person and says, "I feel solicitude for your welfare, delight in your presence, and desire for your approval." We say, "I love you."

Through the ages, love's unique combination of universal appeal and life-altering power has prompted authors, poets, playwrights, lyricists, scholars, philosophers, self-help gurus and ordinary folks to write reams about it. The endlessly growing list includes well-known names such as Confucius, Catullus, St. Augustine, William Shakespeare, Elizabeth Barrett Browning, Rainer Maria Rilke, M. Scott Peck, John Lennon, and Paul McCartney, along with every person who ever penned a love letter, song, or poem.

There are classic lines, such as Browning's "How do I love thee? Let me count the ways," for George Sand and, classic clichés like "Love means never having to say you're sorry," from the film *Love Story*. Just five words, "All you need is love...," can start the Beatles playing in your head. For those seeking deeper meaning, pithy quotes abound from philosophers, scientists, and writers. The *I Ching*, the ancient classic of Chinese thought and literature, contains advice about love. Sophocles, the great Greek tragedian who lived from 495 to 406 B.C., wrote, "One word frees us of all the weight and pain of life: that word is love." In 1970 Toni Morrison took a different view in her debut novel *The Bluest Eye*, writing that romantic love ranks as one "of the most destructive ideas in the history of human thought." I would love, there's that word again, to hear them all debate the subject.

Photographing something that can be considered the best or worst thing to befall humanity is challenging. If you asked all the photographers whose work appears in this book if they intended to photograph love when they took these pictures, some would likely answer that they were shooting life and love found its way into the picture. Others did set out to depict love, either in the studio, on the streets, or wherever they thought it could be seen.

DARIO PIGNATELLI | Italy | Neolithic couple, buried 5,000 to 6,000 years ago

Robert Doisneau, the great French photographer whose photo of the Square du Vert Galant in Paris, taken in 1950, precedes this introduction, once wrote "The marvels of daily life are exciting; no movie director can arrange the unexpected that you find in the street."

Or can they? Doisneau did a little directing, at least once. His most famous picture, "le baiser de l'hotel de ville" or "Kiss by the Hotel de Ville," also from 1950, shows a young couple passionately kissing on a crowded Parisian street. The image was published in *Life* magazine and quickly became an icon representing romance, love, and the effervescent life of the city of *l'amour*.

Having spent time in Paris, I've seen many similar scenes. But one year before his death in 1994, Doisneau was forced by a lawsuit to admit that he posed the shot, using Françoise Bornet, an actress, and her boyfriend at the time, Jacques Carteaud, to recreate a scene he said he witnessed earlier at that spot. Bornet was paid, in part, with an original print. She sold it at auction, in April 2005, for around $250,000, a monumental price for a photograph. The combination of love and work, which Sigmund Freud considered the two driving forces of human life, rarely pays off so handsomely.

The couple kissing in "Square du Vert Galant" bears a remarkable resemblance to Françoise and Jacques. In fairness, Doisneau didn't orchestrate these scenes the way a movie director would. The passersby aren't extras, just everyday Parisians. I doubt he posed the policeman talking to the woman sitting on the bench, craning her neck to look at the kissing couple, or the child standing on the next bench over gazing off into the park. He just told the good-looking young lovers where to kiss and let the city and people he loved do the rest.

Staged or not, Doisneau's photos exalt romantic love, the magic of life in Paris, and the unique *joie de vivre* of the French. They also highlight how difficult photographing love can be. There are many kinds of love. None stand still for long, and they don't always show up when we want or need them. Nor do we all see them the same way. People view love and life subjectively. How we see and react to love depends on many variables—who we are, how old we are, where we are, the times in which we live, the way we feel at a specific moment. Where I see love and magic in Doisneau's photos, someone else may see only lust in a gray city.

Subjectivity is part of all visual art. Even the creator of an artwork may not be able to fully explain its genesis or meaning. When they can, it may not matter to anyone but them. A photographer could stand next to one of his/her prints shouting, "It is about the impossibility of true love," and some viewers will come away convinced they just saw love's quintessence.

Nonetheless, visual artists have been depicting love in various forms and media for thousands of years. The photographs in this book are part of a long line of images in the Western canon stretching back hundreds of years to 12th-century France, when the first depictions of what was then an intoxicatingly new notion, romantic love, appeared as illustrations in manuscripts produced for the courts of the French nobility.

In his influential book *Love in the Western World*, French scholar Denis de Rougemont wrote that the notion of romantic love came to France via Muslim Spain and that its romantic imagery and practices originated in the confluence of Persian Manicheanism and Middle Eastern Sufi rhetoric, exemplified in the odes of Imru' al-Zays and other oral poets of the

late, pre-Islamic era. Their passionate, metaphorical language and imagery pre-dates Shakespeare by about one thousand years.

Romantic love may have affected billions of lives since the 12th century, but love of God was the dominant theme in Western painting until the Renaissance. Christian themes reached their apogee in the schematic, gold-laden compositions and stiff figures featured in Late Gothic paintings of Biblical scenes, such as Lorenzo Monaco and Cosimo Rosselli's *The Adoration of the Magi* from circa 1420, which hangs in the Uffizi Gallery in Florence, Italy.

Thematic and compositional rigidity gave way to naturalism in the Renaissance. People and backgrounds began to look more as they do in life. Secular subjects, such as couples, spouses, parents, children, pets, and possessions appeared in paintings. Love, and its close companion, lust, were no longer taboo subjects for art. Those trends continue to this day.

The invention of photography proved to be a watershed in love's pictorial history. Photos carried a fuller measure of realism and verisimilitude, and they were relatively inexpensive to produce. Portraits of loved ones, once an option only for the well-to-do, became a staple of the masses. Soon, people all over the world were wielding cameras, making cheap, portable pictures, usually of the persons, places, and things they loved.

Those pictures changed the way we visualize familial love. They put faces on our ancestors and gave us glimpses of their lives and times. Thanks to the inventions of Louis J. M. Daguerre and William Henry Fox Talbot, my son knows what his great-great-great grandparents and the generations descended from them looked like. He has seen his paternal great-grand-

mother sitting on the deck of a steamship after she eloped, glowing like a black-and-white Mona Lisa. He has seen pictures of his grandparents when they were young newlyweds and his parents on their wedding day.

But are these really photographs of love? Think of all the wedding photos taken around the world each year. What could be a more direct representation than two people pledging to love each other for the rest of their lives? Now think of the divorce rate in many countries. Does the fact that half those marriages are going to fail mean the wedding photos do not show love? If we cannot say for certain what love is, can we photograph it?

Everyone has to answer those questions themselves. I believe we can and we do take love's picture. Like most people, what little I know about love comes mainly from experience. I know love when I feel it. I know who loves me, whom and what I love, and why. I know there have been times in my life when love or what I thought was love infused me with light, and others when it reduced me to a single-cell organism steeping in pain. Through it all, I always felt love from family and friends. Even when it wasn't visible or tangible, I knew it was there, like a photo of a loved one tucked in my wallet. For that, I count myself lucky. The family and friends in our photographs may die, move away, or become estranged from us, but in that moment when the camera's mechanical eye blinked, they embodied a kind of love. It may not have endured but it existed.

There are, of course, many kinds of love. Sexual love, parental love, filial love, love of country, love of ideas, love of life, to name a few. Different cultures view love differently. In some cultures, for example, romantic love is

seen as the essential component of marriage, a prerequisite. In others, romantic love has little if anything to do with marriage.

The various kinds of love can be seen in the pictures by William Henry Fox Talbot, Julia Margaret Cameron, Henri Cartier-Bresson, Weegee, William Eggleston, Elliott Erwitt, Martin Parr, Mary Ellen Mark, Josef Koudelka, Sam Abell, William Albert Allard, Guillaume Herbaut, Claudine Doury, David Alan Harvey, and the other photographers featured here. Their photos are not valentines or greeting cards. One has to look hard for love in some of them. The search may prove frustrating and fruitless for some viewers. As in looking for love, the bell doesn't ring for everyone every time. Where one person sees love or feels love in a photo, another may see and feel nothing. So life goes. Without such differences, existence, love, and art would be rather dull.

But the love in many of these pictures is easily recognizable. We see the ecstasy and passion that love can bring. We see people being united in matrimony, such as the young Csango couple Tomasz Tomaszewski photographed on their wedding day in Setetpataka, Romania. In other photographs, we see the rituals, the pleading, the posturing, the hopes and fears, the jealousy, the separations, the reunions, and, to borrow from William Butler Yeats's poem *Fergus and the Druid*, "what great webs of sorrow lay hidden" in love.

The photographs were taken all over the world. While there are some images from the earliest days of photography, many come from the early 21st century, including some used to suggest what photographs of love might look like in the future. Following their assignments or their muse, the photographers turned their lenses on their families and friends, as

well as gypsy weddings in Slovakia, ranchers in western Canada, and couples: in a bar in Memphis, Tennessee; in a subway station in Tokyo; and in a park on the Seine in Paris. Love being an unavoidable and inseparable part of life, they photographed what appears to be love, in those places, when they saw it.

"Appears" is the key word. In photographs and in love, things are not always what they appear to be. Couples that seem committed, happy, and content suddenly break up for whatever reason. Photos in this day and age can be manipulated in a computer in ways that destroy their presumed verisimilitude. And, as Doisneau demonstrated, a photo of love could be manipulated long before Adobe Photoshop was invented.

These photographs do not presume to tell love's whole story. No book can do that. Love is too vibrant, too vast, too alive. The swirling ebbs and flows of emotion, rational thought, instinct, and circumstance that mark love in real time are frozen in a photograph. But they do let us look at ourselves, seriously, as well as lightheartedly. From these bits and pieces of our love stories a bigger picture emerges.

In some cases, as with Doisneau's photo, we have quite a bit of information about a specific picture. Some of it is provided by the photographer, albeit belatedly and under duress in his case. Some of it comes from the viewer's personal experience. We recognize places such as Paris or New York City, or people doing things we've done. In other instances, we know little about the photo. Photographers, such as Elliott Erwitt, deliberately provide only minimal information about their pictures in an effort to make the viewer focus solely on the image.

For me, and, I suspect, for most people, that means inventing my own story by associating what I see with my thoughts and experiences. I look until my eyes hurt. I ask myself what is going on in a picture, such as Erwitt's shot of a wedding party in Siberia. The bride and groom sit huddled together, flanked by a young man and a young woman, probably their witnesses. Although the date is 1967, their clothes and hairstyles have a Buddy Holly, mid-1950s, American rock 'n' roll look. The wedding couple stares at the man as if he has just said something shocking. Their female friend looks down, despair personified. The best man has a self-satisfied, smirking grin on his face. We don't know what transpired, but the picture seems fraught with tension and portent, and even though this is Siberia during the Soviet era, I can hear Buddy singing "Maybe, Baby." Is this any way to begin a life together? Is this where love leads? What bombshell did the guy just drop?

In short, I create a story, a fiction fragment, to explain to myself my reaction to the picture. Whether Erwitt or anyone else likes my tale is irrelevant. It grew in the place where my story intersected with what I saw in his photo. For all I know, it was just a passing moment of no consequence and the people in the picture are all alive, well, and in love in Siberia today. But I can only go by what I saw and felt. How do you say disaster in Russian?

Light and sight are cornerstones of life, love, and photography. Earthly life and photography are made possible by the steady deluge of tiny light particles, called photons, from the sun. They started the great chain of life in which sexual and maternal love are the driving forces. Seeing is a key element in both kinds of love. The first face a baby knows is that of its mother, its life-giver and sustainer. "Love at first sight," is a well-documented phenomenon. Each of us is attracted to what we perceive as beauty, which, like love, is an ambiguous concept, another eye-of-the-beholder and know-it-when-I-see-it thing. As the photographer Ernst Haas once said, "A picture is an expression of an impression. If the beautiful were not in us, how would we ever recognize it?" This visual attraction would seem to separate us from creatures that fall in love based on scent. Then again, blind people experience love. And they can also take photographs.

In love and photography, the world and our experiences are winnowed down, sometimes only briefly, to create another reality, one built of moments. When love is present and kind, these moments can be ecstatic. When it is absent or lost, they can be ineffably sad. We've all seen them: A mother and baby, smiling face to face; two brothers bumping chests in celebration; a family standing by a just-filled grave; a bride and groom on a Pacific island; two lovers entwined. These are not Cartier-Bresson's decisive moments, when something happens and a photographer decides to trip a shutter. They are the moments when love emerges from the crowd and shows its face.

To a man and a woman overcome with passion, kissing in public, whether it's in a Manhattan nightclub or the April rain on the Champs Elysées, the rest of the world ceases to exist. The kiss isn't necessarily a prelude to anything. It is a thing in itself, a feeling, a place, a moment shared by two people, joined at the lips, magically stopping time in a universe all their own, totally unaware that they are being photographed. Such moments happen always and everywhere, yesterday, today, and tomorrow. Once in a while, we look around and see them, little pictures taken from a big picture rife with love. ❈

1 | YESTERDAY |

Love and photography wed at the medium's birth. The match was made not in heaven but in Wiltshire, a rural stretch of southwestern England. St. Augustine of Hippo presided in spirit. The wedding photographer was William Henry Fox Talbot, inventor of the negative-to-positive paper process upon which modern, pre-digital photography is based. The nuptials occurred in August 1835, when Talbot used a boxy camera he built to make a small image of the oriel window in the South Gallery of his home, Lacock Abbey. No reception was held. But the picture-taking continues to this day.

The image Talbot made still exists. It is the oldest known photographic negative, showing the Gothic window's panes as gray separated by white lines of lattice. Beyond the glass, the abbey's park-like setting is fuzzily limned in soft charcoal shades. The greater historic significance is naturally Talbot's invention, not what he photographed. Seized by the spirit of discovery, he soon photographed many things, including his home, his wife, Constance, and their three daughters, Rosamond, Matilda, and Ela. Like the window, these subjects are considered secondary, chosen for convenience to demonstrate his invention.

That is only partially true. His family was indeed close at hand, as were a wealth of other subjects. But the new medium was not born in a vacuum. There was already a long-established European pictorial tradition that Talbot knew well. Highly intelligent, creative, and educated, he possessed a refined aesthetic and applied it in carefully selecting and posing his early subjects, all of which were things close to his heart: his family, friends, possessions, and estate. Talbot wasn't merely demonstrating his

invention. He was making considered pictures, meaningful, artful images of his world, his life, and the people he loved. His are not only the first photographs; they are the first showing love.

Love may not leap to mind when one looks at his works, but it is present, even in the people-less shots of house and grounds. The construction of Lacock Abbey, bought by the Talbot family in the mid-18th century and passed down to Henry, was inspired by St. Augustine of Hippo, one of the world's seminal thinkers on the subject of love. The abbey, which Talbot called "a fine old pile," was built in the 13th century by Ela, Countess of Salisbury, as a nunnery of the Augustinian order, devoted to the teachings of the saint who wrote, "Nothing conquers except truth and the victory of truth is love."

Talbot would have made a good Augustinian, with his relentless pursuit of truth through learning, balanced by his loving behavior toward others, within the proprieties of an English gentleman of his time. Seeking to facilitate his photographic research, he had the now-immortal oriel window installed, drenching the abbey's South Gallery in photons, the tiny light particles sent by the sun that are the source and sustainers of all earthly life, love, and photography.

Henry kept photographing his loved ones as he refined his process. They appear to have sometimes been unenthusiastic models. Talbot photographed Matilda, his second daughter, in the early 1840s, when she was about six years old. Leaning on a settee, the child props up her

JULIA MARGARET CAMERON I England, 1865 I "The Red and White Roses"

head with her right hand. Her expression is as sulky and bored as that of some 21st-century children facing parents equipped with the latest digital camera. Unlike her contemporary counterparts, Matilda had to sit still for several minutes because of the exposure time required by the picture box her daddy invented.

Life, love, and technology move faster nowadays. But the underlying impulse for much artistic, commercial and vernacular photography has not changed much since Talbot's first photographs. We take or have someone else take pictures of things we love: grandparents, parents, husbands, wives, children, relatives, friends, pets, houses, cars, stuff. The resulting images capture moments in our world and our lives. The photos become the illustrations, keepsakes, and touchstones of our life stories.

Some of love's stories and pictures are happy, some are sad. Love can alter people's lives in positive ways, carrying them through hard times, despair, and loss. It can also break their hearts, crush their spirits, and kill them. All major religions and political movements are based on love, whether of God, country, or ideology. Over the centuries, tens of millions of people have died in conflicts caused by politics and religion. Innocent men, women, and children, are still dying every day, murdered by other men, women, and children serving their God, country, or cause.

About 70 years after Matilda sat there looking grumpy, two other children, dressed in white summer clothes, were photographed as they sat squished together in a wicker chair on a grand veranda on a bright, sunny day. It is a candid shot. An out-of-focus chair intrudes into the foreground. The kids sit face-to-face, noses practically touching. The little girl's left

arm is around her little brother's shoulders, his left hand is clasped in her right in that hugging-cum-wrestling grip older siblings employ.

Scenes of this sort have been photographed countless times since Talbot's time. They speak of peace, tranquility, the long, lazy summer days of youth, and the love between a brother and sister.

But this isn't just any family. The photo comes from the Romanov Collection, which is housed at Yale University's Beinecke Library. The collection contains letters, papers, and six photo albums of the Romanovs, the family that ruled Russia for generations. Many of the photographs were taken and annotated by Anna Vyrubova , a lady-in-waiting to the Tsarina Alexandra Fyodorovna., others were taken by members of the imperial family.

The children shown are Anastasia Nikolaevna, the second daughter of Tsar Nicholas II and Tsarina Alexandra, and her younger brother, Alexei Nikolaevich. She was probably nine years old at the time, Alexei five. While the photographer is unknown, the photo was taken on the veranda of Livadia, the Romanovs' summer palace in the Crimea.

What is so striking about the photos in the Romanov albums is how similar they are in content to so many family albums. The photos show the family at work and play, in public and in private. To judge from their photos, the Romanovs cared deeply for one another, and the affection between Anastasia and Alexei was genuine.

From our vantage point, we know the Romanov story ends badly. The entire family, along with their physician and servants, was executed by

the Bolshevik authorities in 1918. All the love of their parents, siblings, and protectors did not save the children in the chair.

Yet love is also a cause for hope, a source of joy, and an enduring inspiration for people everywhere. Every day, babies are born, anniversaries and birthdays are celebrated, the faithful go to worship, grateful for God's love, and people go to jobs they love. As you read this, a couple somewhere is getting married. Ethnological studies have found marriage to be an institution in almost every culture. Studies also show that few societies prohibit divorce, suggesting a kind of universal recognition that love can go awry.

Since love is central to all human existence, it is no surprise that people—men, women, children, mothers, fathers, lovers, families, and friends—are front and center in the photographs in this book, and in this chapter. In many of the pictures, we see couples looking back at us, photographed in studios or in everyday situations. Some simply sit or stand together, facing the camera in their everyday garb, as in Mike Disfarmer's quietly radiant "Mr. and Mrs. Barger," shot in rural Arkansas. Others seem oblivious to it, such as the couple André Kértész photographed kissing in Budapest, Hungary, in 1915, or the more flamboyant couple Brassaï caught spooning in a little Parisian café on the Place d'Italie in 1932, a photo made possible by the 35mm Leica camera's ease of handling and technical capabilities.

In other photos, couples are holding hands, embracing, dancing, kissing, or celebrating their wedding day, things they have been doing for thousands of years. As the *I Ching* advised the people of China in 1150 B.C., "a close bond is possible only between two persons, a group of three engenders jealousy."

The force bringing most couples together is reproduction. As psychologist Ada Lampert wrote in 1997, in her book *The Evolution of Love*, "If love was indeed selected by natural selection processes, it was selected according to the universal criterion of evolution: contribution to the reproduction of offspring. The essence of natural selection is that it selects those traits which have an advantage in the process of reproduction. We must, therefore, look for the advantages of the talent to love adjacent to the giving birth to and raising of children. Indeed, the two major loves that we experience are sexual love and parental love—the love that brings children into the world and the love that raises them."

Those life experiences differ for each individual. The same is true of love. We all go through it, each of us in our own way. For one person, love can make life worth living. For another, love makes life living hell. In between is a vast smorgasbord of themes and variations, playing out in mysterious ways. Even when it has been unkind, love can be funny. American writer Dorothy Parker once described love's roller coaster effect with the words, "Oh, life is a glorious cycle of song; / A medley of extemporanea; / And love is a thing that can never go wrong; / And I am Marie of Roumania."

Those are just a few of love's aspects visible in these photographs. Looking at them is a bit like rummaging through some family photo album found in a box in the attic. That is, if you came from a family of extraordinarily talented photographers.

At first glance, many of the subjects look as uncomfortable as Matilda Talbot, and their black-and-white world seems quite drab compared to our color-saturated version.

Yet photography has brought them into our present. Everyone depicted here may be dead and gone. But we can still see them. Reduced to images on paper, their faces and stories fit well in our world. Just as we do, they pose for the camera. Like us, they kiss, hug, snuggle, and struggle to find ways of knowing and showing love. When life and love end, they, too, feel loss. We can see that in some of their faces.

These photographs are timeless, telling excerpts from the immense, constantly growing pool of visual images. They were taken by some of the finest documentarians and artists ever to lift a camera. Whether Talbot, Julia Margaret Cameron, André Kértész, Henri Cartier-Bresson, or Robert Capa, each was looking for images that connected an individual's tale to something greater, to a story about human life told in the primal language of pictures. We see what was in front of the lens, but also the photographer's way of seeing the world, his or her take on humankind. Looking at their photos as a group, we can see how the world, photography, and love have evolved since the medium was born.

Photography changed the way individuals visualize love. Rather than having to imagine what love looked like, which usually meant imagining the physical appearance of a loved one, people could look at a photographic portrait of that person. That picture was a powerful thing. Gazing at such portraits brought personalities to mind and to life. Although it was only a picture, not the living person, the photograph made the object of one's love seem present. Unlike a painted portrait, the photo was portable. It could easily be moved about in a room or home, carried in one's personal effects, or sent to someone else.

The way society visualized love also changed as technology allowed photographs to be reproduced in newspapers, magazines, books, and postcards. Previously, the mass media could only offer the public stories, engravings, or sketches of celebrities, actors, singers, and public figures. Through photo-mechanical reproduction, the masses could see a famous person's photograph, a far more realistic and often compelling likeness. Those photographs made it possible for someone who lived thousands of miles away from the celebrity to feel connected to them, even to fall in love with them. Some 120 years after Talbot photographed his daughters, girls all over the world would fall in love, "love me do," mooning over the photographs of four English fellows named John, Paul, George, and Ringo.

Obsession and compulsion existed long before the Beatles or photography. But photos provided a potent visual aid. St. Augustine, who wrote in his *Confessions*, "I loved not yet, yet I loved to love...I sought what I might love, in love with loving," would have understood the photo-induced longing.

As Talbot envisaged, photography was quickly embraced by other practitioners as a means of artistic expression. Among the earliest and most unusual was Julia Margaret Cameron, whose photo "The Red and White Roses" begins this chapter. Born in India in 1815, she was the daughter of a prominent British family. As a young woman, Julia married a British civil servant considerably older than she. They retired with their family to a home on the Isle of Wight, not far from that of British poet laureate Alfred, Lord Tennyson.

At age 48, Julia began taking photographs after her daughter gave her a camera. Captivated by the medium, she set up a studio at the family

home and became fairly adept at the collodion wet-plate process. Like Talbot, Cameron photographed her family, servants, friends, and acquaintances. The latter group included some of the most creative individuals of her time, among them Lord Tennyson, the artist Dante Gabriel Rossetti, the scientists John Herschel and Charles Darwin, and the portrait painter George Frederick Watts.

Partly through her initial technical ineptitude, Cameron began producing blurry, soft-focus portraits of her subjects. When she began showing them, critics were generally unenthusiastic, complaining about the lack of sharpness. Her arty friends, however, loved her photos and that became her signature style. Cameron, in turn, was strongly influenced in her choice of subject matter by literature and the paintings of Renaissance masters such as Raphael, Giotto, and Michelangelo, whose works she knew from prints. From the first, her aim was lofty: "My aspirations are to ennoble Photography and to secure for it the character and uses of High Art by combining the real and Ideal and sacrificing nothing of the Truth by all possible devotion to Poetry and Beauty."

Besides her portraits of luminaries, Cameron created a series of allegorical photographs, such as "The Red and White Roses," a frame-filling portrait of two little girls taken in 1865. The flowers and the picture bloom with metaphors: love, purity, innocence, youth's fleeting, fragile beauty. The models were Kate and Elizabeth Keown, daughters of an artillery officer who lived near Cameron's home at Freshwater on the Isle of Wight. Cameron adored children, as well as play-acting, art history, art-making and beauty, and her passions come through in her photos.

Henri-Cartier Bresson was also captivated by photography and beauty. Unlike Cameron, he saw and photographed the beauty found in daily life, rather than creating it in a studio. The bride and groom he photographed celebrating their nuptials at an outdoor café in Joinville-le-Pont, on the Marne River near Paris one afternoon in 1938, embody the happy mood that prevails after many weddings the world over. The new husband and wife laugh like children as he pushes her, standing up, on a swing. It is a joyous moment, the giddy start of a life together. "Love," as St. Augustine wrote, "and do what you like."

The photo doesn't tell us whether that life lasted happily ever after. Love is seldom easy. According to German poet Rainer Maria Rilke, "For one human being to love another; that is perhaps the most difficult of all our tasks, the ultimate, the last test and proof, the work for which all other work is but preparation." Looking back through time, the wedding date is worrisome. Europe was one year away from World War II. For all love's power, it did not prevent that catastrophe.

No one could have known what was to come that afternoon. It seems likely Cartier-Bresson was feeling fine, exercising his remarkable vision at a happy event on a sunny day. Instead of wide-eyed gazes and formal poses, advances in photo technology allowed him to catch life in full swing. The bride and groom are enjoying themselves and couldn't care less about some guy with a camera. No one needed to tell them that just as naturalism enlivened European painting during the Renaissance, it was injecting fresh life into the marriage of love and photography. They were natural, living proof. We can see that now, looking back. �ખ

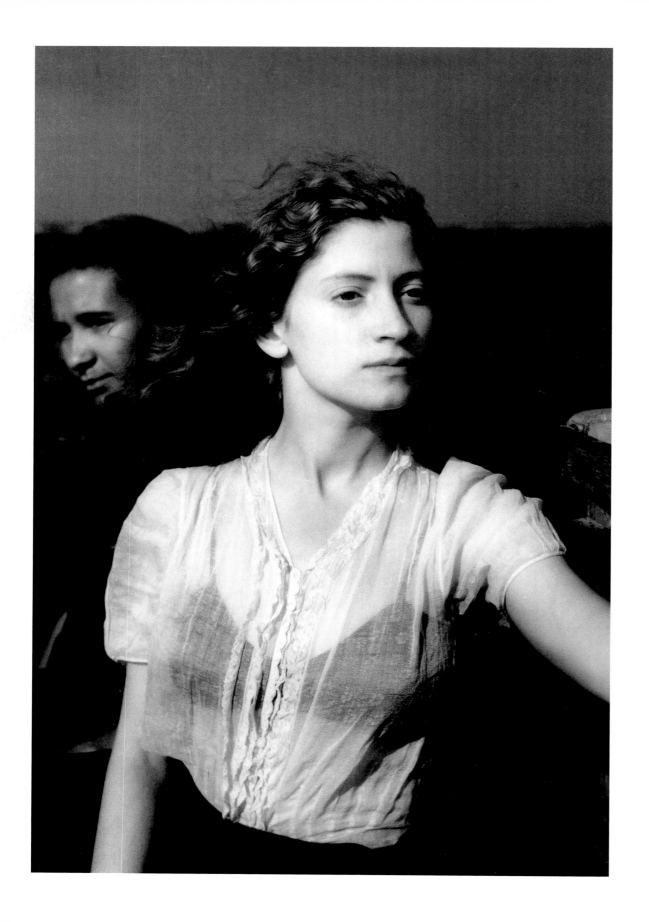

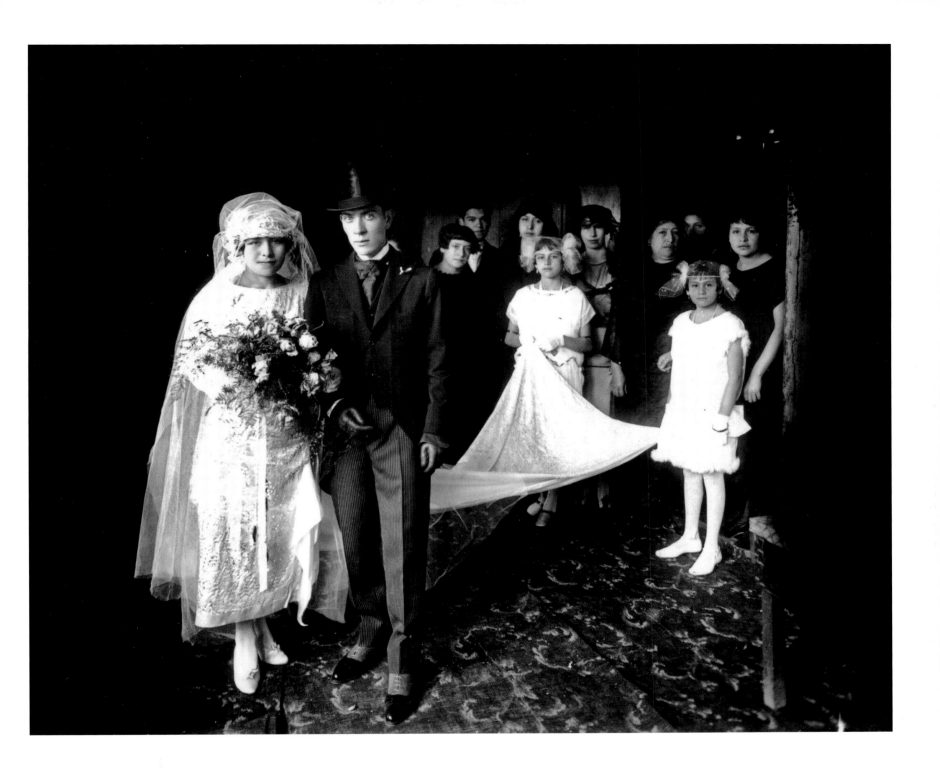

MARTIN CHAMBI I Peru, 1930 I The Gardea wedding
OPPOSITE: EDOUARD BOUBAT I France, 1947 I Lella

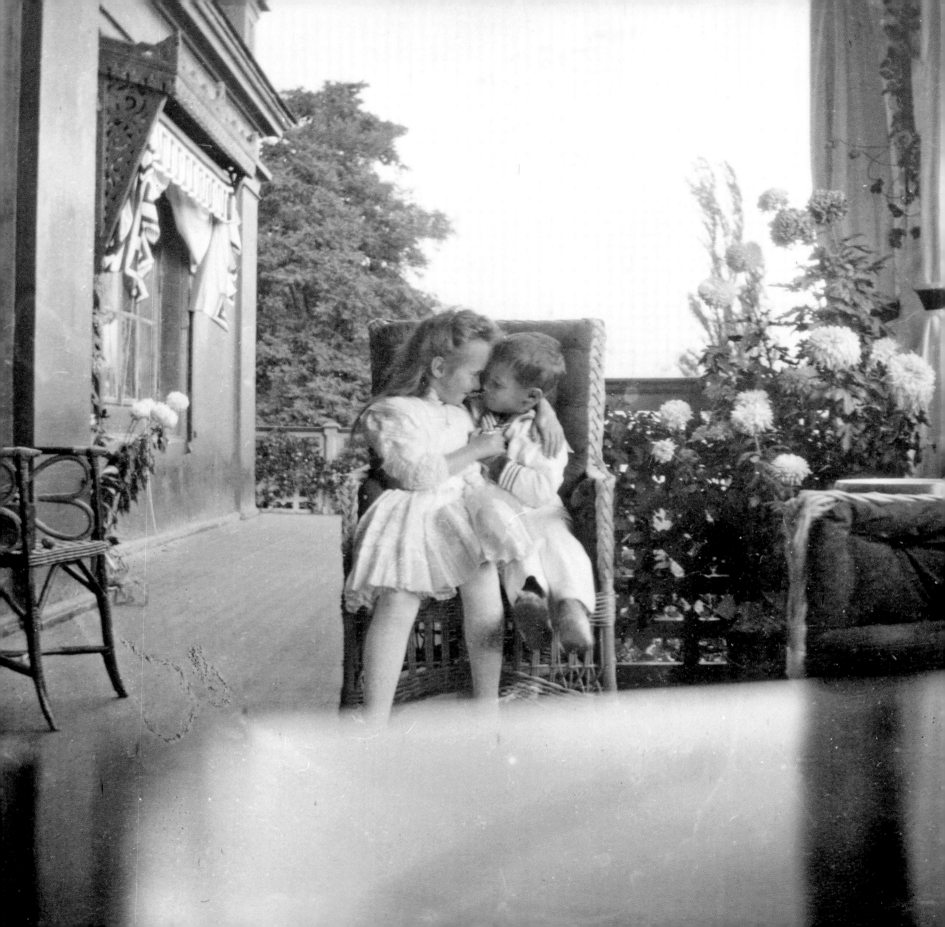

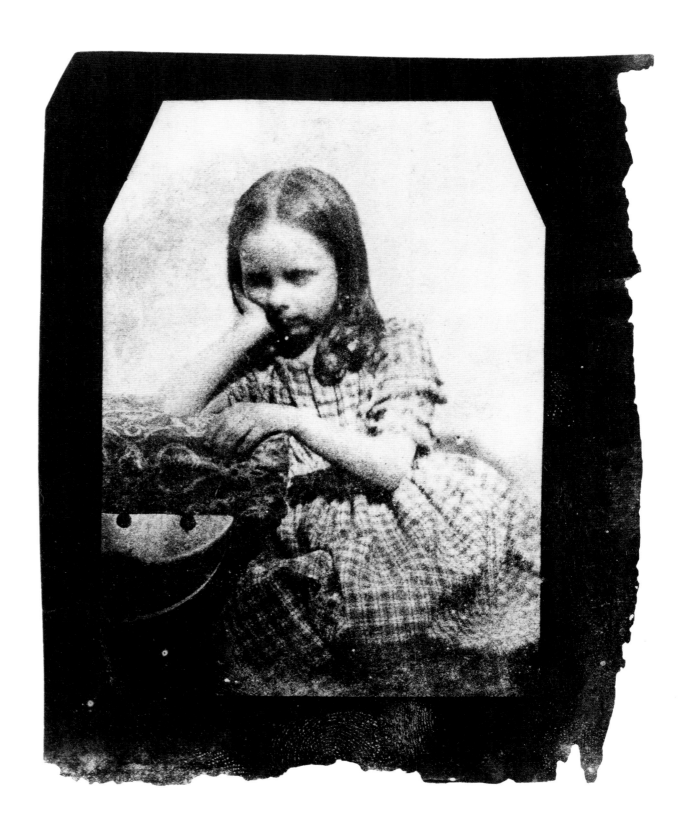

WILLIAM HENRY FOX TALBOT **|** England **|** Matilda Talbot
OPPOSITE: **PHOTOGRAPHER UNKNOWN |** Crimea, 1909 **|** Princess Anastasia and Prince Alexei

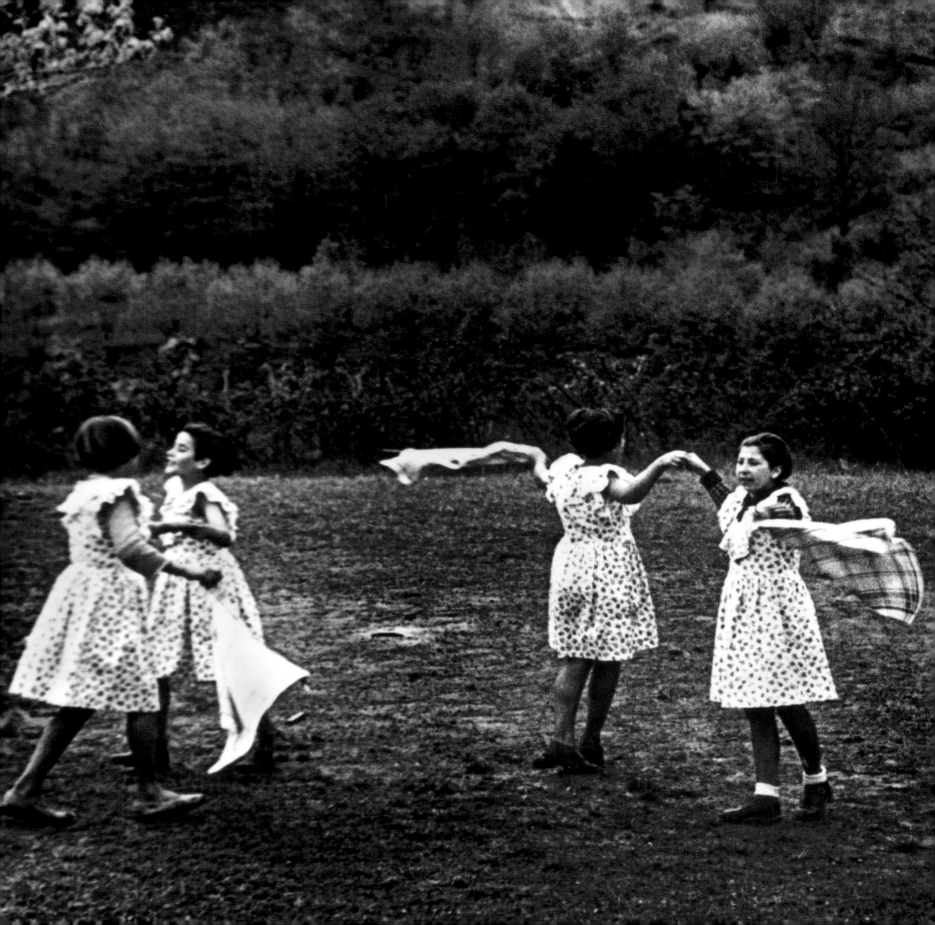

ROBERT CAPA | France, 1939 | Orphans of the Spanish civil war

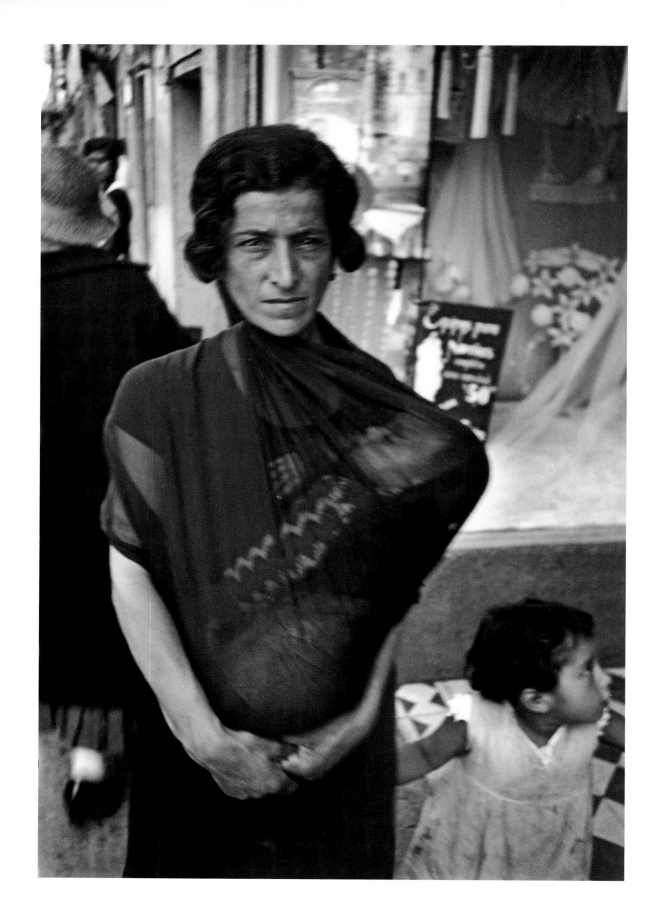

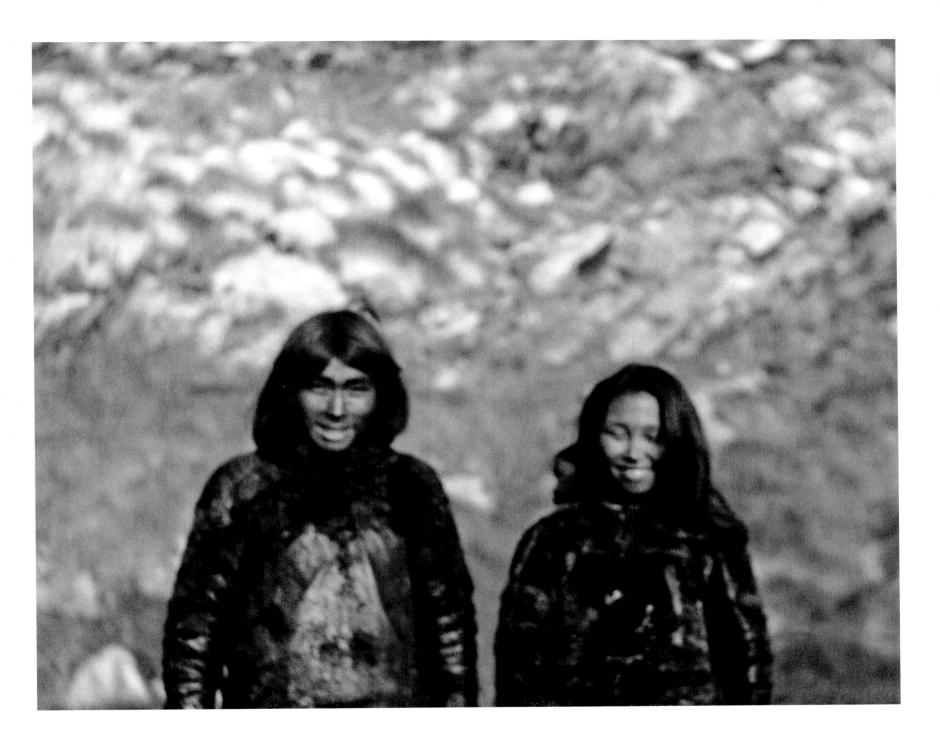

ADM. ROBERT E. PEARY ❙ Greenland, 1905-6 ❙ Inuit couple

OPPOSITE: HENRI CARTIER-BRESSON ❙ Mexico City, 1934

JOSEF KOUDELKA | Slovakia | Gypsy wedding procession

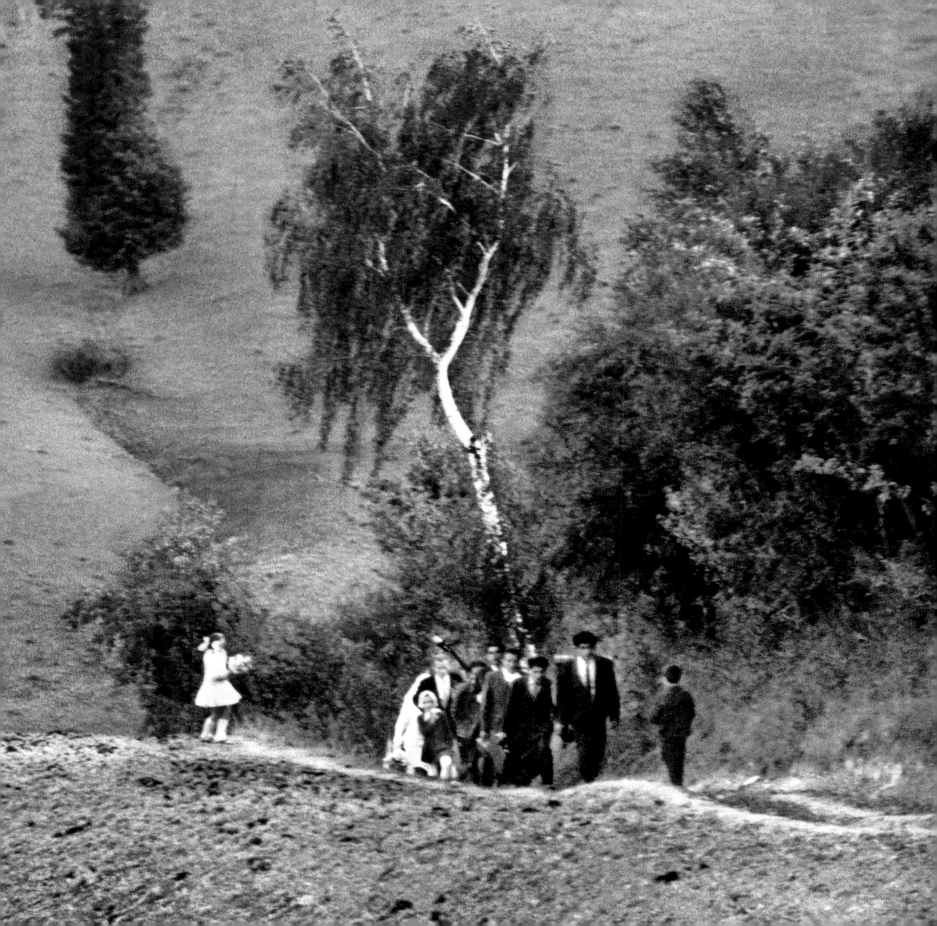

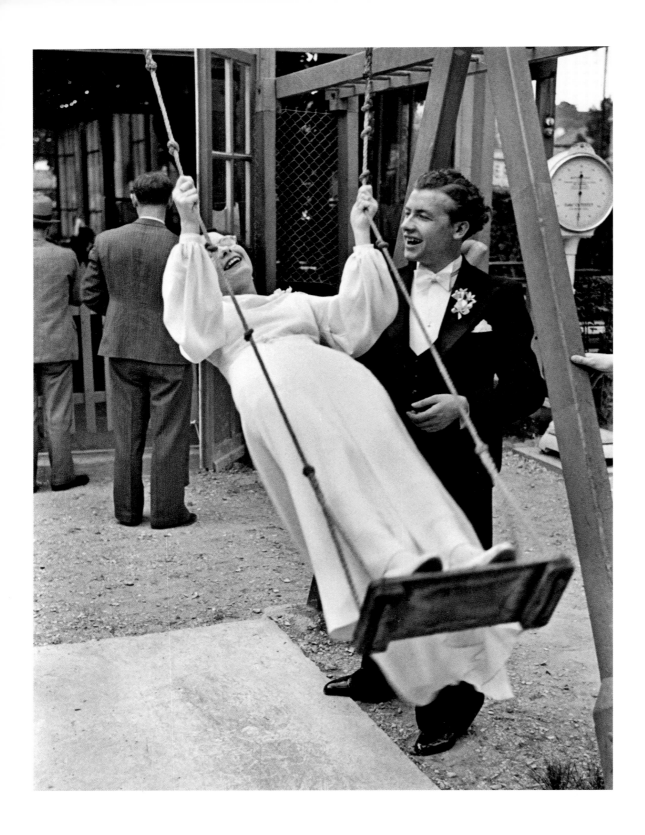

HENRI CARTIER-BRESSON | France, 1938 | Newlyweds at an outdoor café on the Marne River

OPPOSITE: **BRASSAÏ** | Paris, France, 1932 | Young couple at a ball

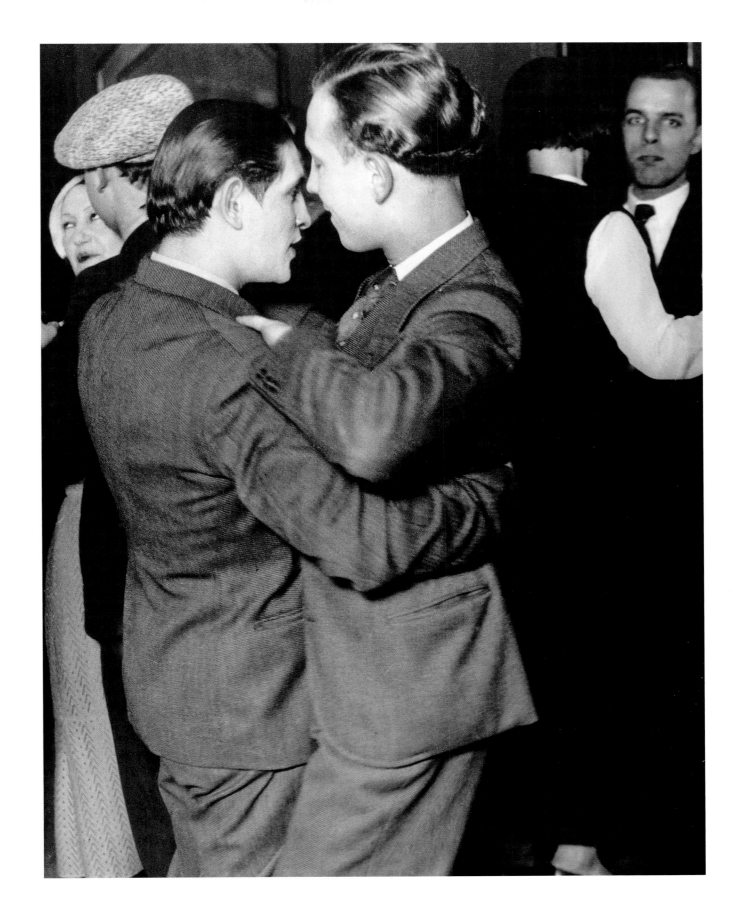

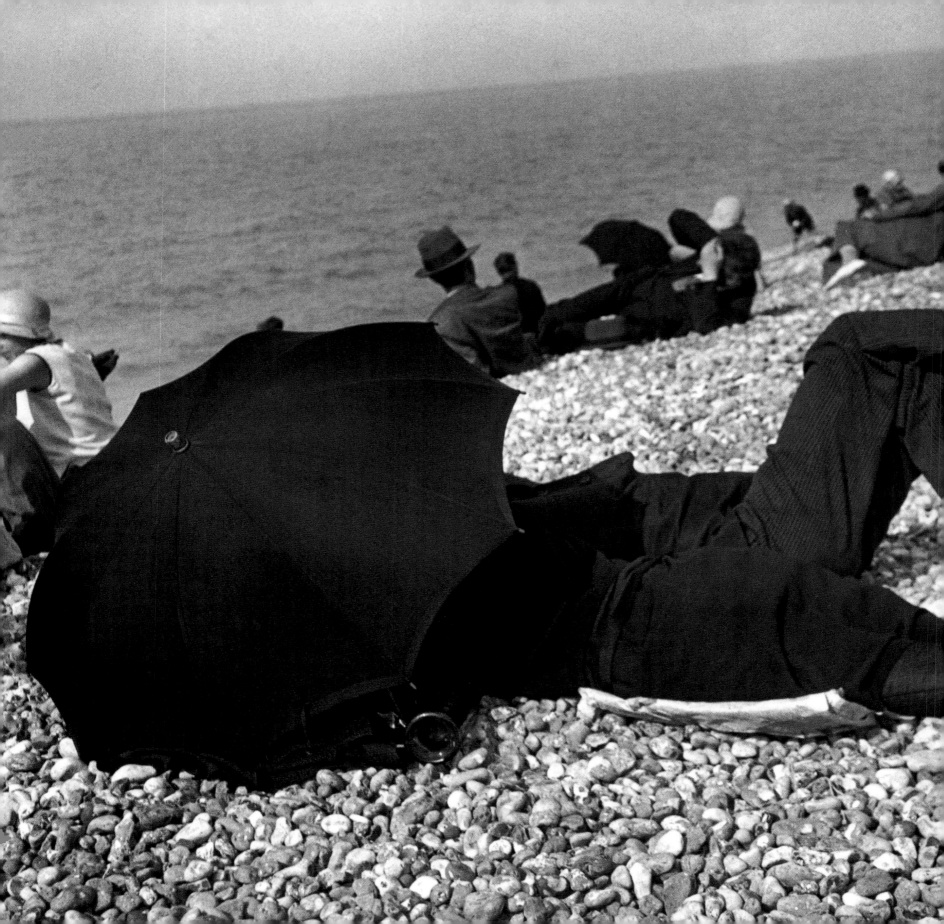

HENRI CARTIER-BRESSON ❘ France, 1926 ❘ Beach scene in Normandy

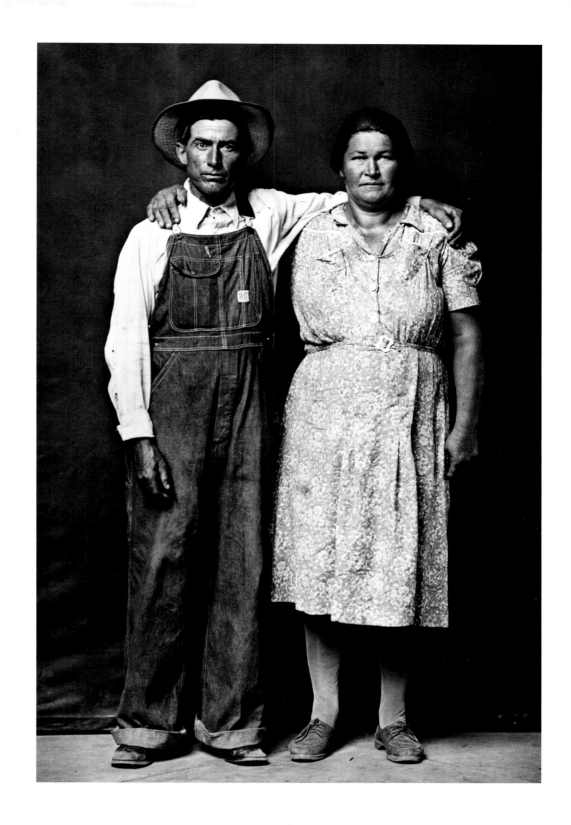

MIKE DISFARMER I Arkansas I Mr. and Mrs. Barger
OPPOSITE: AUGUST SANDER I Germany I Farm children, Westerwald
FOLLOWING PAGES: DAVID SEYMOUR I Barcelona, Spain, 1938 I Party in honor of the International Brigades

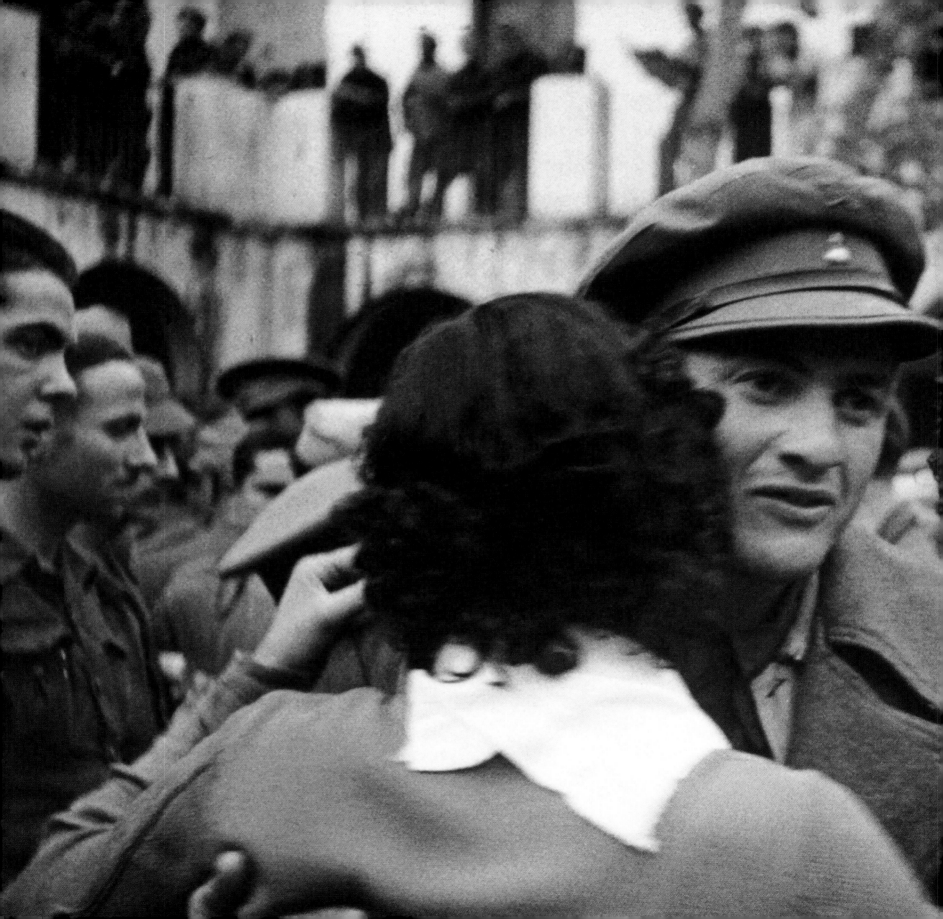

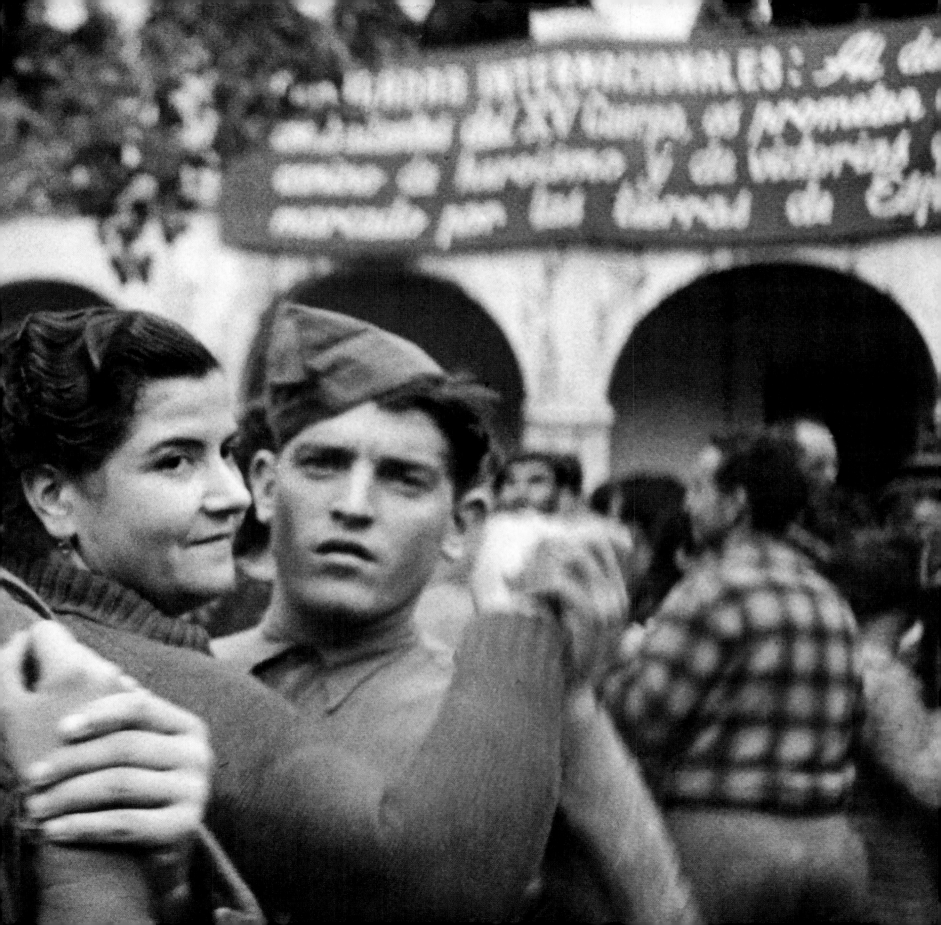

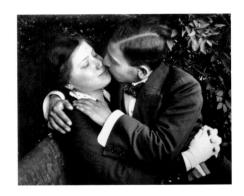

ANDRÉ KÉRTÉSZ **|** Budapest, 1915 **|** "The Kiss"

OPPOSITE: **BRASSAÏ** **|** Paris, France, 1932 **|** Café scene in the Place d'Italie

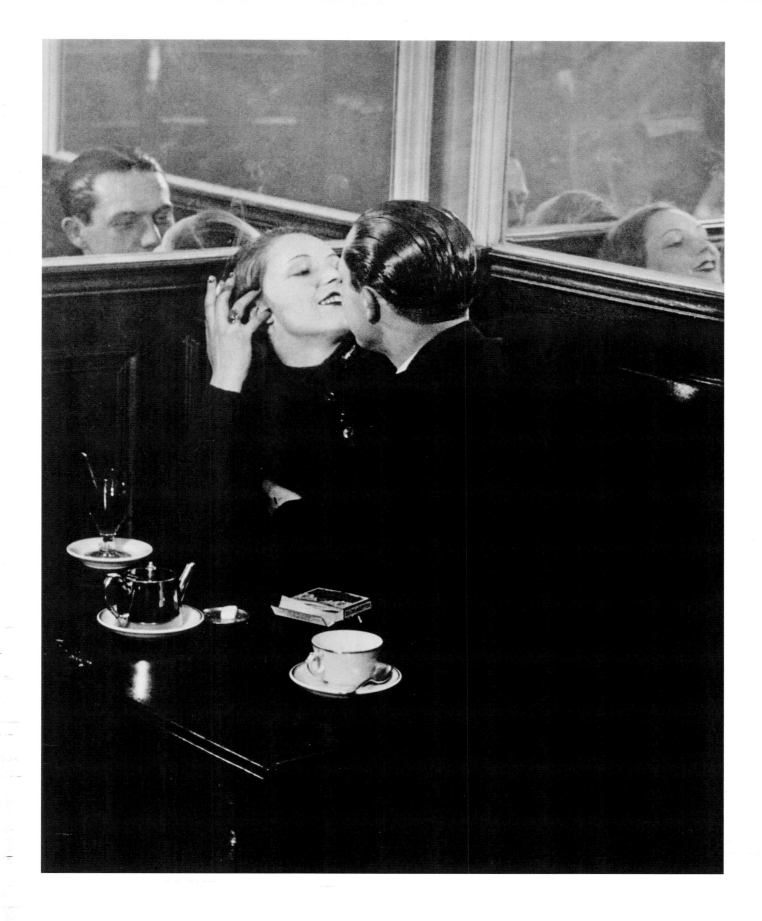

RUSSELL LEE **|** Oregon, 1941 **|** Carnival ride

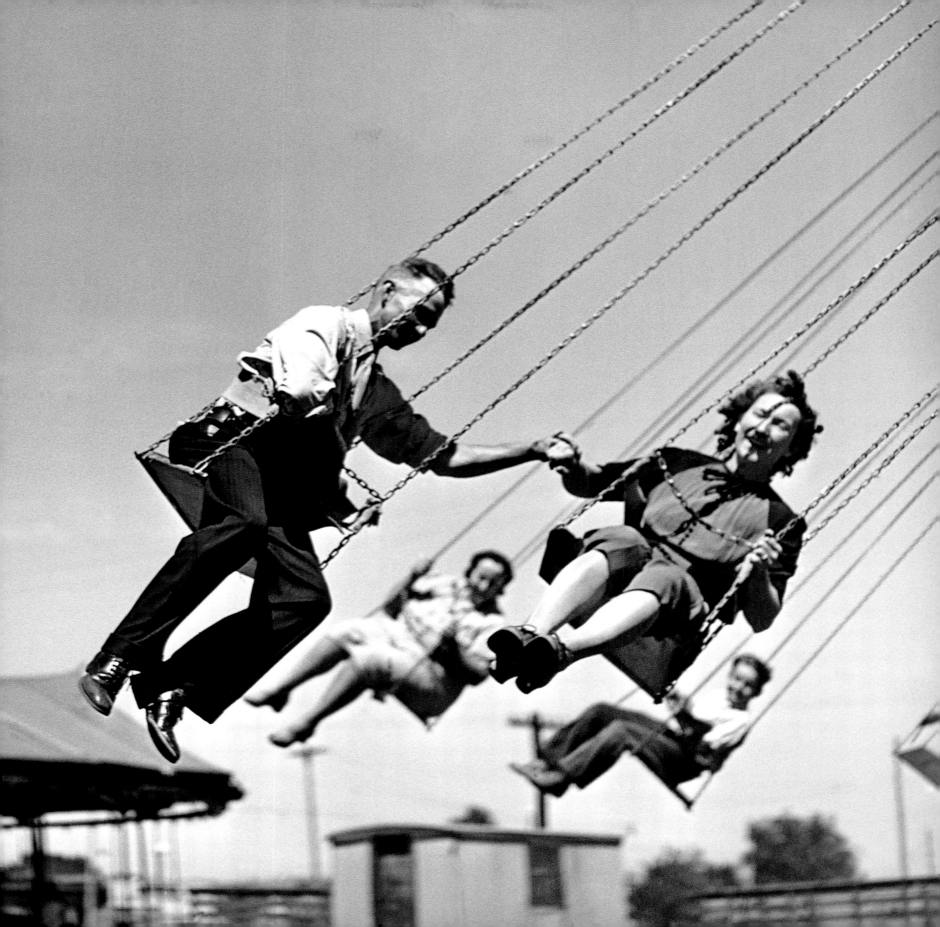

JOE CLARK | Cumberland region, USA, 1943 | Square dance on the cane stalks

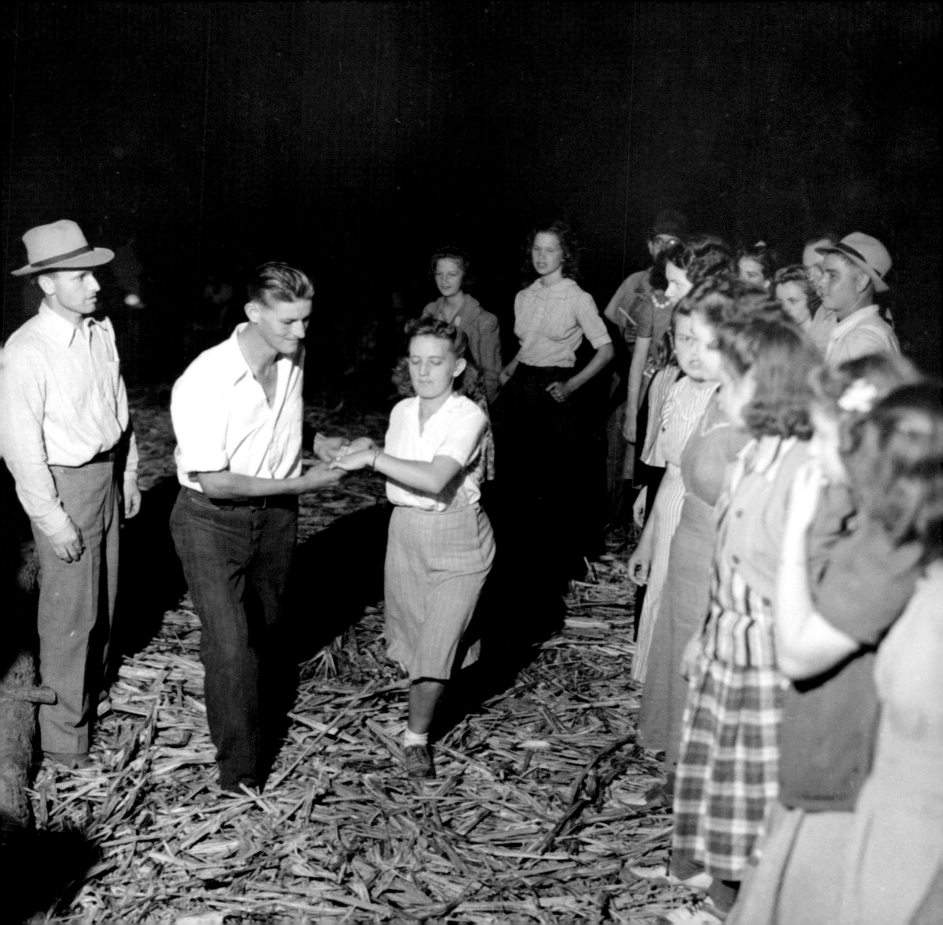

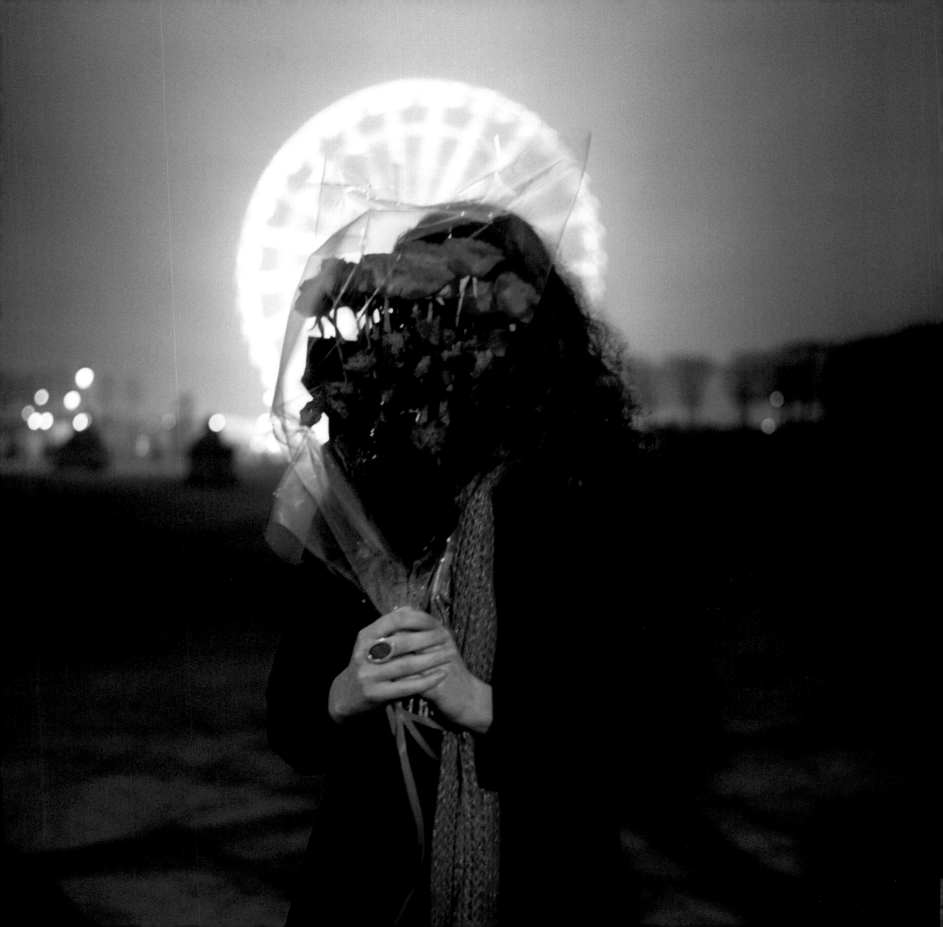

2 | IN PUBLIC |

The young woman stands before the camera, hiding her face among the petals, stems, and thorns of a bouquet of red roses wrapped in cellophane. It is the evening of Valentine's Day, in the Tuileries Gardens in Paris. Love is out and about, pausing to have its picture taken in the charged dusk of one of the most romantic cities on Earth.

Guillaume Herbaut, the photographer, has positioned the woman so that the lights of a Ferris wheel in the distant background give her a glowing halo similar to those gracing Late Gothic Madonnas painted by the likes of Italian masters Jacopo Bellini and Andrea Mantegna. That beatific effect is reinforced by her hands, clasped as if in prayer around the stems. The red blooms also recall the blood spilled when the three saints named Valentine or Valentius, who are recognized by the Roman Catholic Church, were martyred, all dying, as legend has it, for love. The religious imagery is countered somewhat by the flowers, a classic symbol of love, but also a reminder of the orgy of commercialism that is Valentine's Day, when the price of red roses soars.

The portrait Herbaut created in the public gardens is charming and unconventional. We cannot see the woman's face. She peeks through the bouquet as if sizing up not just the person taking the picture and all who see it, but the mystery of modern love. She is posed and composed but enigmatic, like Da Vinci's Mona Lisa. Is there an undecipherable smile behind the roses, a special look reserved for her one, true love? Did Herbaut just happen upon her and see a terrific photo opportunity? Is she his wife, girlfriend, muse, or just an acquaintance? All we know is what we see: a photo taken one February evening that evokes thoughts of love—alluring, confounding, super-marketed, and sacred.

The line separating photographs of love in public from those of love in private often seems as thin as the curtain on an automated photo booth like the one that produced Babbette Hines's picture at the very beginning of this book. In the digital era, the line has become blurrier than ever before. Ideas about what constitutes public and private life have changed as technology has made every image potential Internet fodder. Everything seems public, as if the curtain is gone.

Photographing love in the public sphere is a relatively new activity in historical terms, dating to the medium's invention in the 19th century. But love has had a public presence since the first hominids roaming the Earth under African skies were gripped by the feeling and did what they had to do. Notions of privacy likely didn't come along until much later when humans went from being hunter-gatherers to raising crops and constructing permanent dwellings grouped into villages. Even then, love—sexual, parental, filial, or religious—would sometimes appear out in the open, in places where anyone walking by could see it.

What was there to see? People. Men, women and children. Couples embracing, kissing, even making love, oblivious to where they were or who might see them. People holding hands. A husband and wife sharing a meal under a tree. A widow walking to a place of worship. A kid holding a pet. A baby clinging to its mother. Best friends laughing together.

GUILLAUME HERBAUT I Paris, France I Valentine's Day, Tuileries Gardens

Families mourning the death of a loved one. A young girl, holding a bouquet of flowers. In short, public scenes of human life in which love appears. The same scenes—some dramatic, some mundane—can still be seen in public today, all over the world.

No single photograph, no single art work can capture something as vast and complex as love. The photographs you see in this chapter offer glimpses of how love appears in public, where it appears, and why. Viewed as a group, they highlight how truly universal love is, and how fleeting it can be. The people of various ages from all over the world—embracing, kissing, dancing, holding hands, sitting on park benches, or relaxing in the sun—illustrate the way love changes over the course of a person's life. Love begins with the unselfconscious happiness a baby feels touching and being touched by its mother. As the child grows, a variety of loving behaviors develop, taking it through the fireworks of adolescent awakening, the romance, sex, and mating rituals of adult life, and the joys and sorrows of marriage, partnership, family life, aging, and death.

Many of these photographs are candid and poetic, visually distilling life and love to their essence in the great and now waning tradition of street photography pioneered by artists such as André Kértész, Henri Cartier-Bresson, and Brassaï. Street photography relies on photographers with uncommonly quick seeing ability, intuition, and reflexes, enabling them to catch those moments when life offers both art and meaning in visual form. Garry Winogrand's photo of a couple dancing at the El Morocco nightclub in New York City, in 1955, is a terrific example of that practice, as well as of how love can look on a night out in another big city.

Winogrand's picture is a brilliant improvisation rather than a meticulous composition à la Herbaut's angelic flower girl. Here, we see the woman's face, and she is no angel. The photo freezes her in the midst of a braying laugh, possibly over something her dancing partner just said. But the effect of the picture is not comical. Winogrand makes the woman seem like some fierce, feral beast or a vampire about to strike. Her tightly coiffed head is thrown back, and her mouth is wide open, revealing gleaming white teeth. The ice-pick sharp fingers of her left hand look as though they could pierce her partner's shoulder as if it were tissue paper.

He is just a slick cipher. The top of his head is cut off, his ears are angled gray gashes on the picture plane separated by darkness and hair, and the collar of his white shirt neatly bisects his neck. His suit is a tone poem written in black. In this picture, he is as much a fall guy as Fred McMurray was for Barbara Stanwyck in *Double Indemnity.*

This is a classic example of what Cartier-Bresson called the "decisive moment." Decisive, that is, for the photographer. Everything in that club at that moment aligned in just the right way for Winogrand to take the picture. We know nothing about the subjects other than the fact that they caught his eye. Yet, through this one photograph, Winogrand pulls in life, the world, the social mores of the 1950s, New York City, the nightclub, film noir, comedy, horror, a man, a woman, and, perhaps, love.

You get the sense that Winogrand loved this photo and loved taking it. Photographers, each in their own way, love looking at life, seeing the world and all that is in it through a viewfinder or a lens. Whether it's a person, place, or thing, animal, vegetable, or mineral, action or inaction,

they are moved to take a picture preserving something of what they saw and felt at that moment.

Creating the photographs you see in this chapter and throughout this book required the photographers' passion, desire, commitment, as well as a sense of self and subject. They have to work at their art, the same way people work to maintain their love relationships. Even for professional photographers, the failure rate for individual pictures is high. What you see are the pictures that succeeded. Many more were taken. Psychologist Erich Fromm could have been referring to photography when he wrote in *The Art of Loving*, "There is hardly any activity, any enterprise, which is started out with such tremendous hopes and expectations, and yet which fails so regularly as love."

Sometimes photographers fall in love with a particular picture. Just as love can make a person blind to any faults their beloved may possess, it can make problems with focus, depth of field, perspective, light, or color irrelevant to the person who took the picture. Of such things, fights between editors and photographers are made. The editors usually win.

In life, each of us edits the love we see in public when we encounter it. What we see and how we react to it depends on who we are, where we are, and the culture in which we live. Culture shapes our attitudes toward public displays of love and affection. In some parts of the world those attitudes have changed significantly over the years, in others they have changed very little.

Over the course of the 20th century, for example, taboos in the Western industrial nations against hugging and kissing in public have largely disappeared. The only person we see disapproving of the couple kissing madly in Dennis Stock's photo taken outside the Café de Flore in Paris one night in 1958, is the white-jacketed waiter, standing impatiently with his broom, thinking the French equivalent of "get a room." In other cultures, kissing in public is taboo and the couple could be stoned.

The way pictures showing love are made has evolved dramatically over the years, reflecting the changes in society and the way we make pictures. The invention of photography brought unprecedented immediacy and accuracy to picture-making. The earliest photographs showing love were largely private in nature, centered on the families and friends of the medium's pioneers. Their pictures required unblinking poses, strong light, and long exposure times. The subjects were fully and often formally dressed. Beyond faces and hands, little skin was shown. Sexuality was downplayed, if not repressed. As a result, many 19th-century photos can seem stiff and unrevealing, lacking the emotional depth and electricity we associate with love.

That soon changed for better and worse. During the 19th and 20th centuries, photography, life, and love became faster and ever more public. The evolution of photo technology and mass production made cameras smaller, lighter, more portable, and affordable, making it easier for the general public to take them along wherever they went. Improved lenses and film made pictures clearer and sharper. Photos could be taken from shorter distances or much farther away, allowing for close-ups and candid shots. After World War II, color photography took off like a rocket, enlivening even mundane snapshots with vivid hues, at least until they yellowed and faded.

Photography, life, and love had become mass phenomena. The world's population was exploding, as were photography's possibilities and uses. The mass media, business, and industry quickly seized on the combination of love and photography as a terrific way to sell not just books, newspapers, and magazines, but products of every kind. The basic pitch is still potent today: Buy this product and you will become more lovely and loveable; you will enjoy more love in your life, just like the celebrity smiling at you.

These days love seems to be rampant in the public realm. Even if you live in a remote, rural area and never see a newspaper, magazine, or billboard, telecommunications satellites are beaming songs, stories, and pictures of love of every ilk at you 24-7. Love of every kind can be found in public, and there are countless photographs of public displays of love, ranging from the kind of shots all of us take of family and friends to paparazzi pix and fine art photography. In the mass media version of love, everyone is young, privacy is passé, sexuality is in your face, and just about anything goes for poses and attire. At times, the volume of this visual onslaught via the media feels overwhelming and oppressive.

Viewed as a mass phenomenon, even romantic love can seem banal, the doings of Valentine's Day drones marching to the maudlin orders of greeting card companies, candy makers, florists, and restaurateurs. How can love be so special if millions of people around the world fall in and out of it every day? Despite that, the cash keeps flowing, the profits from the sale of red roses keep rising. Love at the start of the 21st century is just a four-letter word for a stylized, mass-media, mega-marketing monster designed to make us spend and consume more.

Add video cameras and shameless egomania to the mix and you get homemade celebrity porn, narcissistic self-promotion masquerading as unbridled passion.

Yet love transcends it all. Because each of us experiences love as an individual, it is not distanced and banal but lived and felt, fresh and radical, stirring our bodies, minds, and souls, altering the course of our lives. Each person's love story follows its unique course from beginning to end. The plots and dialogue may be similar, the endings may be tragic or happy, but to the story's characters, the tale is always new. Valentines, flowers, candy, and candlelit suppers are just props provided by consumer culture.

Love is rooted in our species' collective DNA and passed from one generation to the next. Our ability to love and to reason sets us apart from all other creatures. Love is a psychological and physiological need that begins with the mother's touch we come to crave as infants, and continues throughout our lives as the desire for sexual and spiritual intimacy, companionship and friendship. Love gives meaning to our lives.

As Dr. Martin Luther King said in a sermon in 1967, "When I speak of love I am not speaking of some sentimental and weak response. I am speaking of that force which all of the great religions have seen as the supreme unifying principle of life. Love is somehow the key that unlocks the door which leads to ultimate reality. This Hindu-Moslem-Christian-Jewish-Buddhist belief about ultimate reality is beautifully summed up in the first epistle of Saint John: 'Let us love one another, for love is God and everyone that loveth is born of God and knoweth God.'"

Love, like religion, is nothing if not a story. Most love stories center on a couple or couples involved in a romantic relationship. Around the world, there is a seemingly insatiable appetite for such tales, replete with trials, tribulations, and triumphs. That universal appeal has made love a staple of literature, theater, visual art, popular culture, and mass media.

Sometimes the stories are sad, as are some of these photographs. Weegee's photo of a man facing forward and a woman facing backward on adjacent park benches catches the loneliness and isolation felt by many people. Patrick Tourneboeuf's blurry shot of a young man leaning against a wall at wedding reception, clutching a heart-shaped decoration while a young woman in a chic, black dress leans against the wall just a few feet to his left makes the distance between the two seem endless, in marked contrast to the idea of marriage as a uniting of two people as one. The photo brings to mind a passage by Rainer Maria Rilke in his *Letters to a Young Poet,* written between 1903 and 1908:

"The point of marriage is not to create a quick commonality by tearing down all boundaries; on the contrary, a good marriage is one in which each partner appoints the other to be the guardian of his solitude, and thus they show each other the greatest possible trust. A merging of two people is an impossibility, and where it seems to exist, it is a hemming-in, a mutual consent that robs one party or both parties of their fullest freedom and development. But once the realization is accepted that even between the closest people infinite distances exist, a marvelous living side-by-side can grow up for them, if they succeed in loving the expanse between them, which gives them the possibility of always seeing each other as a whole and before an immense sky."

We cannot know the story of every person who appears in these photographs. In many instances, the photographer has no idea who the people are. Nor do we need to. We don't know the story of people we see on the commuter train or in cars when we are stuck in traffic or walking down the street. But we know they have a story and that somehow it involves love.

It may be the love of God that Dr. King spoke of, a love that moves millions of people in various ways and which is the basis for Juan Manuel Castro Prieto's photograph of Hindu women, praying as they stand in the waters of the Ganges River in Varanasi, India, waters they consider holy. It may be the love and feeling of loss evident in Paul Fusco's photos of a young family standing by the Pennsylvania Railroad mainline on a summer day in 1968, as the train passed bearing Robert F. Kennedy's body to its final rest. It may be a senior citizen from New York, taking a picture of his wife standing next to a stuffed moose in a museum in Anchorage, Alaska, documenting the journeys on which love took them.

Photographs let us take a long look at life and love. That is particularly important where love is concerned because when we see it in public or private we often do not recognize it or we find looking at it awkward and uncomfortable. If a couple is kissing on a street, we don't know if they are in love or not. But we look. Maybe just for a few seconds before we avert our eyes, maybe a longer gaze that only ends if someone, like one of the folks kissing or a passerby, catches us in the act of looking.

The irony is that we're uncomfortable even though many of us have done the very same thing at some point in our lives. When you're in love,

you just don't care sometimes where you are or who is looking at you. All that matters is what you feel at that moment, the sense of being one with your beloved in the charged universe created by your linked neurological circuitry. Kisses can be magical.

Noticing when two people are publicly and passionately embracing is human nature, one of those instances when we recognize the basic biology and psychology of our shared humanity. It is not voyeurism, unless the person watching gets sexual gratification of some kind from what they are seeing. That doesn't appear to be the case with the somber museum-goers that Elliott Erwitt photographed by Auguste Rodin's sculpture "The Kiss," in London's Tate Gallery.

If sexual love is a sculpture in a museum, people will stop and look at it dispassionately from every angle. Visiting an exhibition with my parents at the Ludwig Forum Aachen in Germany, we encountered one of Jeff Koons's "Made in Heaven" sculptures, showing him in sexual embrace with his then-wife, Italian porn star Ilona Staller. I expected my mom to walk away in disgust. Instead, she circled the piece, muttering, "where's the beef?" Then she called to my father, who was viewing something else, "We've got full frontal here, Tom."

Photographers are experts at looking and don't shy away from seeing love in museums or elsewhere. That comes through in Bill Brandt's photo taken in Britain on March 31, 1945, toward the end of World War II. A courting couple, a soldier and his girlfriend, are frozen by an automobile's headlights as they stand, holding each other by the side of the road. They stare blankly at the light, which will sweep on, leaving them to their passion.

Years later in Russia, Gueorgui Pinkhassov photographed a young couple walking hand-in-hand down a roadside in the town of Petrapavlovsk in Kamchatka, heading toward what is known locally as the "hill of love." In both instances, young couples in love were seeking privacy in public. On a tree trunk by some lover's lane in Romania, Josef Koudelka photographed two hearts with an arrow through them carved on a tree trunk. Whether the carver's love endured, we don't know, but similar carvings can be found on trees in countless countries.

In David Alan Harvey's photograph from 1988 of French teenagers aboard a *bateau mouche* on the Seine River in Paris, we get to see young people caught up in the strange round dance of the eyes that a public display of affection can cause. At the bottom of the frame a dark-haired fellow in a suit jacket kisses the cheek of a carefully made-up blond girl seated by the boat's rail. Close by her left side, another girl, presumably a friend, is holding a cigarette and looking away with theatrical indifference. She doesn't notice a third girl, sucking on a cigarette until her cheeks implode, staring daggers at Miss-I-don't-see-a-thing. Such visual and emotional commotion, caused by a kiss.

In William Eggleston's photograph that shares a page with the table of contents in the front of this book, a young woman and a young man sit at a table. The man's disembodied head with its feline face, scraggly moustache, and long black hair rests on the woman's shoulder. His eyes are closed. In the sudden burst of light from a bounce flash, his oily skin has the sheen of a copper pot. The woman's left arm is wrapped around his shoulders, casually cradling him. There is a mug of clear, iced beverage, maybe a vodka-tonic in her right hand. Her clear, brown eyes

aren't hidden by a bouquet of red roses. She is looking straight into the camera with a bemused, unguarded expression, a slight smile tugging her lips upward. Neither person seems to give a damn that some skinny dude with a big 5 X 7 camera and a hippie assistant working the flash are photographing them in a bar in Memphis, Tennessee, at 3 o'clock one morning in 1973.

Is this love? Whether the man and woman were a couple deeply in love or simply two people who met 20 minutes before Eggleston tripped the shutter, I can't say. They may have been totally devoted to each other. Maybe they are out there somewhere as you read this, living happily ever after in their own Graceland. Maybe they woke up later that day, looked at each other, saw the kind of cold, hard truth country star George Jones sings about, went their separate ways, and never looked back. All we know of them is the photograph Eggleston took. The rest comes from the viewer.

Eggleston's approach did not please many critics when curator John Szarkowski exhibited the photographer's work at the Museum of Modern Art in New York in the 1970s. Critic Hilton Kramer wrote that Eggleston's portraits were "perfectly boring." In *Artforum* magazine, Max Kosloff's review of the show was headlined, "How to Mystify Color Photography." In it, he ripped Szarkowski for being "sensationally irresponsible and derisory" and accused him of springing an unknown artist like Eggleston on the public without going into detail on "the artist's origins, intellectual outlook, creative development, professional contacts, even the identity of subjects that reappear and have personal meaning."

No love there, although by that yardstick, many pictures, such as the fascinating tavern portraits painted by Dutch artists Jan Steen and Frans Hals in the 17th century, should be removed from museums straightaway. What the critics wanted was the story behind the pictures. Who was Eggleston? Where had he studied? Who did he know? Had he kissed Ansel Adams's ring? That they couldn't find any point of connection with Eggleston's work suggests limited life experience. Perhaps they had forgotten what the critic John Ruskin wrote in *The Two Paths*, "The purest and most thoughtful minds are those which love colour the most." Or maybe they needed to get out more at night and see how love and the world look in bars after midnight.

I think Brassaï, whose photo of a couple kissing in a Paris nightclub is in the previous chapter, would have understood. Describing the making of his book *Paris de Nuit (Paris by Night)*, from 1933, he wrote, "Rightly or wrongly, I felt at the time that this underground world represented Paris at its least cosmopolitan, at its most alive, its most authentic, that in these colorful faces of its underworld there had been preserved, from age to age, almost without alteration, the folklore of its remote past."

One Valentine's night in the early 21st century, another photographer took a picture in the Tuileries. Then the young woman lowered the bouquet from her face, the Ferris wheel started turning, and life moved on, leaving us with a picture of what looks like love in a public place. ❀

FOLLOWING PAGES: **JULIEN DANIEL** I Ukraine I Galleries in Odessa opera house

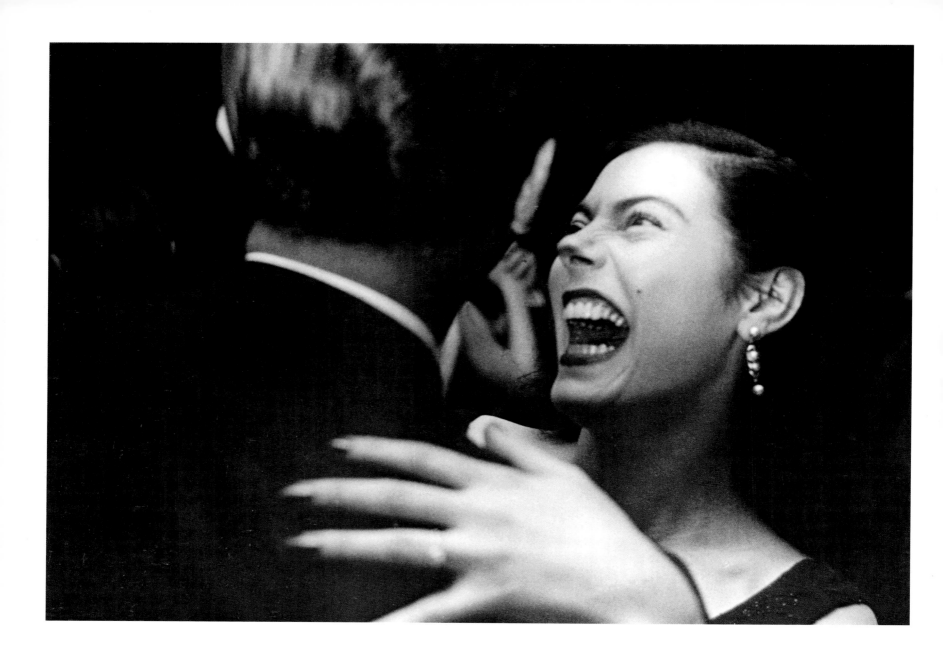

GARRY WINOGRAND **|** *New York City, 1955* **|** El Morocco nightclub
OPPOSITE: **TONY RAY-JONES** **|** England **|** Ballroom in Morecambe, Lancashire

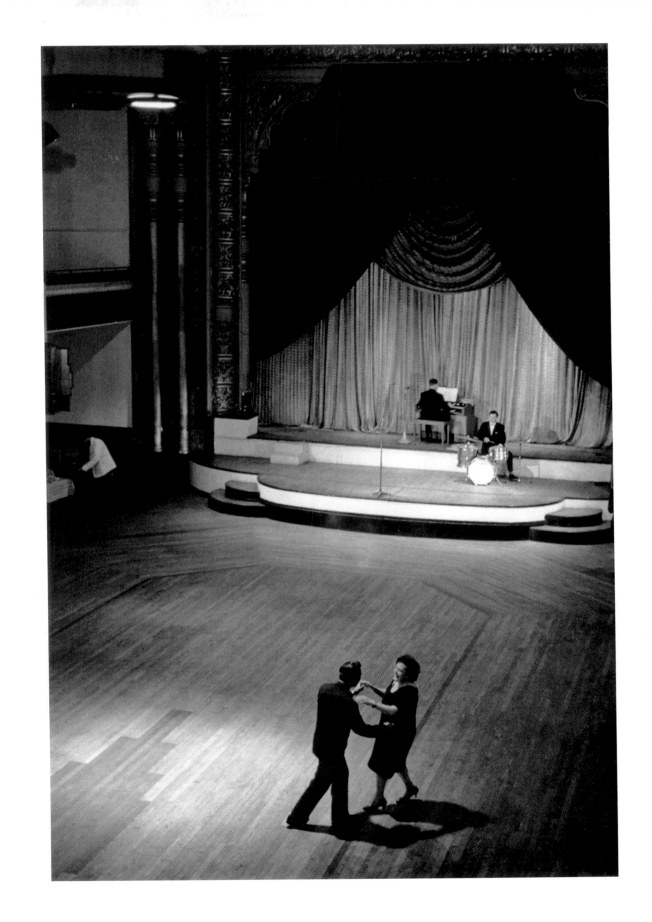

PRECEDING PAGES: **ALEX MAJOLI** | Paris | Wedding photos at the "Athis D'or" studio

ELLIOTT ERWITT | Bratsk, Russia, 1967 | Wedding couple

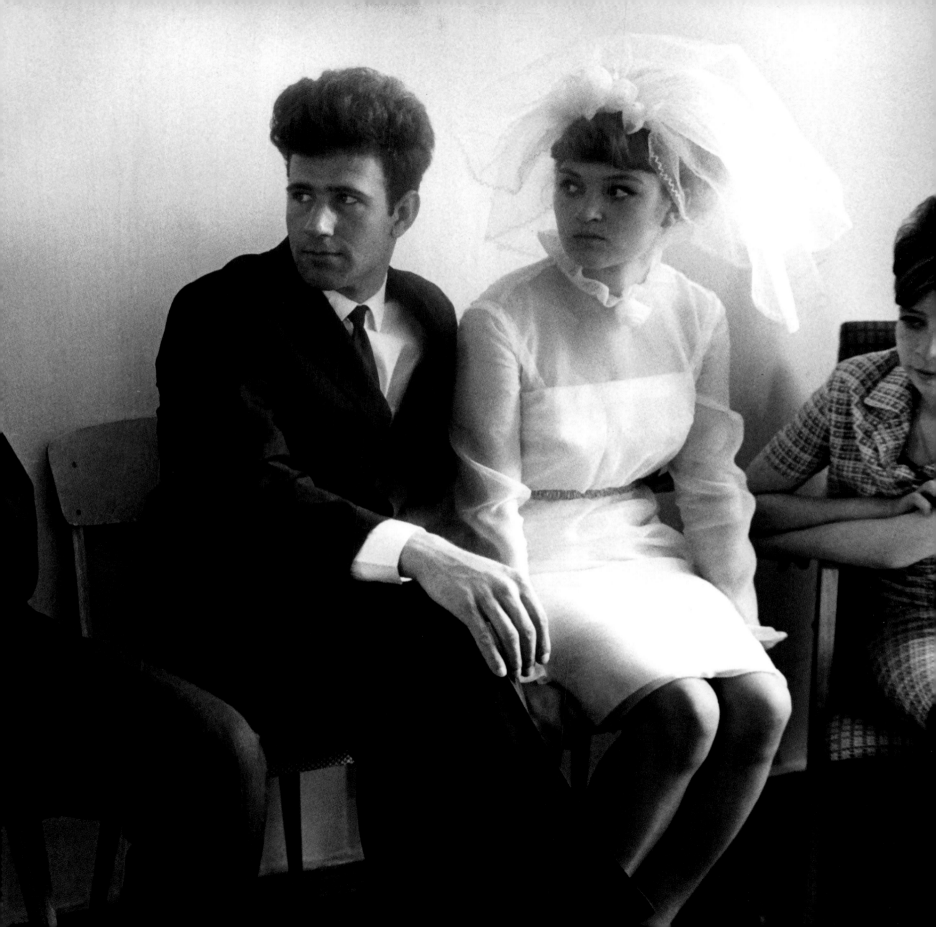

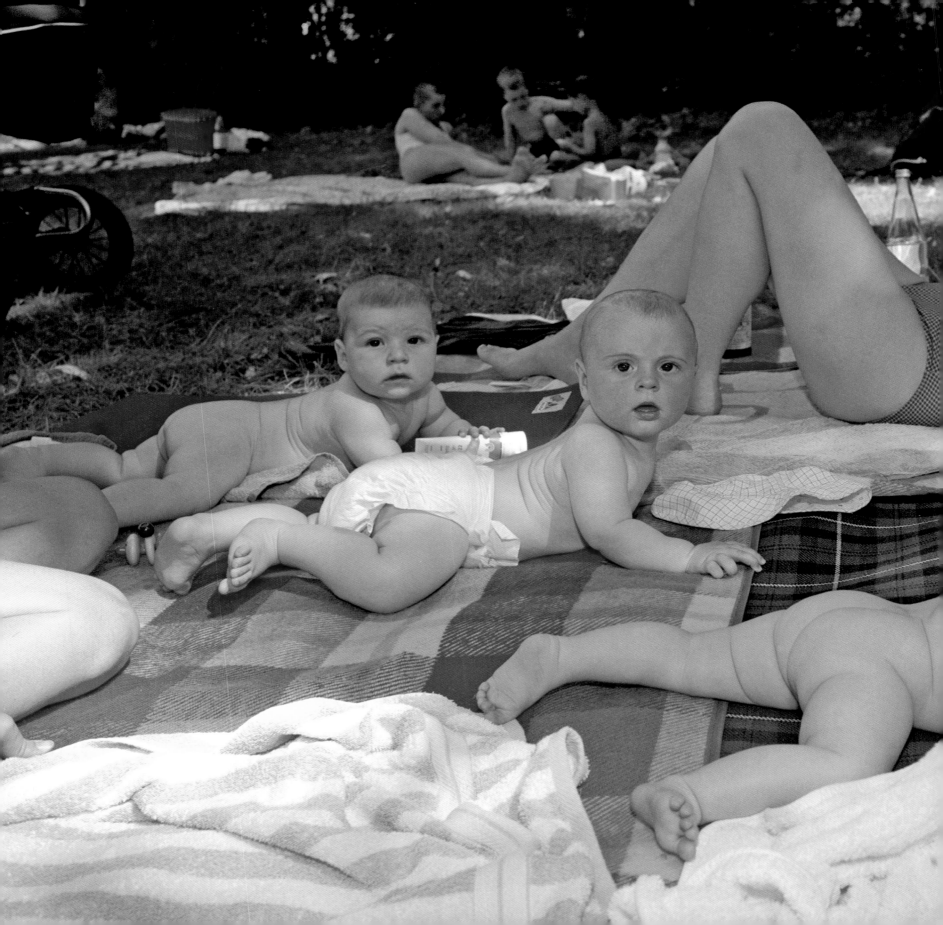

MARTIN PARR | Berlin, Germany, 2002

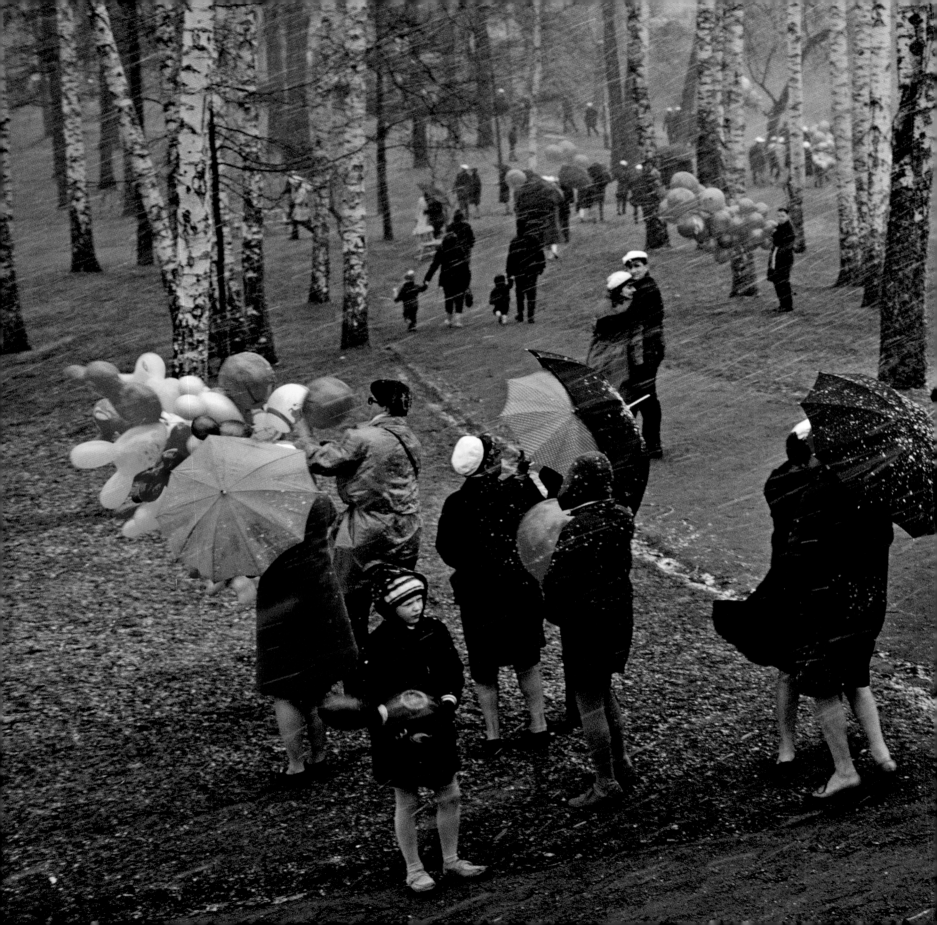

GEORGE F. MOBLEY | Kaivopuisto Park, Finland | A May snowstorm

JOEL MEYEROWITZ | New York City

DAVID BUTOW | Guangzhou, China | A nightclub

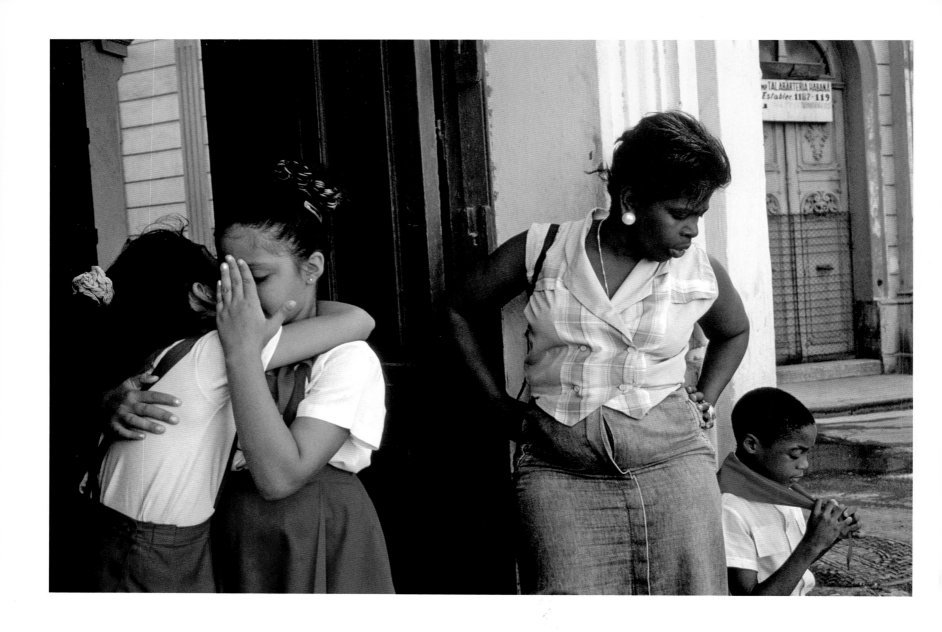

ALEX WEBB | Havana, Cuba, 2002 | Outside a school

OPPOSITE: **STEVE MCCURRY** | India, 1983 | Porter at New Delhi railway station

FOLLOWING PAGES: **DAVID ALAN HARVEY** | Puerto Rico, 1995 | Valentine's Day on North Beach

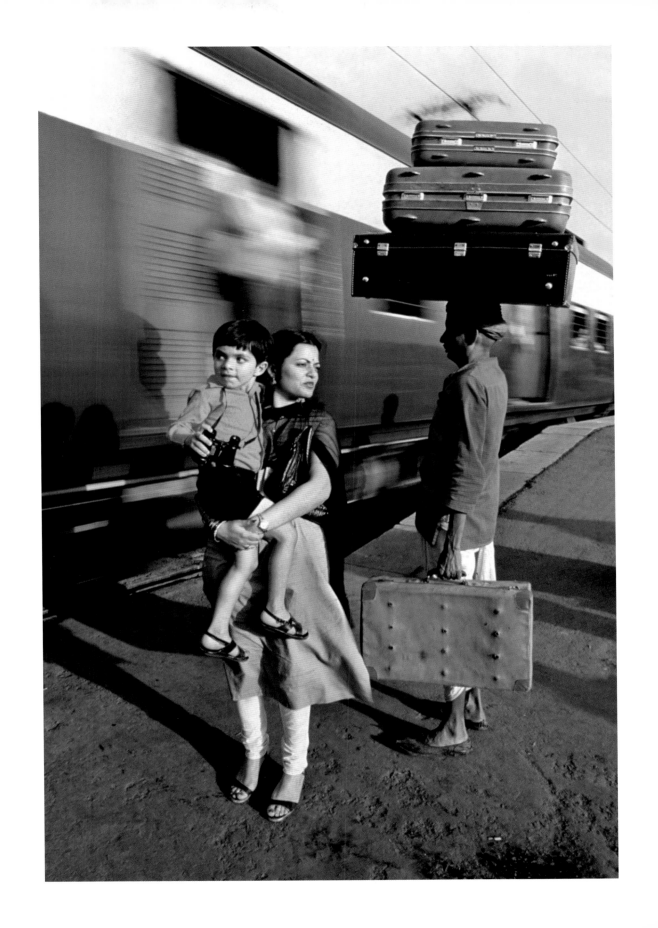

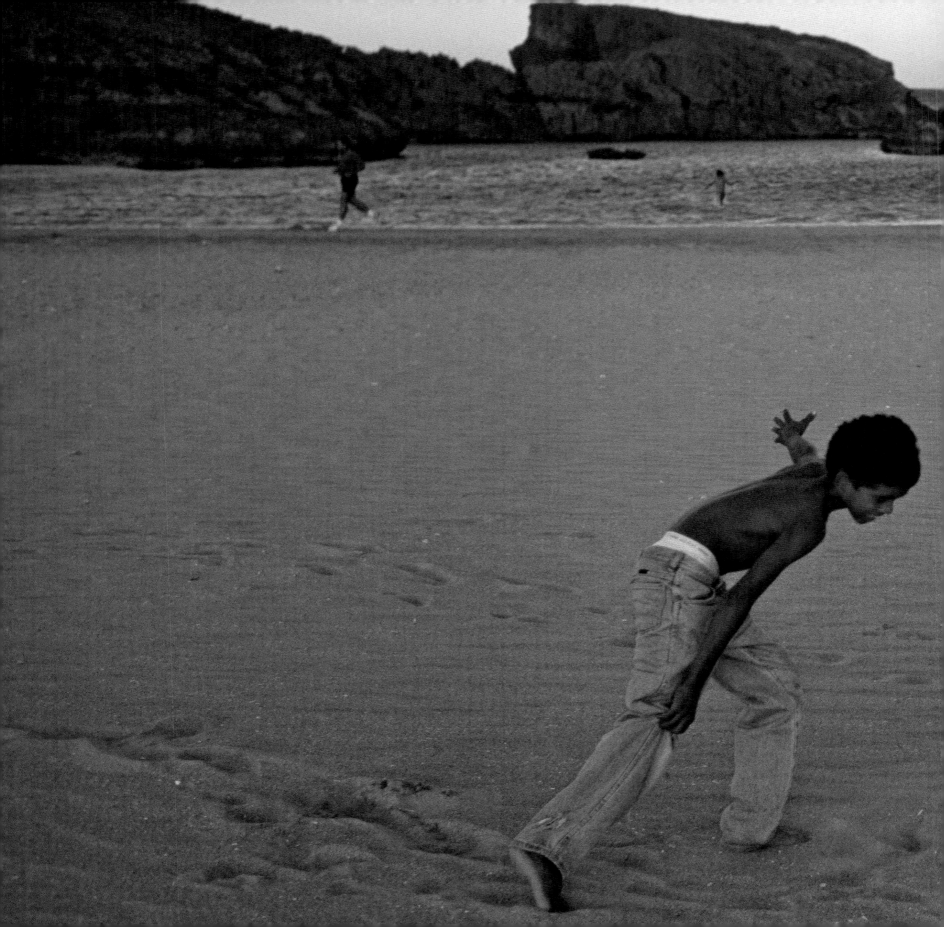

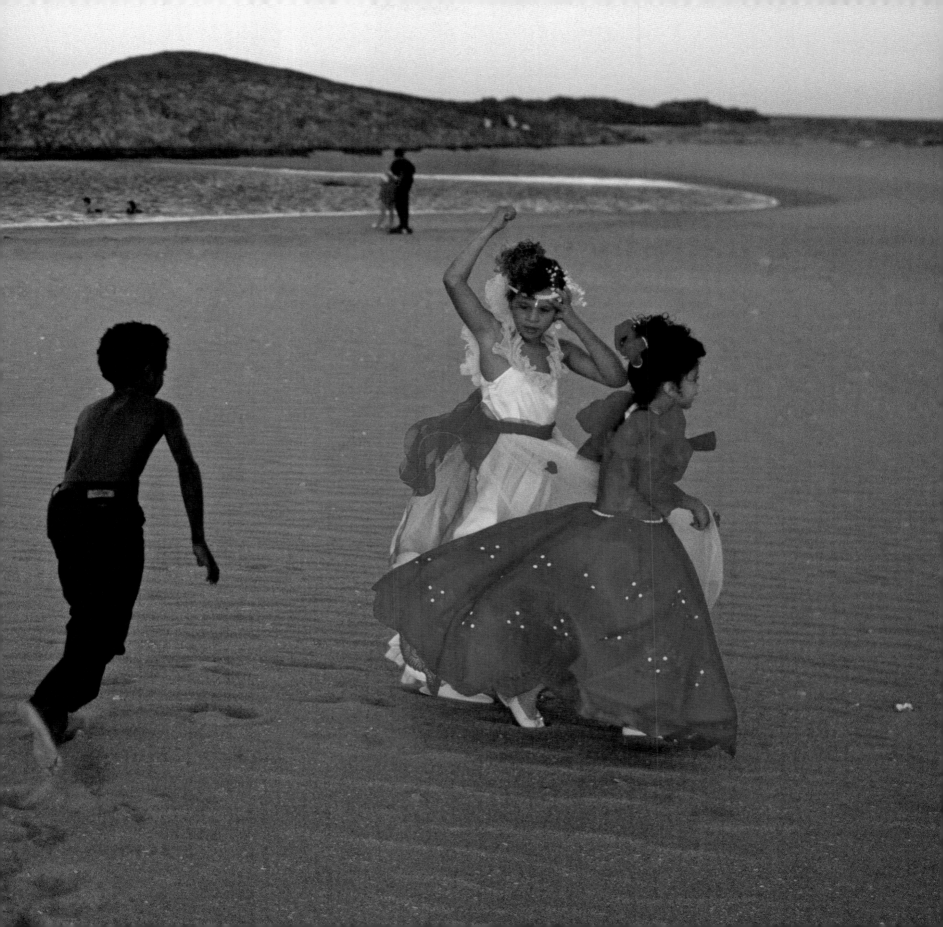

WILLIAM KLEIN **|** Paris, France, 1968 **|** November 11

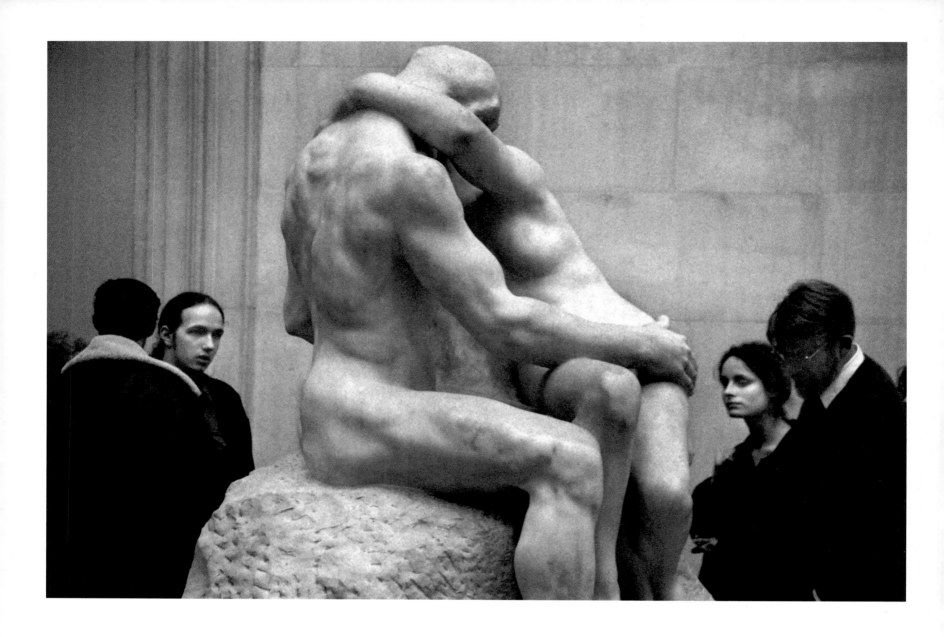

ELLIOTT ERWITT | London, 1993 | The Tate Gallery

OPPOSITE: **HERBERT LIST** | At the Baltic Sea, Germany, 1933 | "Wrestling Boys II"

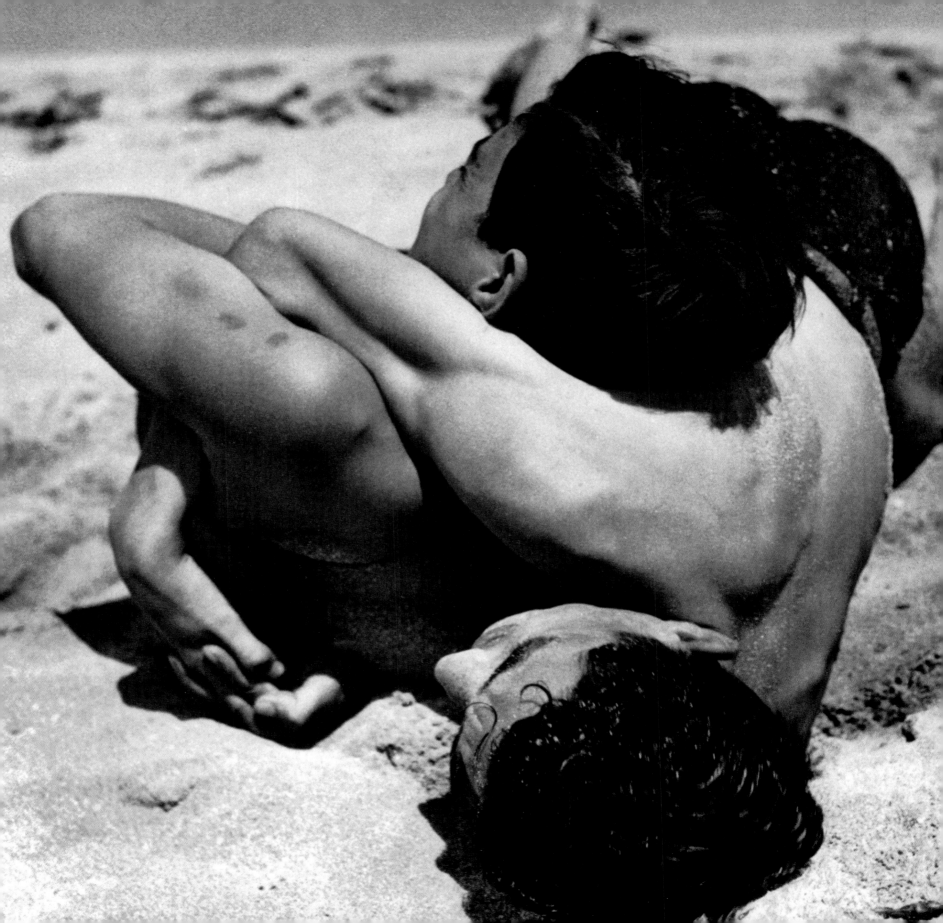

ELLIOTT ERWITT **l** Brasilia, 1961

FOLLOWING PAGES: **PATRICK TOURNEBOEUF l** France **l** Marriage of Claire and Denis

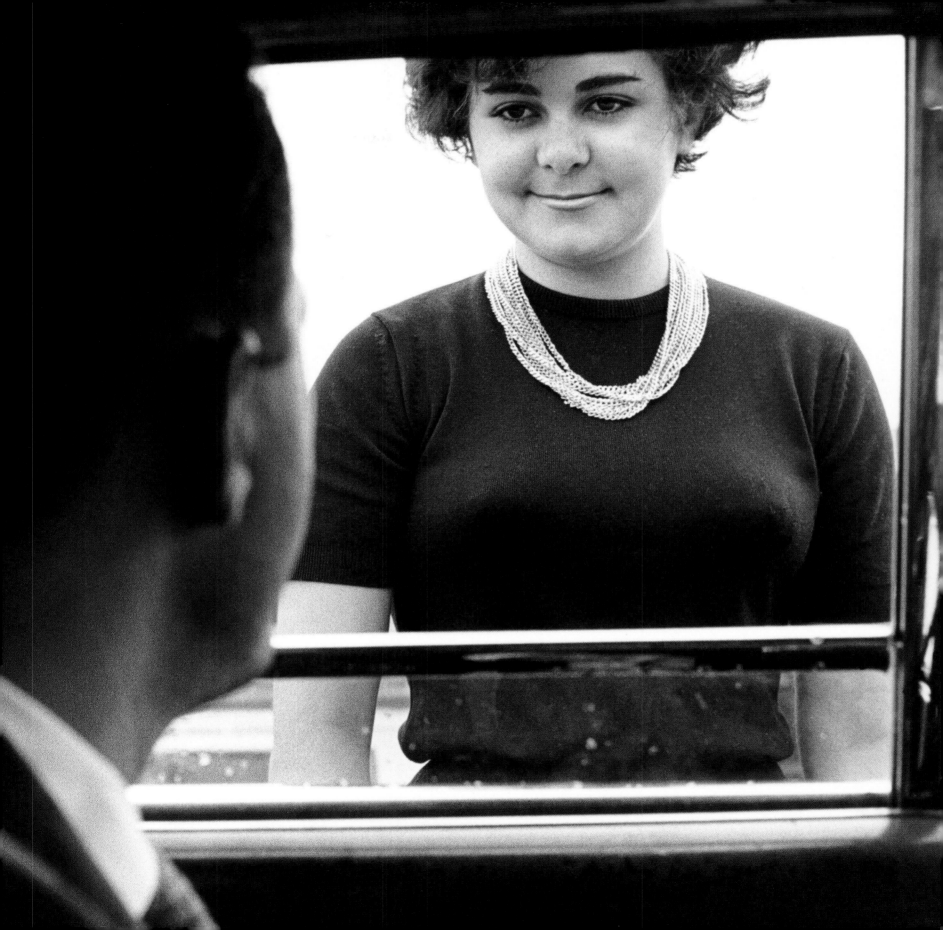

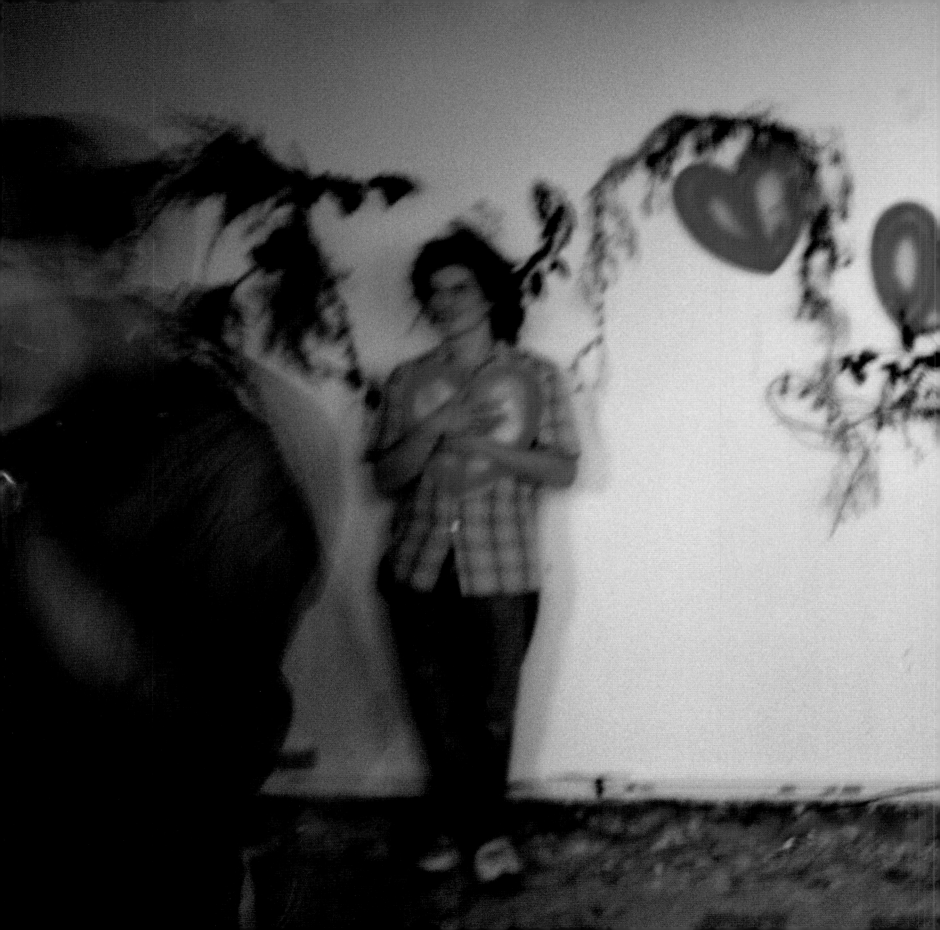

GUEORGUI PINKHASSOV I *Montreal, Canada, 1997* I *On the subway*
OPPOSITE: **GUEORGUI PINKHASSOV** I *Kamchatka, Russia* I *"Hill of Love"*

CARLOS BARRIA I Cuba, 2006 I On the bus

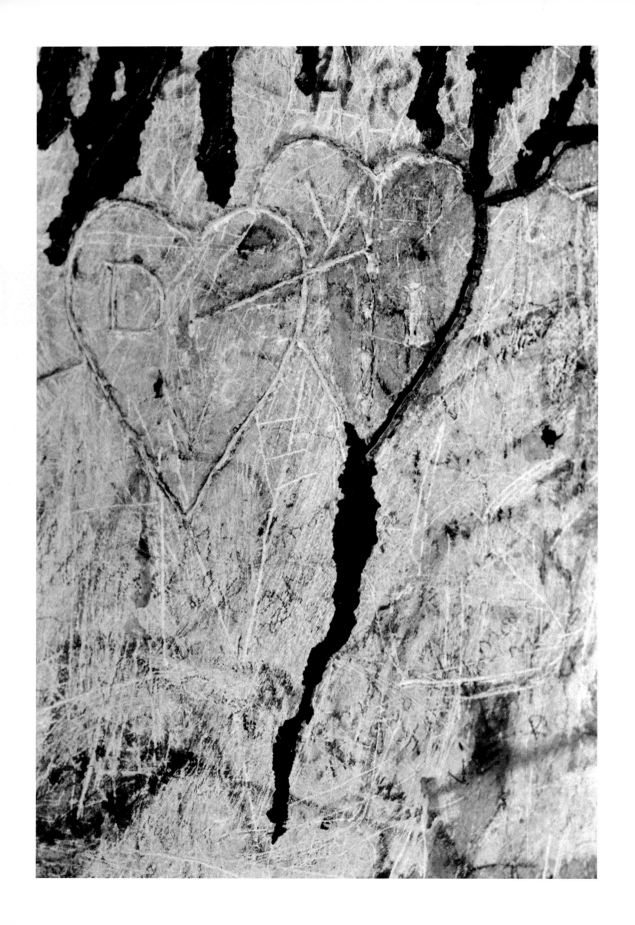

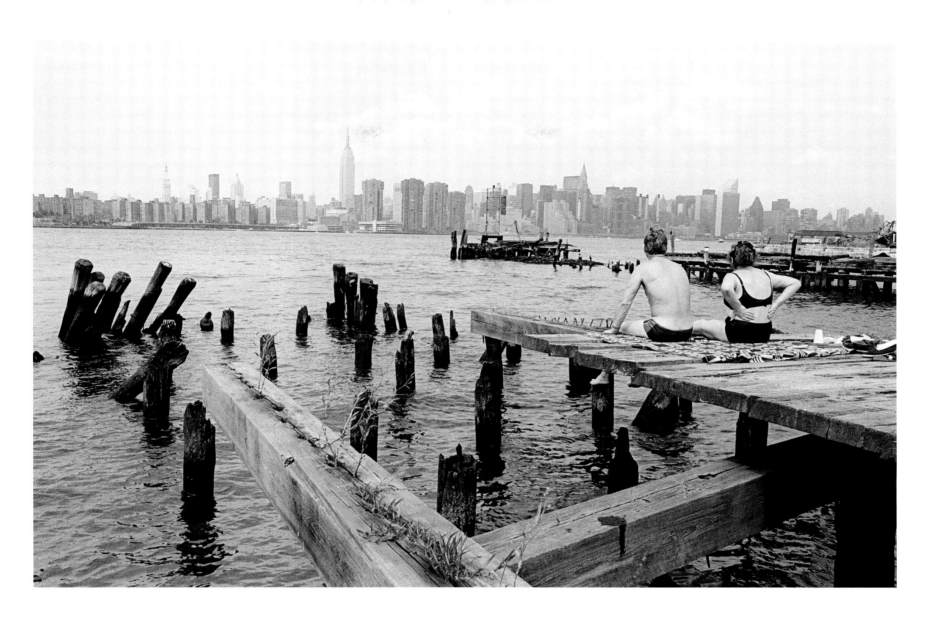

KENNETH JARECKE | *New York City, 1990* | View of the city from a pier in Brooklyn

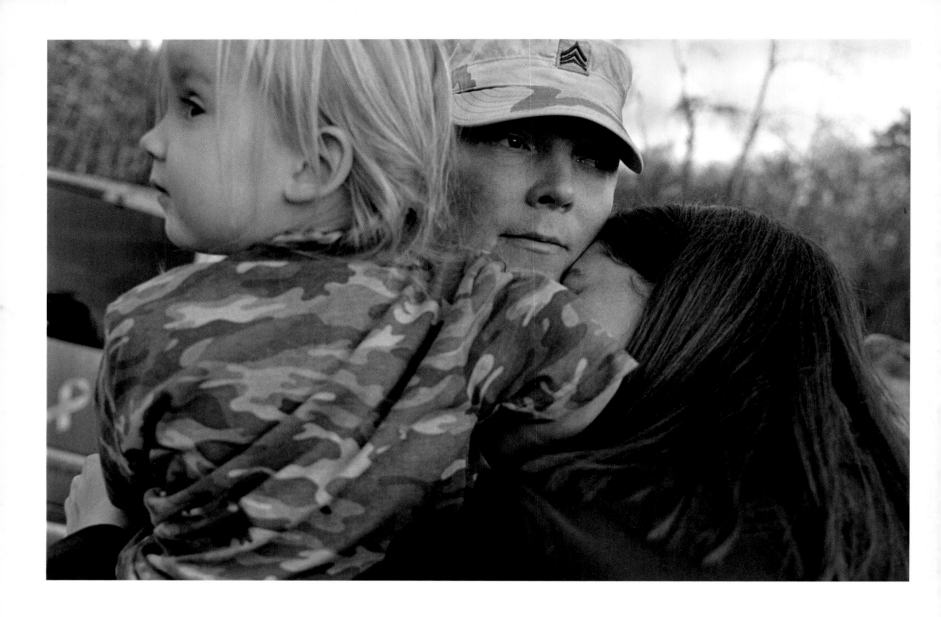

EUGENE RICHARDS **|** *Pennsylvania* **|** *National Guardsman returning from Iraq*

OPPOSITE: **BRUCE DAVIDSON** **|** *New York City, 1966* **|** *East 100th Street*

FOLLOWING PAGES, LEFT: **ALEC SOTH** **|** *Bogota, Colombia, 2003*

RIGHT: **PEKKA TURUNEN** **|** *Vespä, Finland, 1990* **|** *Mila and Milja*

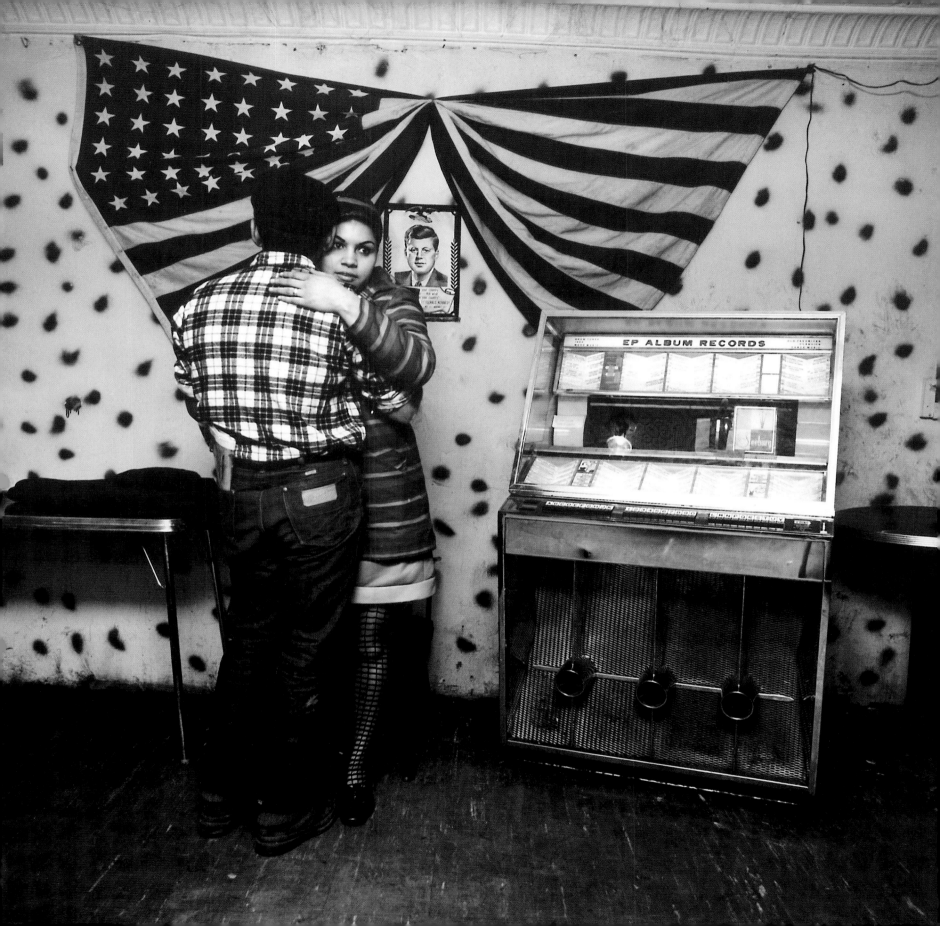

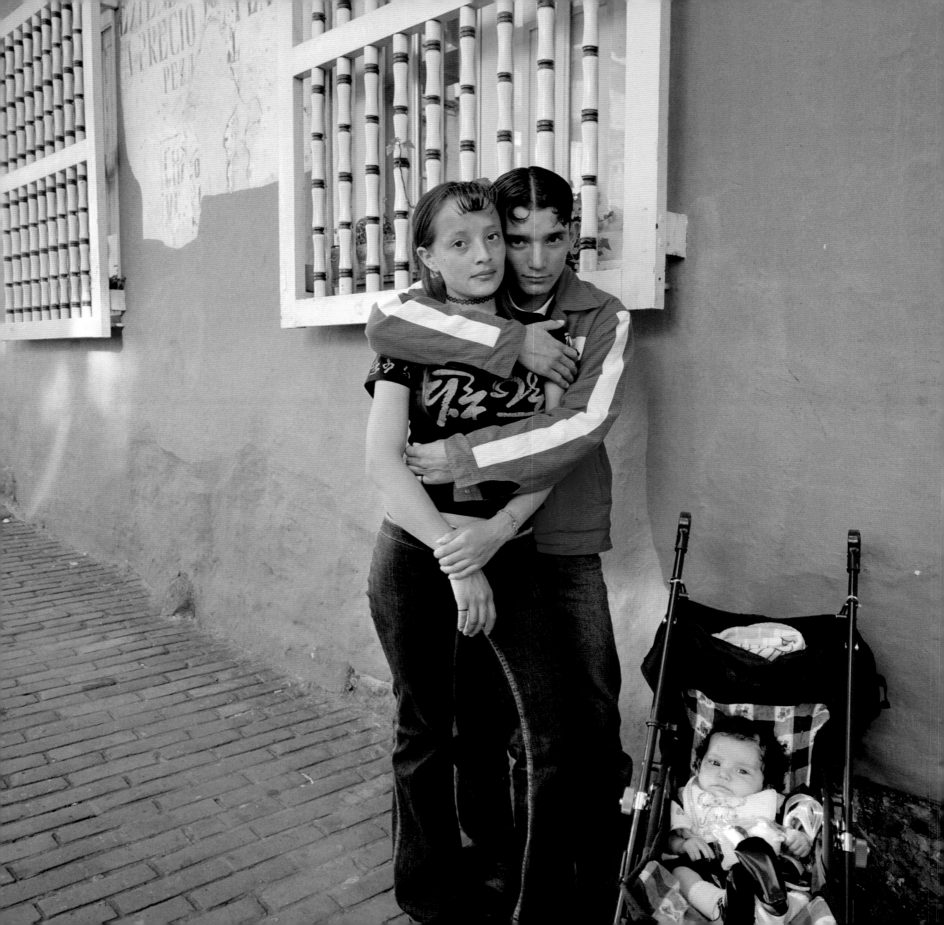

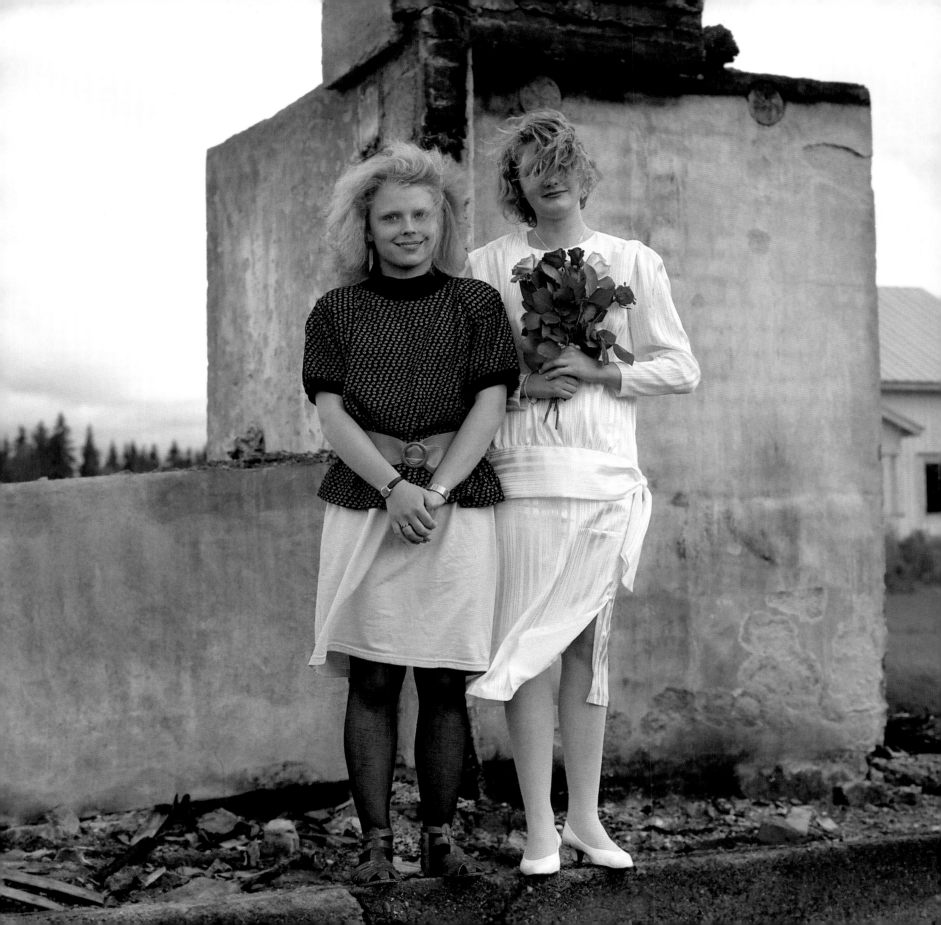

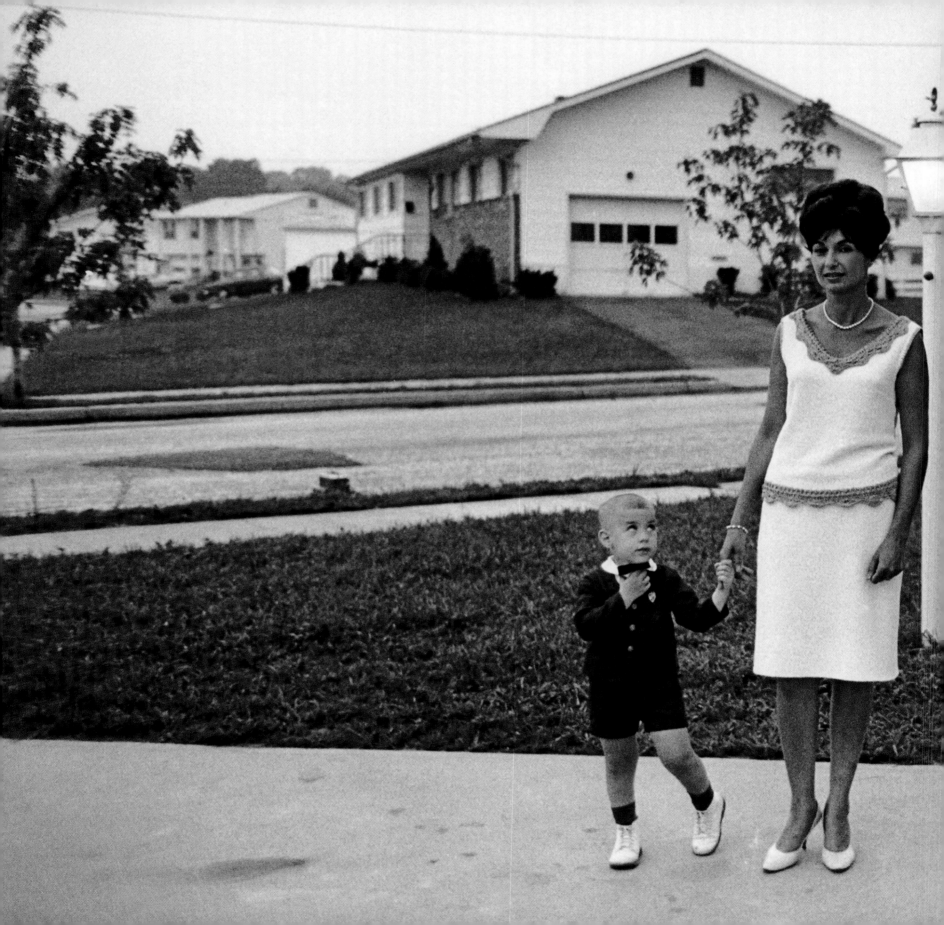

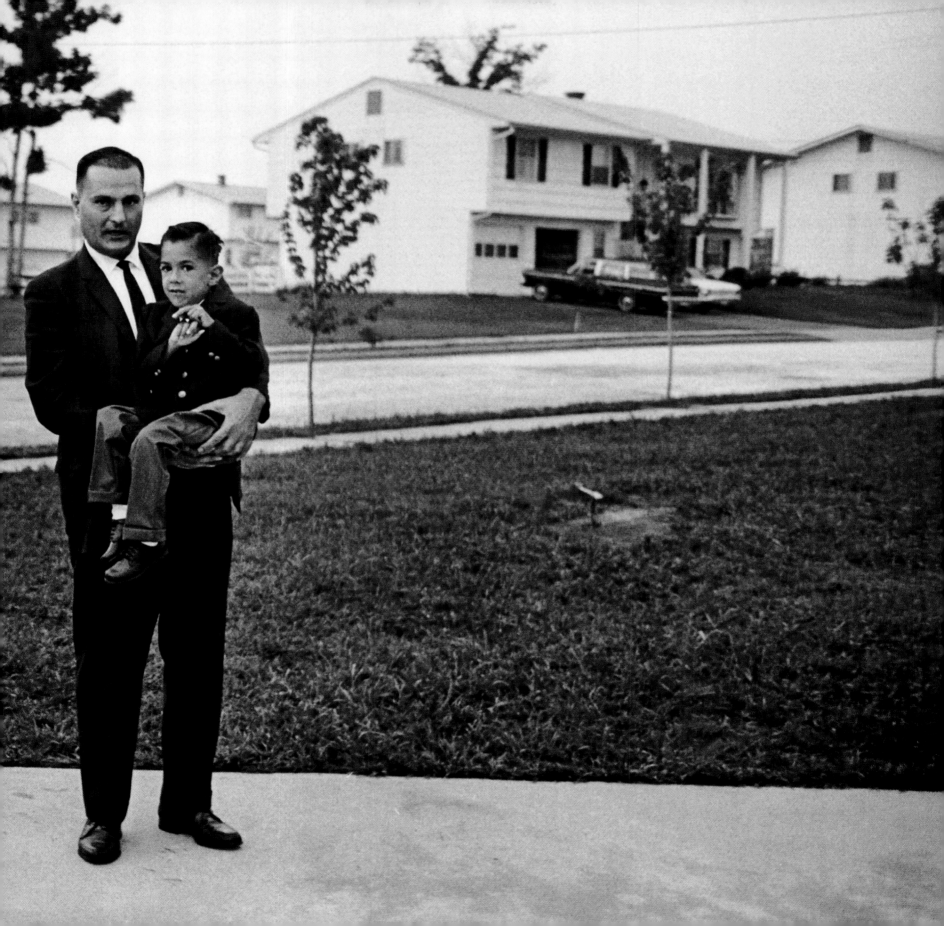

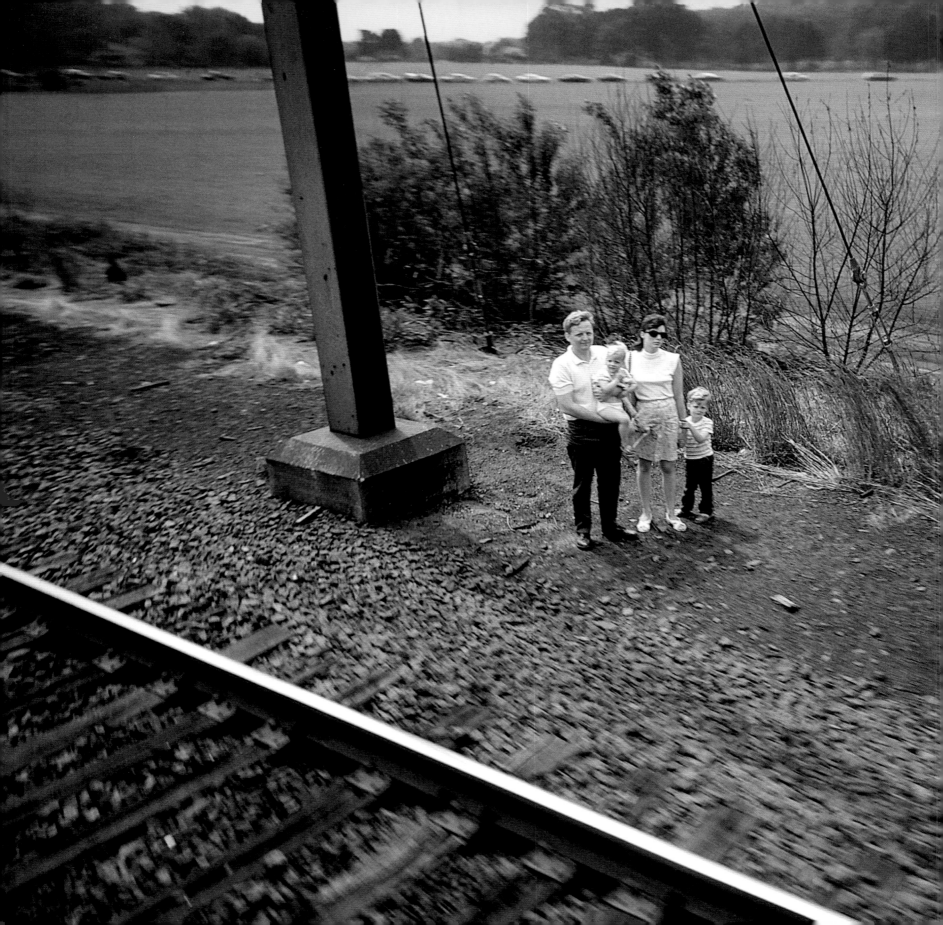

PAUL FUSCO I U.S.A., 1968 I Watching the Robert Kennedy funeral train
PRECEDING PAGES: ELLIOTT ERWITT I Ohio, 1965

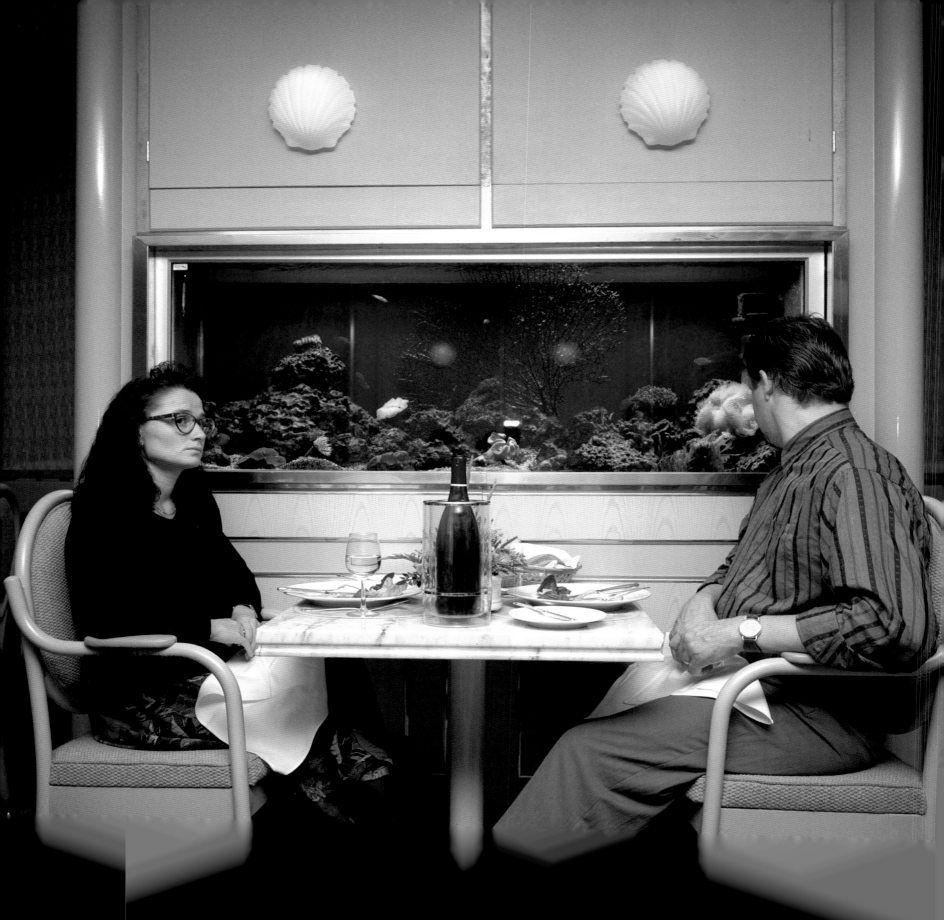

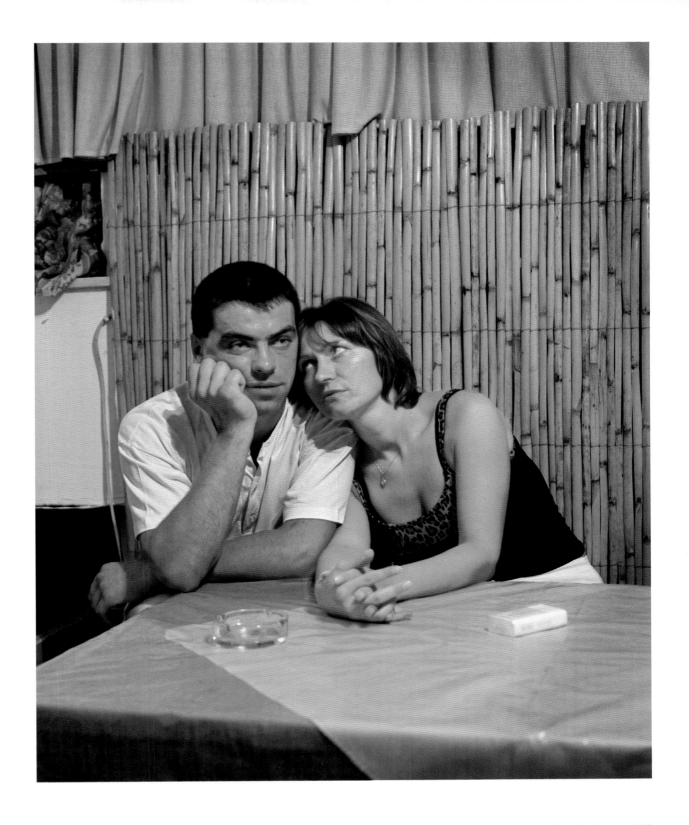

JIM GOLDBERG I Greece, 2003

OPPOSITE: **MARTIN PARR** I Scandinavia, 1991 I Ferry between Helsinki and Stockholm

FOLLOWING PAGES: **CHRIS JOHNS** I Anchorage, Alaska I Tourists admiring a stuffed moose

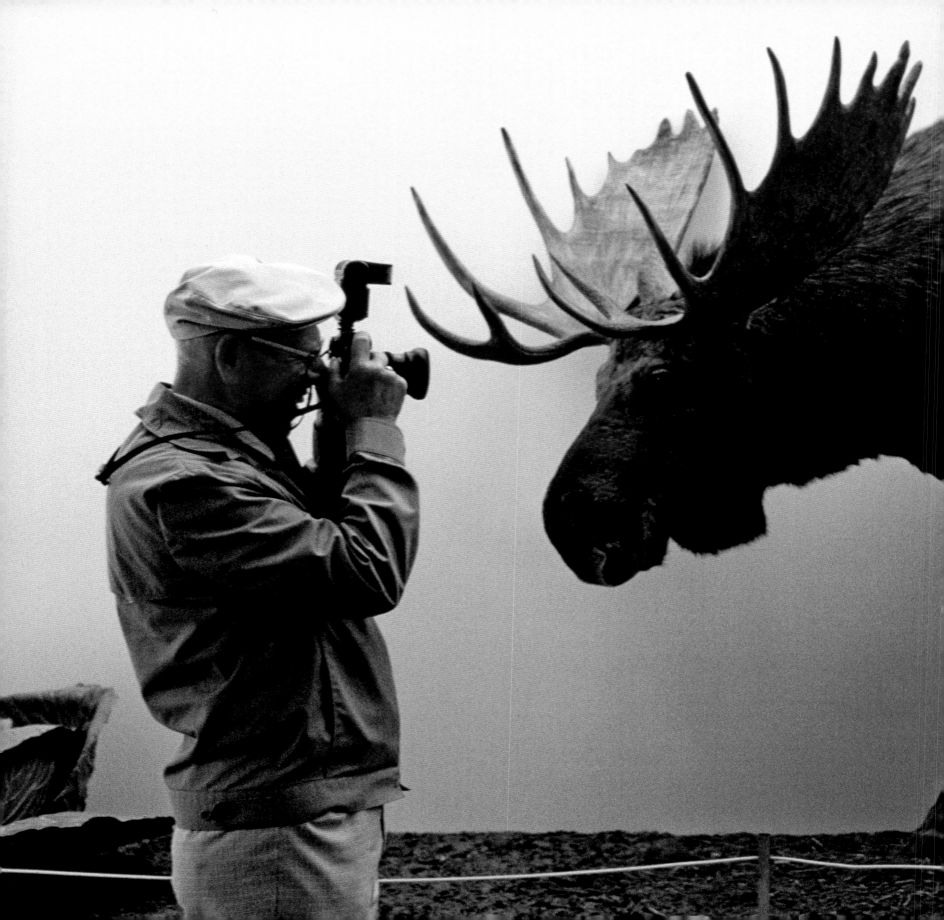

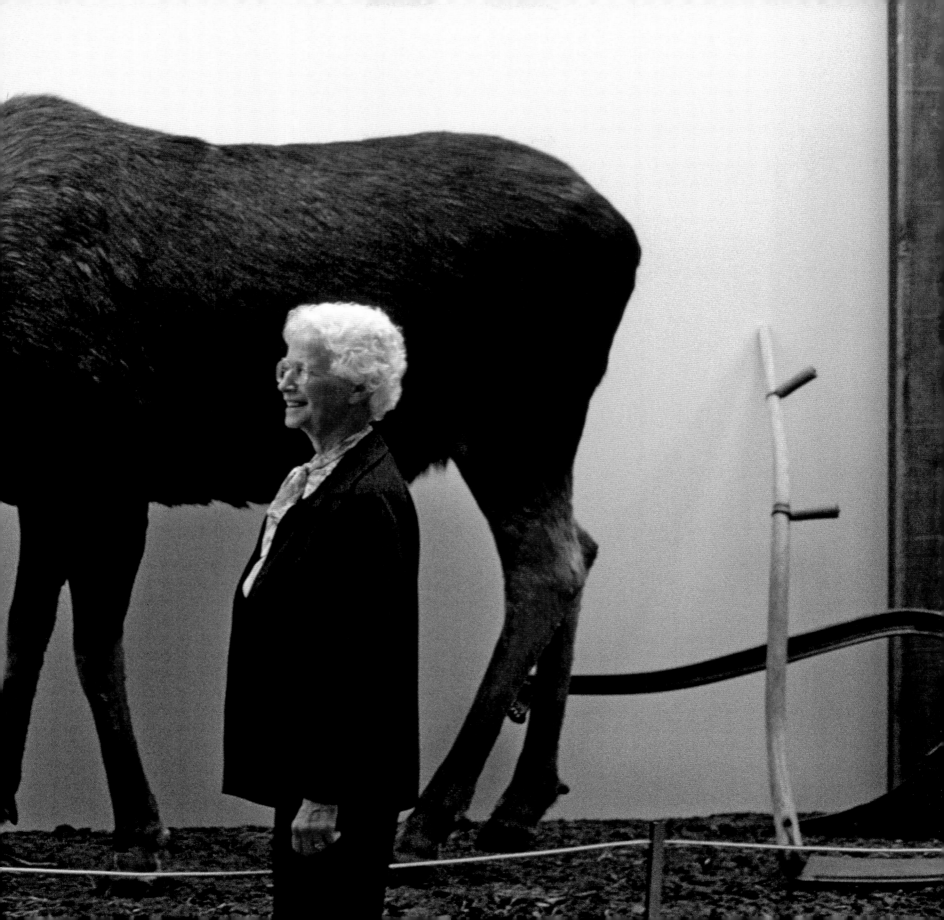

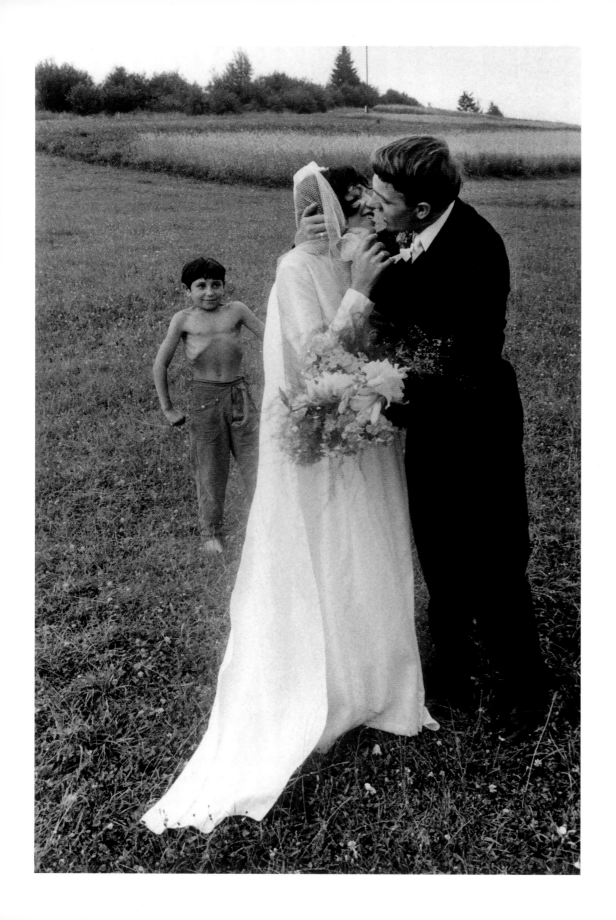

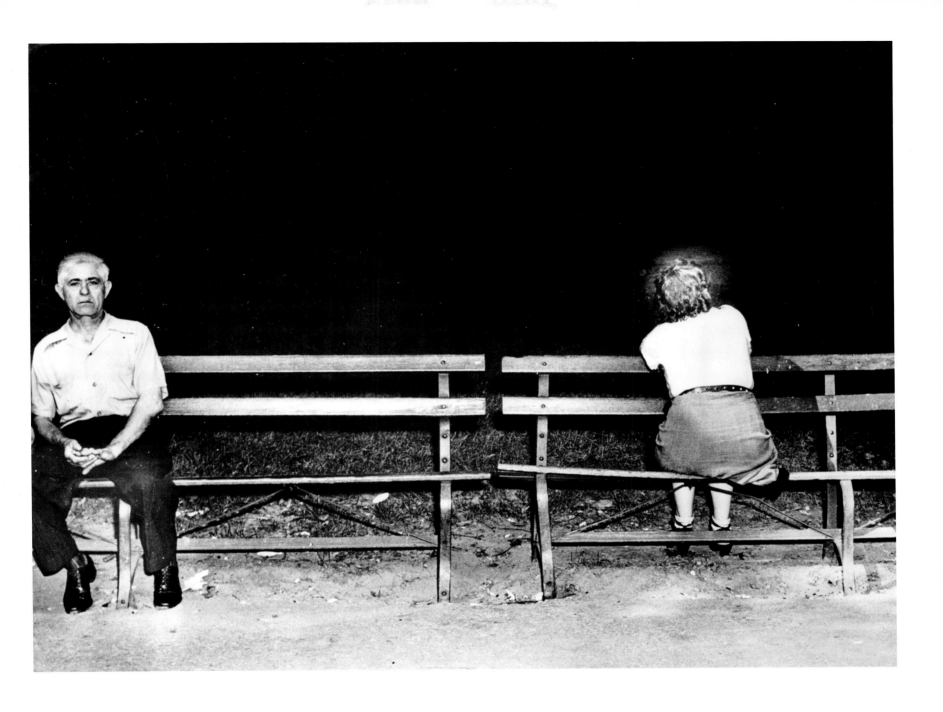

WEEGEE | U.S.A., 1940 | In the park
OPPOSITE: **JOSEF KOUDELKA** | Czechoslovakia, 1967 | Gypsy wedding

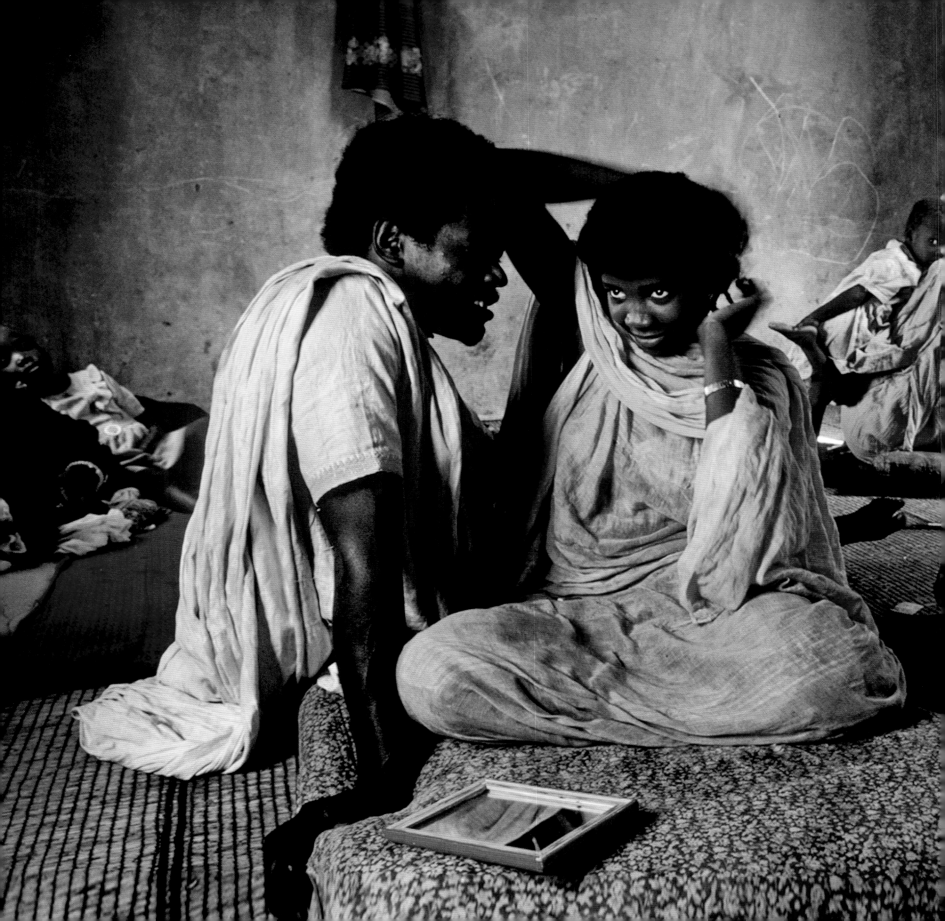

STEVE MCCURRY | Mauritania, 1986

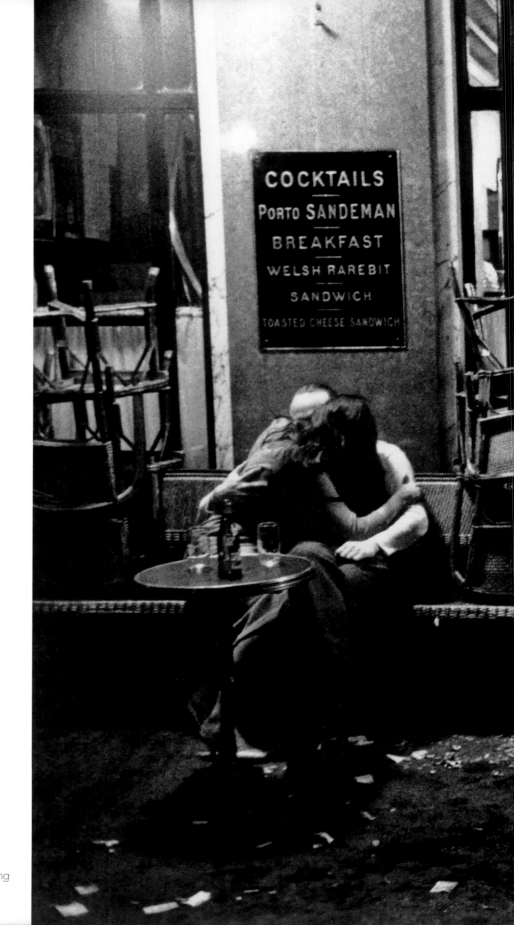

112

DENNIS STOCK I Paris, 1958 I Café de Flore

FOLLOWING PAGES, LEFT: JOSEF KOUDELKA I Czechoslovakia, 1963 I Praying

RIGHT: JUAN MANUEL CASTRO PRIETO I Benares, India, 2004 I Hindu women praying

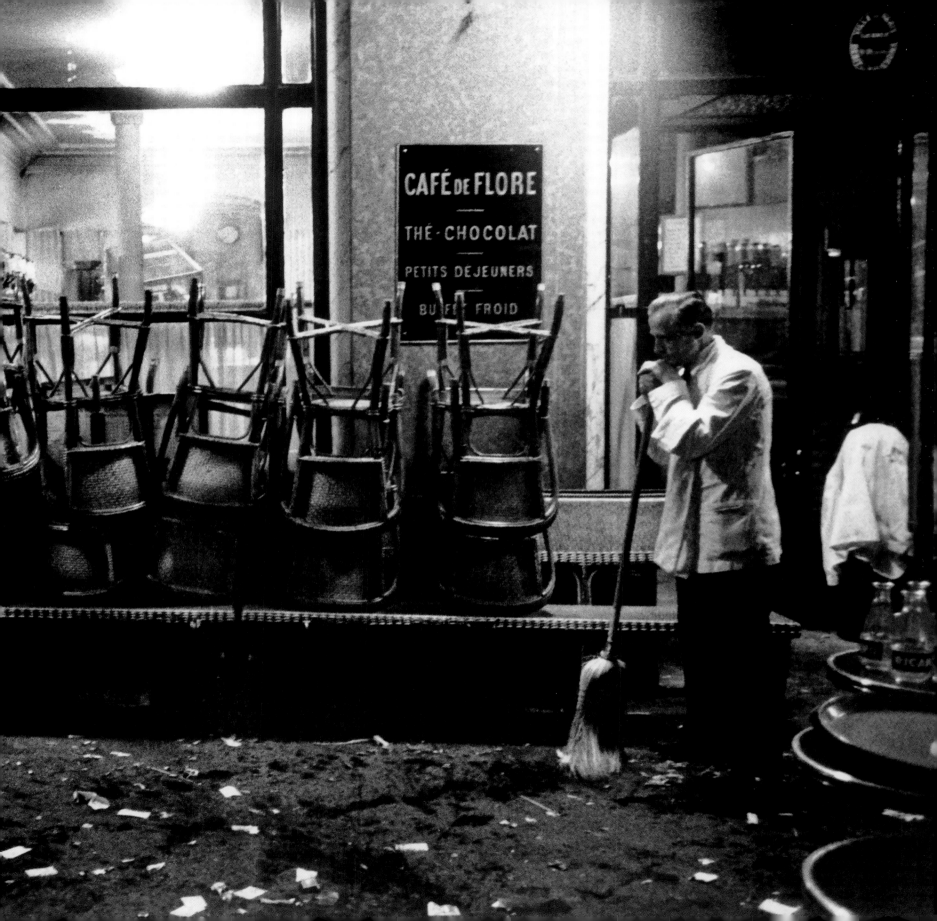

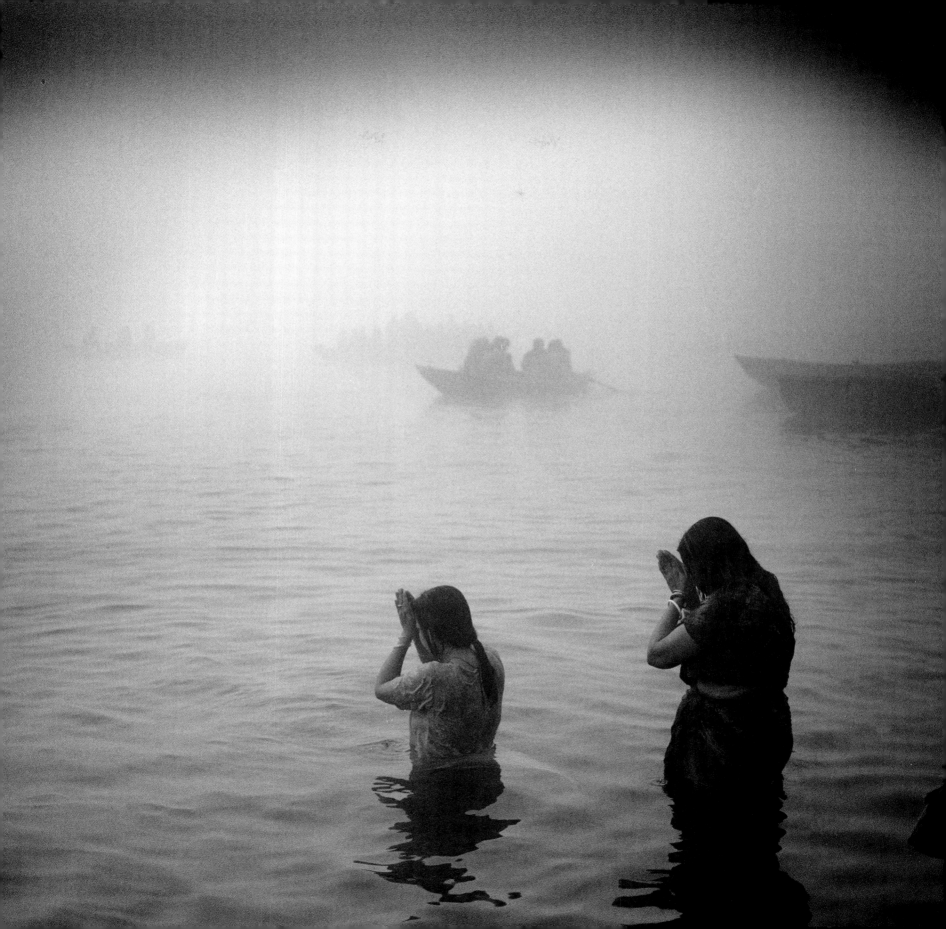

STUART FRANKLIN I Jaipur, India, 2000 I Annual kite festival
PRECEDING PAGES: PAOLO PELLEGRIN I Vatican City, 2005 I Funeral of Pope John Paul II

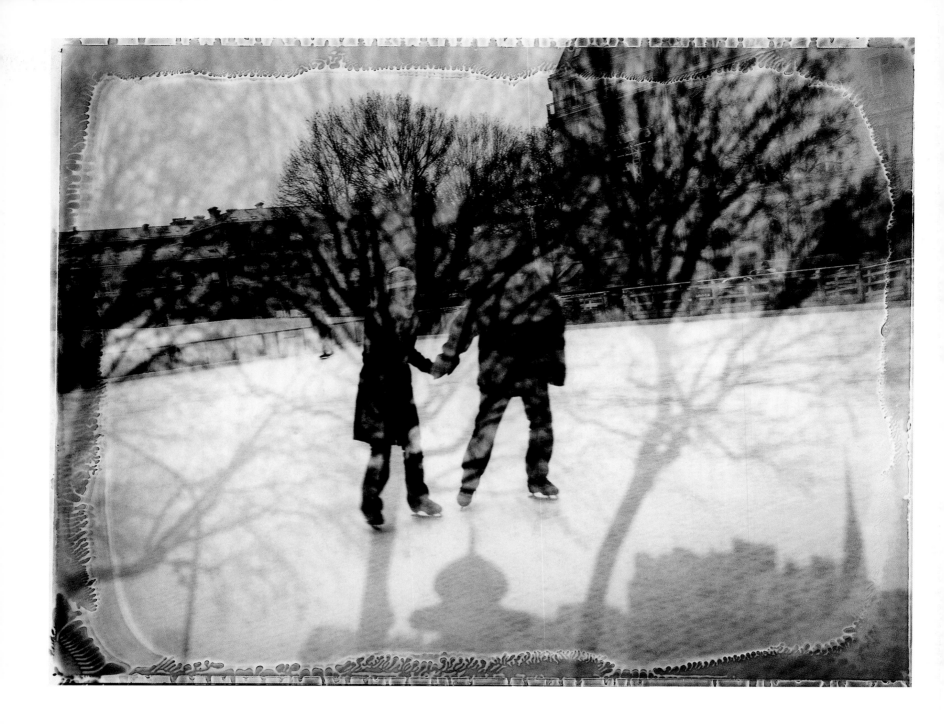

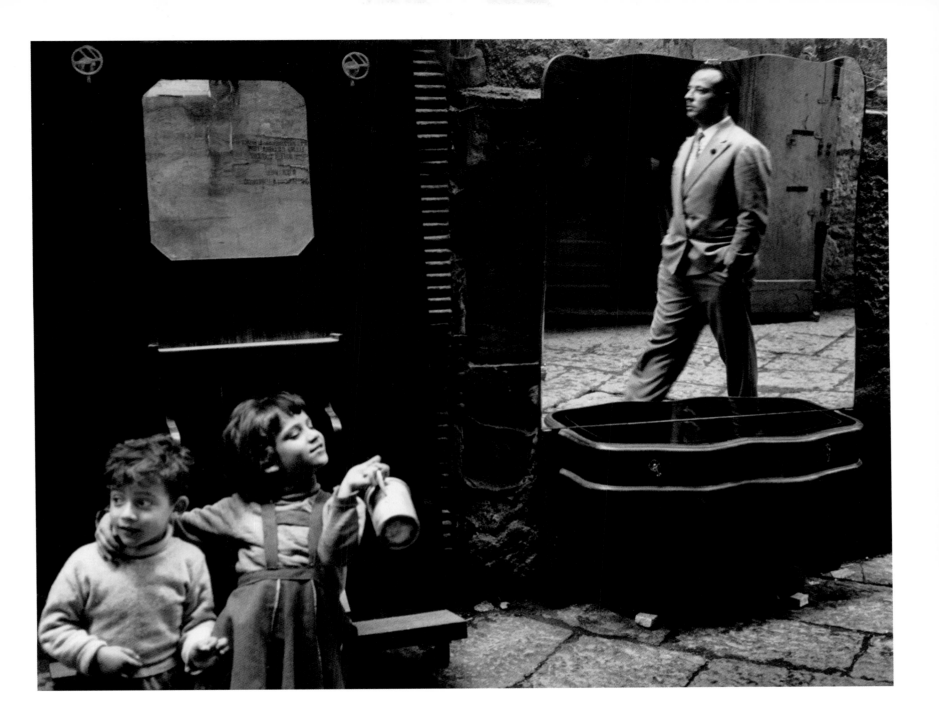

OPPOSITE: **GUILLAUME ZUILI** ❙ Paris, 2006 ❙ Skaters

HERBERT LIST ❙ Naples, Italy, 1959 ❙ Selling furniture in the street

DAVID ALAN HARVEY | Paris, 1988 | Teenagers on a boat on the Seine

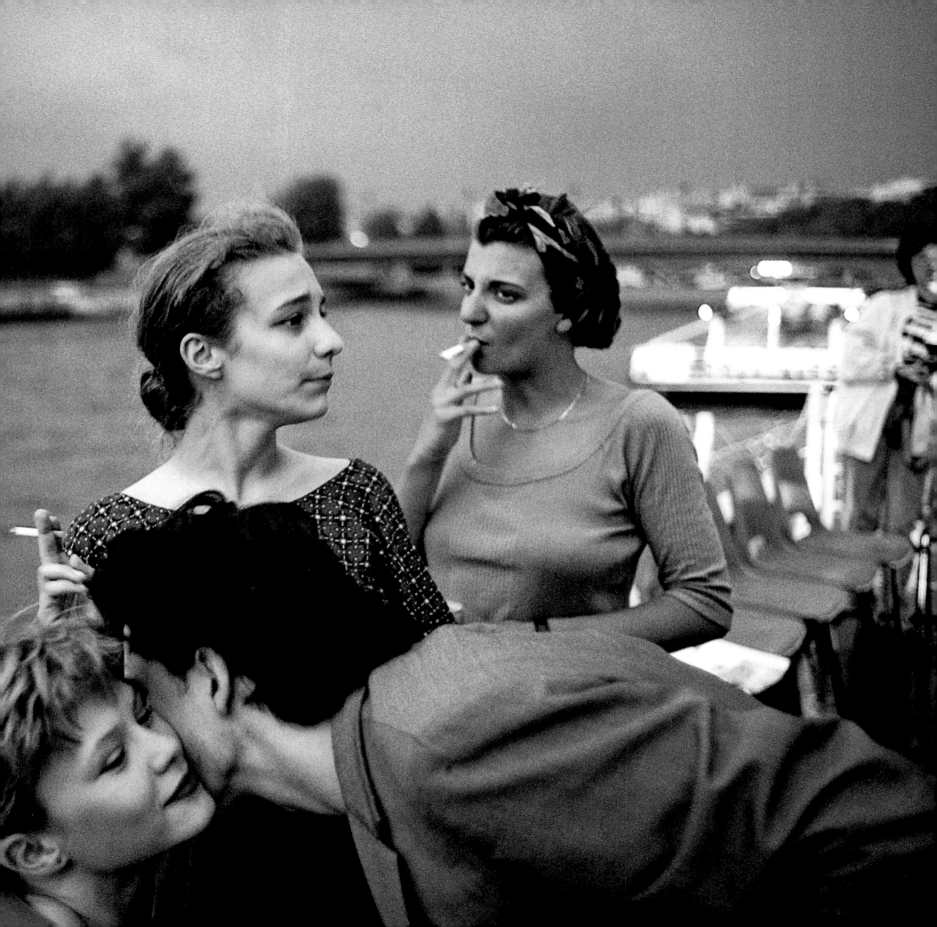

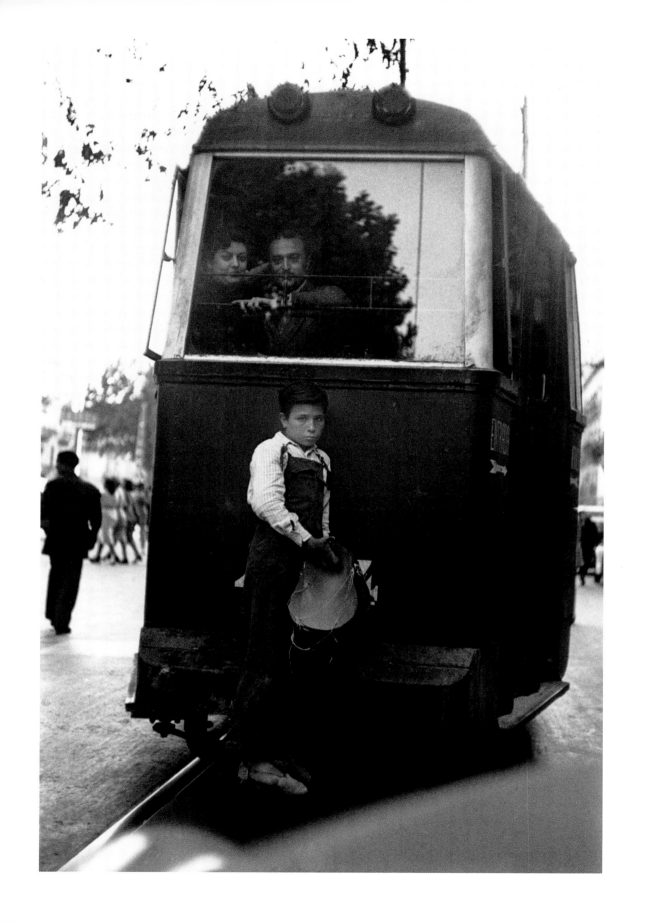

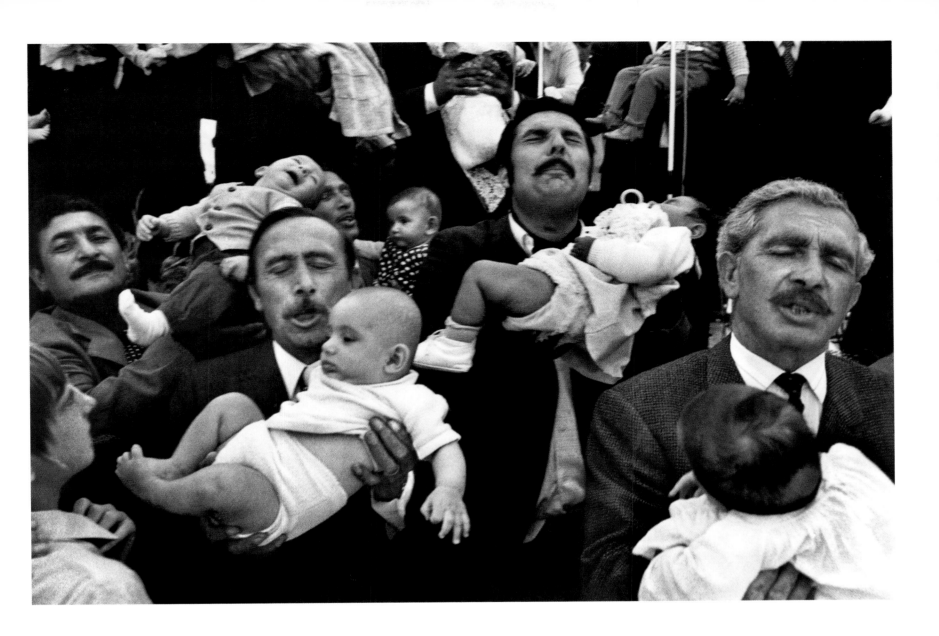

FRANK FOURNIER | Brooklyn, New York, 2001 | Italian festival

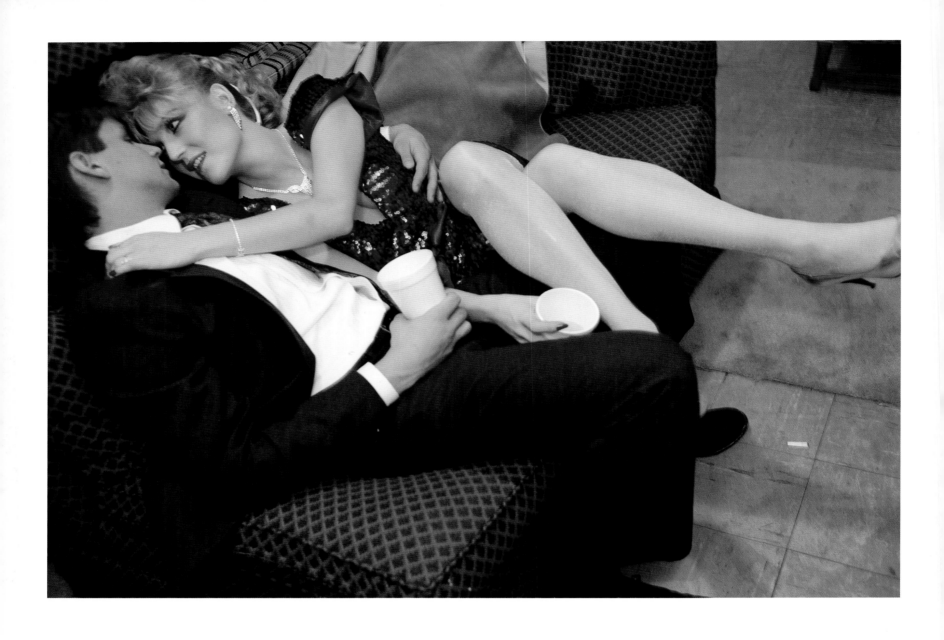

WILLIAM ALBERT ALLARD | Mississippi, 1986 | Ole Miss fraternity party

OPPOSITE: **ADAM BROOMBERG AND OLIVER CHANARIN** | Tanzania | Alex and Mariana at their wedding

FOLLOWING PAGES: **RAYMOND DEPARDON** | New York, 1981 | On the ferry to Staten Island

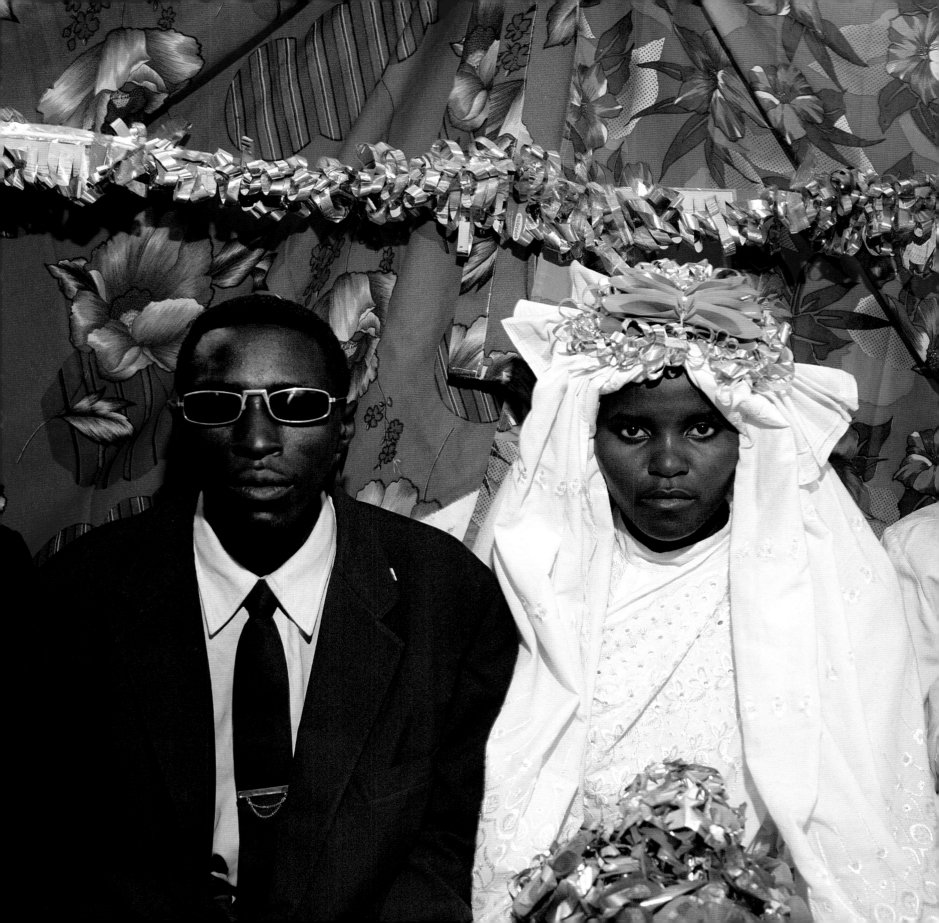

MARTIN PARR I Miyazaki, Japan, 1996 I Ocean dome

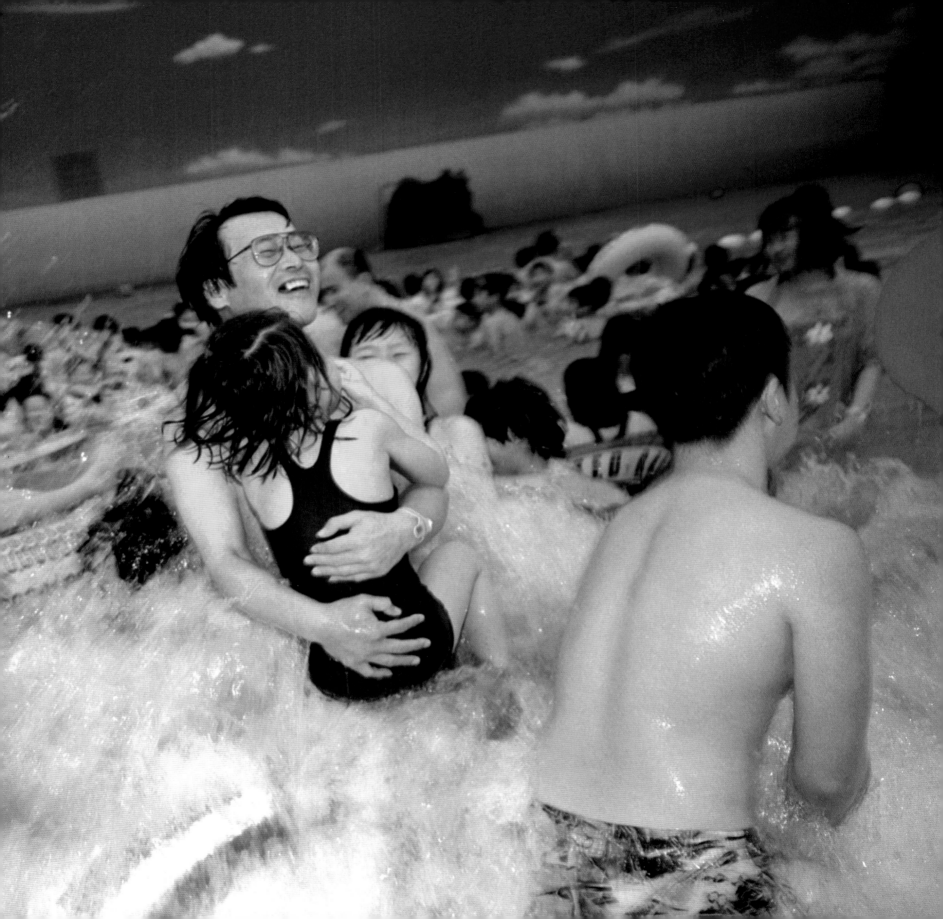

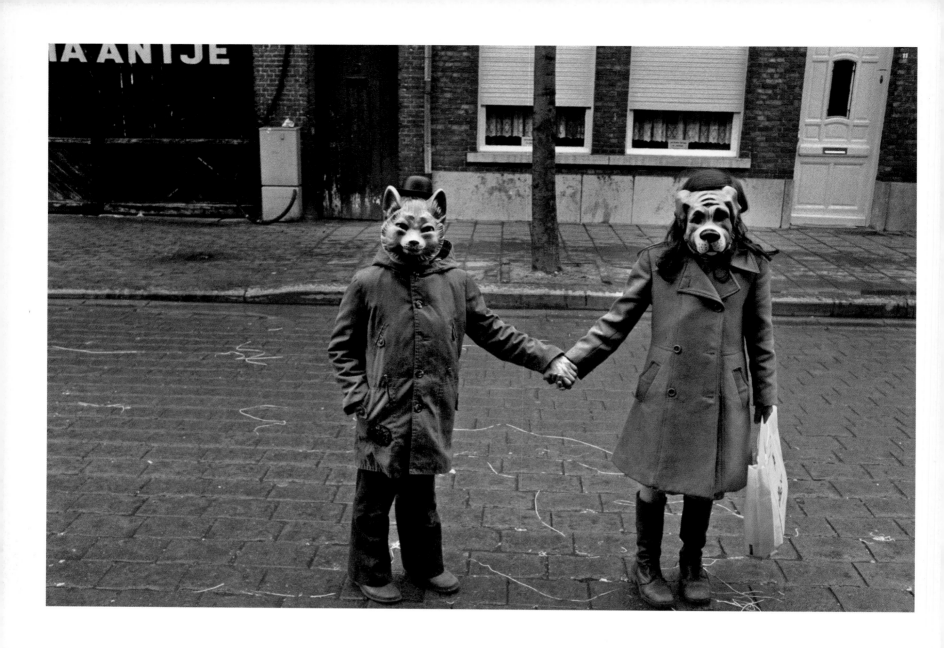

HARRY GRUYAERT **I** Belgium, 1975 **I** Carnival

OPPOSITE: **BILL BRANDT** **I** England, 1945 **I** Caught in the headlights

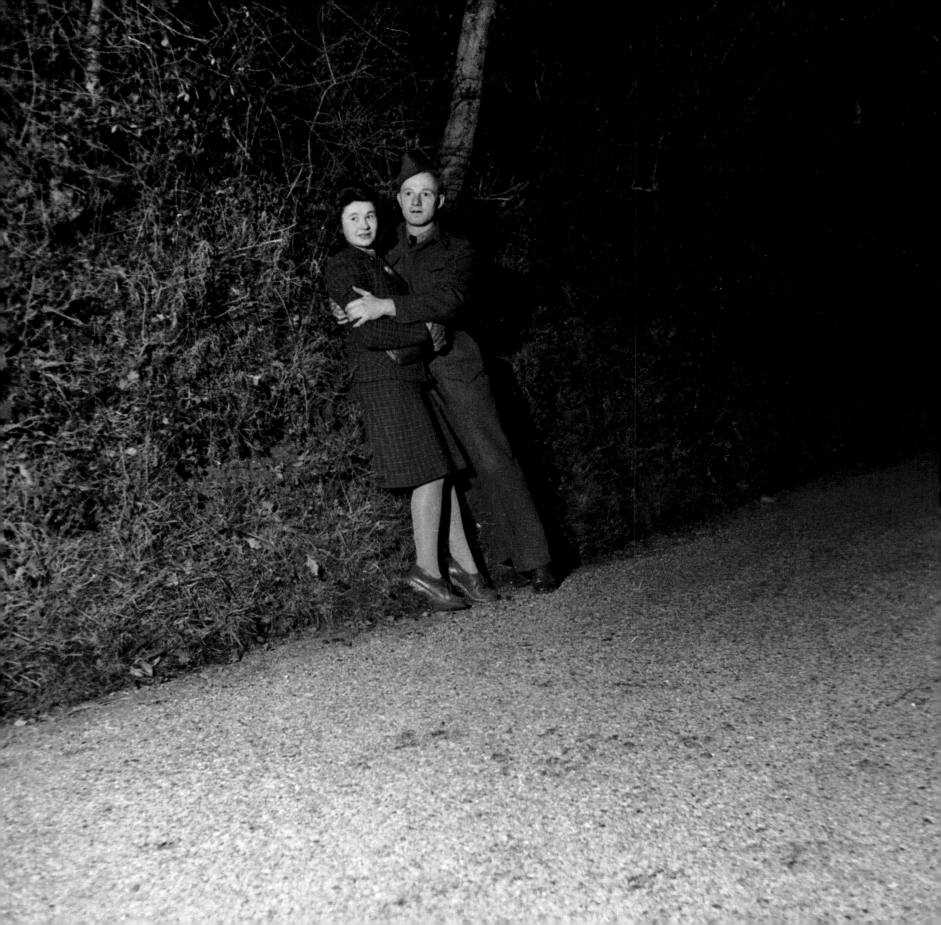

WILLIAM ALBERT ALLARD I Mississippi, 1987 I Couple in Greenville

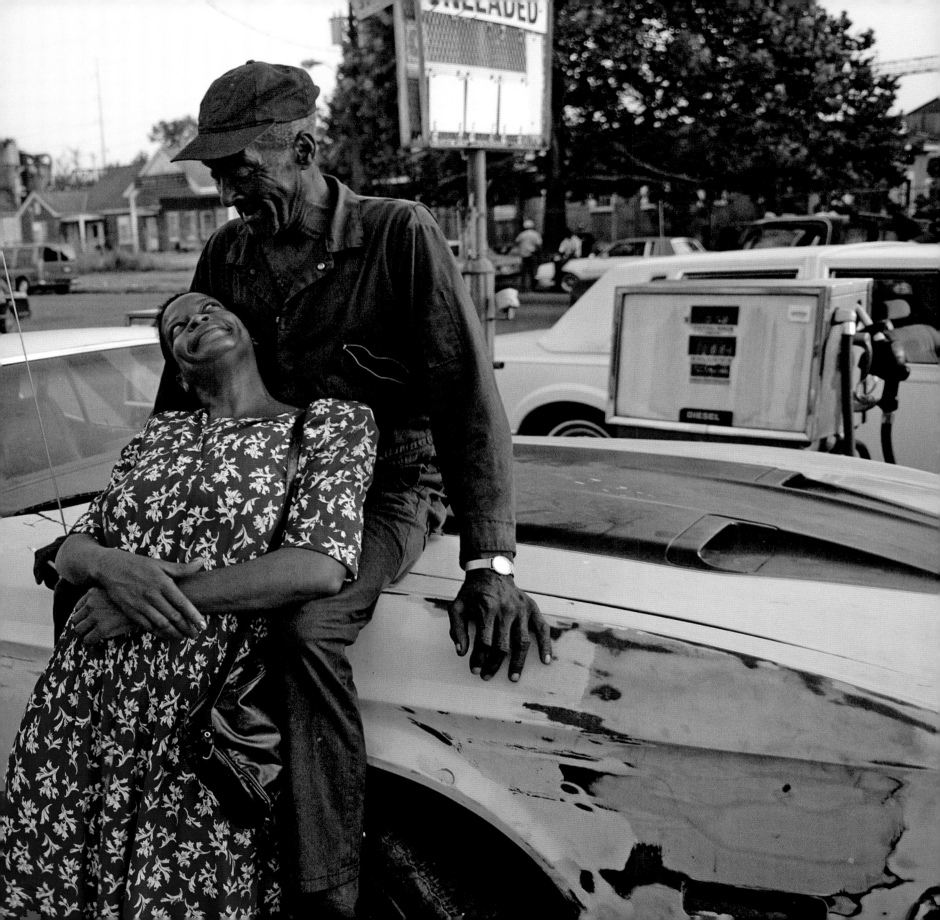

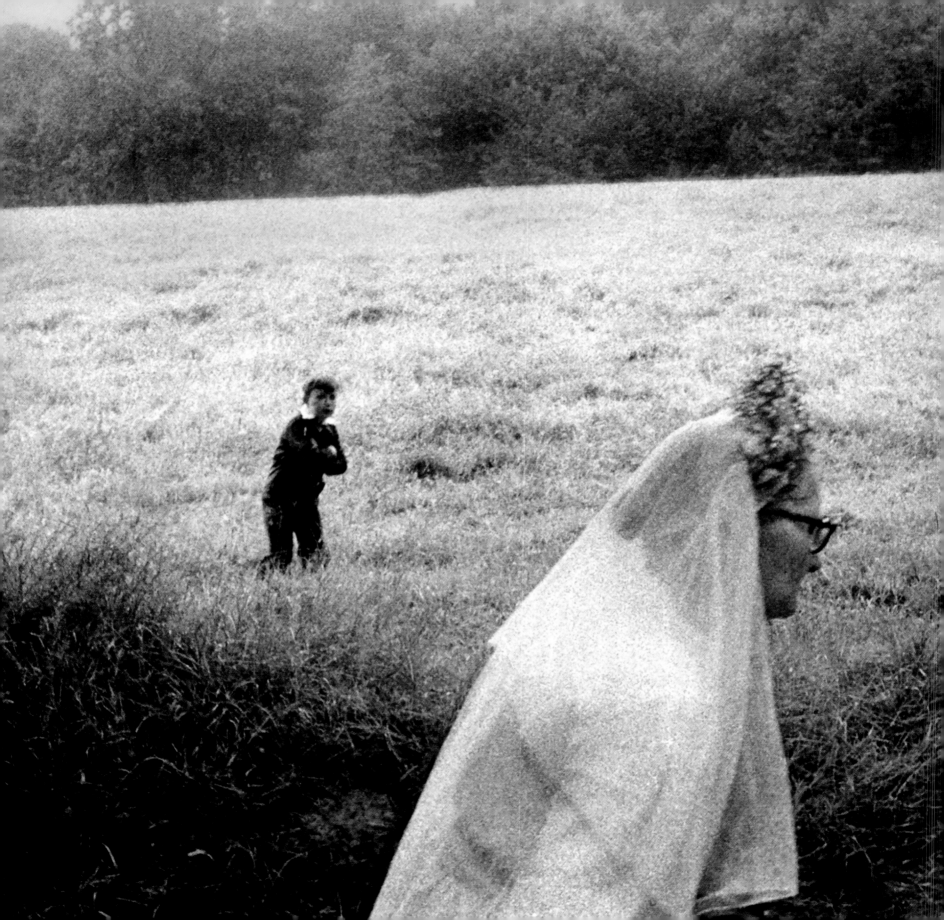

ANTONIN KRATOCHVIL I Poland, 1978 I Procession of the Virgins
FOLLOWING PAGES LEFT: THOMAS DWORZAK I New York, 2004 I Subway
RIGHT: JOHN LAUNOIS I Japan, 1960 I New meets old in Kyoto

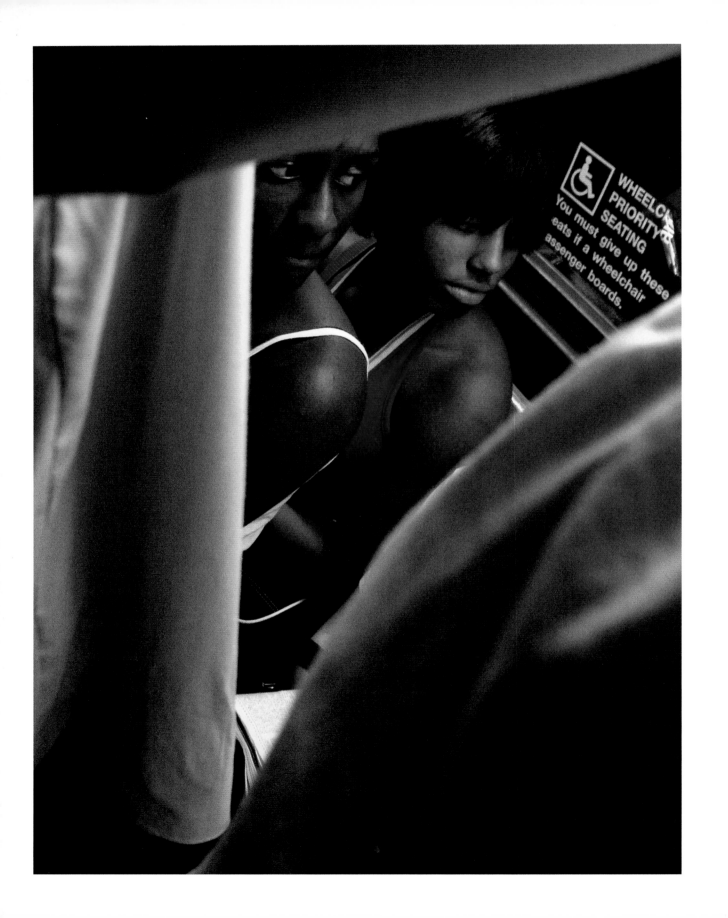

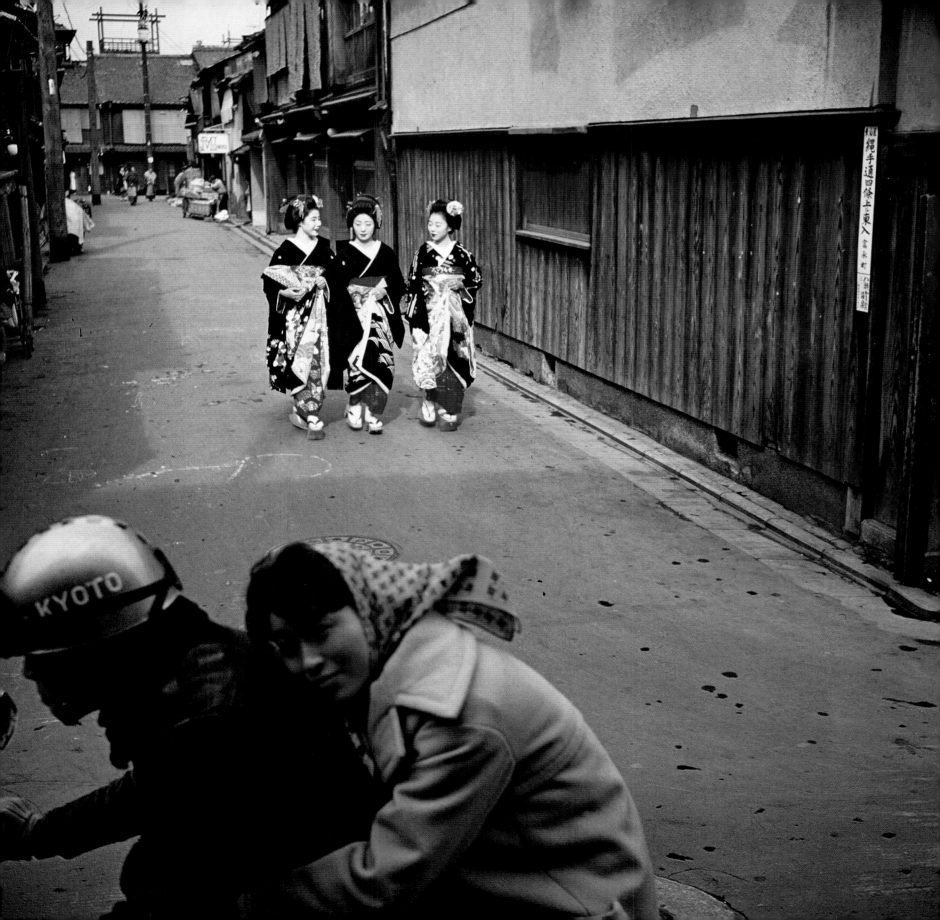

ALEX WEBB I Istanbul, Turkey, 2005

FOLLOWING PAGES: **LEONARD FREED** I West Germany, 1965 I Dancing school

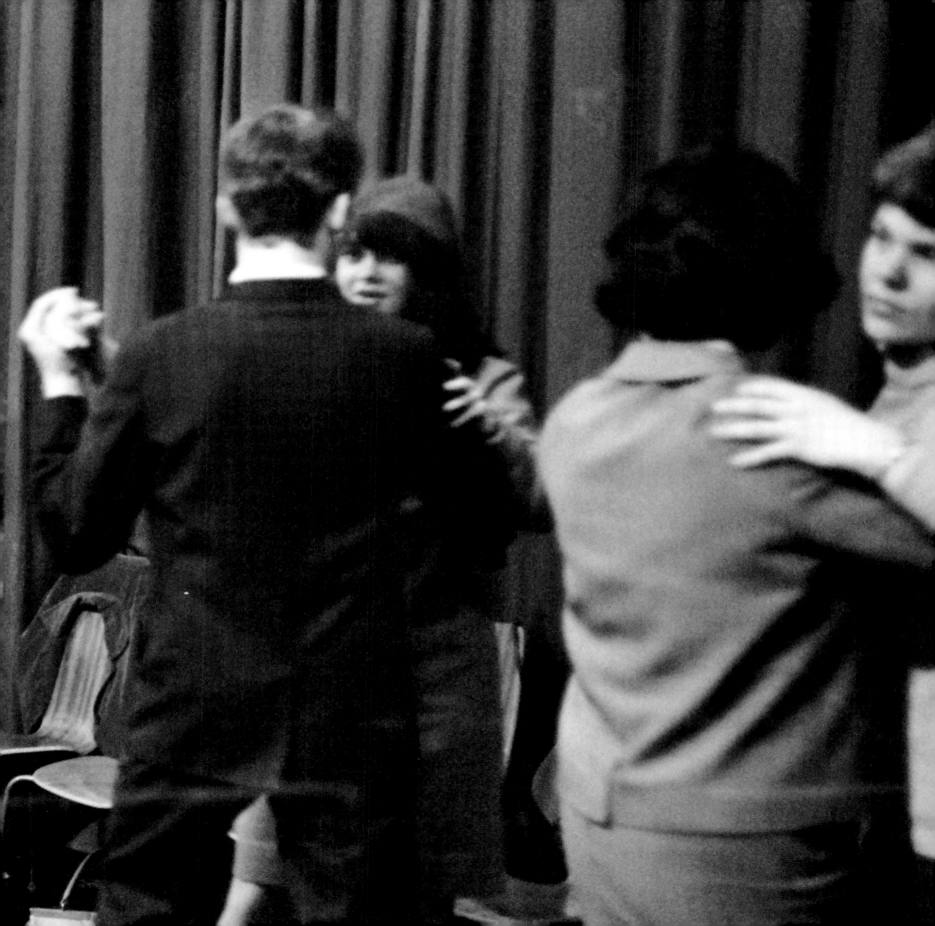

KAREN KASMAUSKI | Virginia, 1999 | Homecoming festivities at Jeb Stuart High School

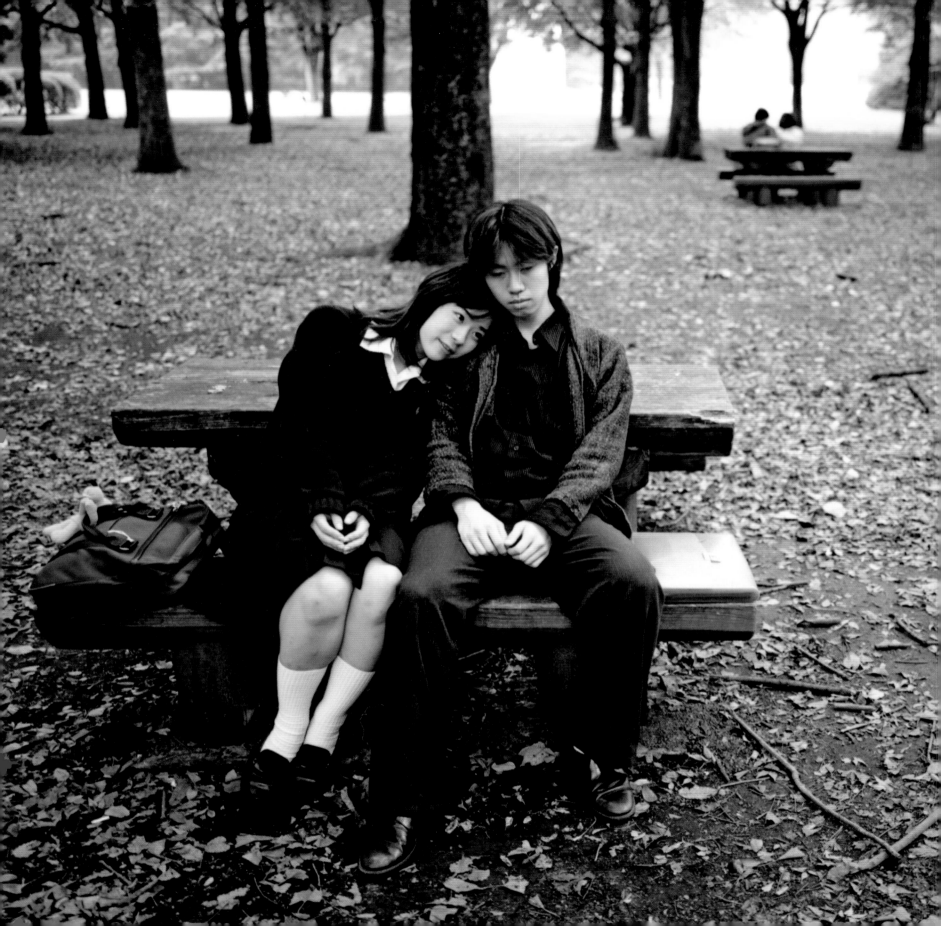

BERTRAND DESPREZ I Japan, 1998 I Teenagers

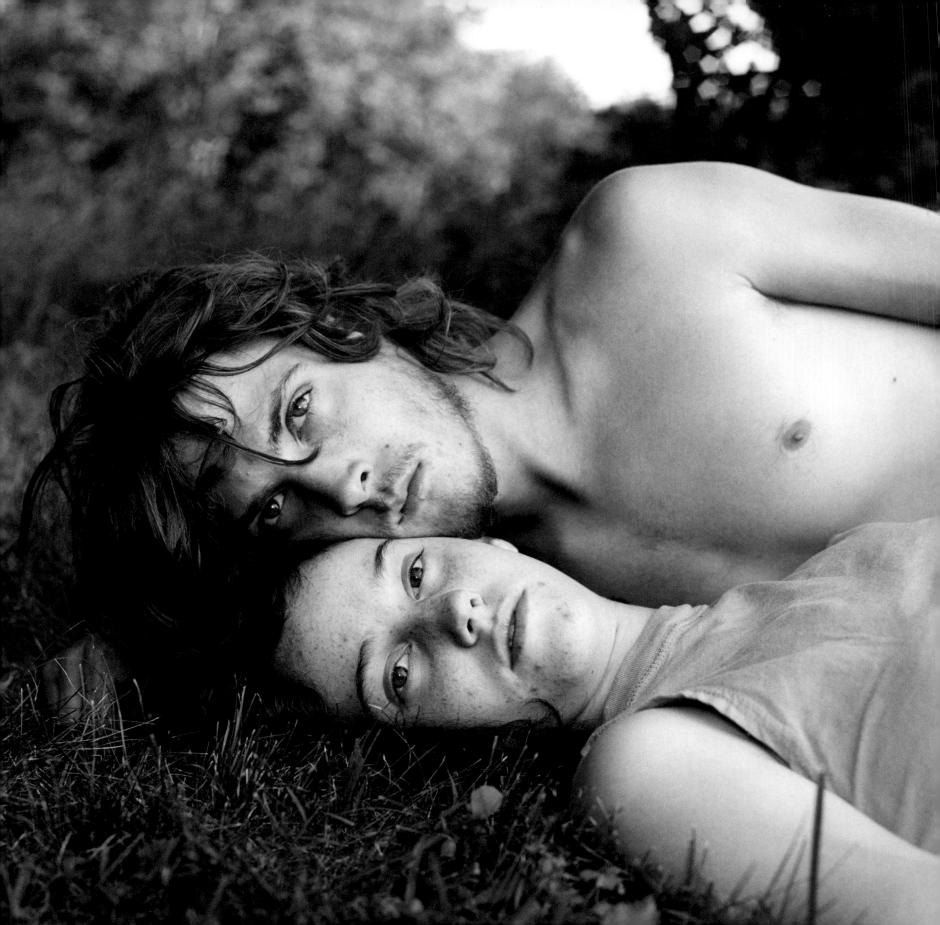

3 | IN PRIVATE |

Some years ago, my two sisters and I gathered in July with our families at my parents' home in Ohio for a brief vacation. The first evening, my father got out a box of family photographs. The earliest images were daguerreotypes from the 1860s, the most recent color prints from the late 1980s. Dad had begun sorting through the old photos first, separating those that bore information about who was in them, where they were taken and when from those with blank backs. There were a lot of blank backs.

As we got to the early 20th-century pictures, he put a black-and-white print on the table and asked if we knew who the person in it was. The image was of a young woman wearing a dark skirt and a soft white blouse with a high, buttoned collar, sitting on a deck chair on some ship. Her long, brown hair had been pinned back and a warm smile was on her face as she gazed into the camera. We knew her instantly: our paternal grandmother. My dad flipped the photo over. On the back, Grandma had written, "Who am I?"

That made no sense until my father explained. His mother and father had eloped. Why they married that way, he didn't say, and we didn't think to inquire. Our eyes and thoughts were focused on the photo taken during their honeymoon aboard a steamer cruising Lake Erie.

My grandmother had sent the picture and the question to her sister. The answer was simple; love had given the girl from a farm near Norwalk, Ohio, a husband, a new surname, and a new life. She was not who she had been just days before.

About a month after the visit, my father died suddenly from a stroke. When I look at that photo of my grandmother now, I'm glad he told us the story behind her playful question and I wish I knew more. Looking at my young, happy grandmother, whom I still love deeply, I feel sorrow and loss, knowing she is dead, as are her husband, her only child, whose birth was years off when the shutter was tripped, and his wife. I console myself with the thought that something of my grandparents and parents lives on in me, my siblings, and our children.

But the pain lingers, even after I put the photo away. In his book *Camera Lucida*, Roland Barthes wrote about looking at a photograph of his late mother, words I can only second. "It is said that mourning, by its gradual labor, slowly erases pain; I could not, I cannot believe this; because for me, Time eliminates the emotion of loss (I do not weep), that is all. For the rest, everything has remained motionless. For what I have lost is not a Figure (the Mother), but a being; and not a being, but a *quality* (a soul): not the indispensable, but the irreplaceable."

Looking at a photograph of a loved one who has died can cause pain. You don't have to be a French philosopher to know that, but it underscores the inherently tragic nature of love. We can hold on to our loved ones with all our might for as long as we can. But the day will come when we have to let go. And their absence can break our hearts instead of making them grow fonder.

Photos, however, can also help keep the feeling alive after a loved one

MARY ELLEN MARK | Valdese, North Carolina, 1990 | James and Natasha Gurley

dies. During the 20th century, displays of photographs depicting the deceased's life from infancy to final birthday became commonplace at funerals and memorial services. In private, some people routinely speak to a photograph of their departed spouse, parent, or child as if that person were alive and present. As the Roman poet Catullus wrote, *"Difficile est longum subito deponere amorem,"* "It is difficult suddenly to lay aside a long-cherished love."

The photograph of my grandmother bearing her written question came to mind when I was looking at the pictures in this chapter not because of the love I feel, or the pain, but because of the way she was looking at the person who took the picture, a person I presume was my grandfather. Her gaze is strikingly relaxed, trusting, and unguarded. She looks at him with warmth, tenderness, and love. It is a truly intimate photo even though it was taken in a public place.

None of the subjects you see in these pictures had just eloped with the photographer. But that same unguarded, emotionally open, trusting look is on their faces. That is no coincidence. Unlike Garry Winogrand, William Eggleston, André Kértész, or Henri Cartier-Bresson, most of the photographers in this chapter were not snaring lyrical, meaningful images on the wing in everyday life. They were creating them by becoming personally involved, sometimes quite closely, with their subjects. That personal involvement, in some cases lasting for months or even years, gives the photos by Jane Evelyn Atwood, Mary Ellen Mark, William Albert Allard, Jean Gaumy, Jim Goldberg, Simon Wheatley, and the others a feeling of intimacy that street photographs sometimes lack.

Whether that intimacy is genuine or illusory is debatable. When the photograph in question is being used to suggest aspects of love in private, questions arise. How private can love be if a camera is present? At a time when the belief in photography as an inherently accurate representation of the world is eroding, how can we know that what we see has anything to do with love?

These photographs were obviously taken to be made public. Some of them have been published in books and magazines or exhibited in galleries and museums. Nonetheless, they originated in private. Unlike the pictures in the previous chapter, these could not have been taken by someone just passing by with a camera. Most of these were taken in homes, backyards, neighborhoods, or public places where the subjects found some modicum of privacy that was meaningful to them and that involved the person holding the camera.

The intimacy of these photographs comes through exclusion. Where good street photography captivates by connecting the depicted scene to the vast, vibrant world beyond the photo's frame, these pictures seem to get so close to their subjects that the wider world is shut out even when the photograph was taken in a public space. Someone could have stood or squatted next to Mary Ellen Mark when she took her picture of James and Natasha Gurley and photographed them from the same angle. But that picture would be neither private nor intimate because the trust, the bond between Mark and the Gurleys would be gone.

Because of that trust we get a closer look at the subjects. There is a sense in the photos by Eugene Richards, David Alan Harvey, and Bill

Owens of the subjects effectively defining themselves. They let the photographer into their lives, and show us who they are, what they do, where they live, how they feel. There is no pretense in Richards's photo of a father in Dorchester, a working-class neighborhood of Boston, Massachusetts, sitting in a kitchen chair, hugging his son with one hand, holding a beer can in the other, wearing plastic vampire fangs, and looking blearily toward the camera as if he's just gotten home after a tough day at work. That's love with its shoes off, tired and probably a bit cranky.

Other pictures suggest love's changeable nature, its beginnings and endings, its separations and unions, its ecstasies, jealousies, passions, fears, and worries. The camera takes us into French photographer Jean Gaumy's bedroom, where he is sprawled under a duvet, talking to Marie, his daughter, as she lies in the crib next to him. Other photos, such as Allard's shot of a Mississippi blues musician leaning in for a kiss late on a Sunday afternoon at his home, or Mark Leong's photo of a couple on a rail journey through China show love's sexual side.

Ferdinando Scianna caught a different kind of love in his picture of Paola kissing Nanà's nose in Milan, Italy, the love born in the physical and psychological relationship between a mother and infant that is common to all mammals. This maternal love, which begins with touch and is the wellspring of all love, can also be seen in Nicholas Nixon's image of his wife, Bebe, gazing down at her daughter, Clementine, whom we see only as a tiny right fist raised like a symbol of baby power.

Some of the photographs can be viewed as testimony to the strength and endurance of the subjects' love, such as Randy Olson's picture of

Earl and Versie Henry of Hasty, Arkansas, who had been married for 57 years, when the picture was taken. They sit smiling on their living room sofa, photos of their three daughters hanging on the wall above them. David Burnett photographed the Lubbers outdoors at their farm near Missoula, Montana, in 2006, and noted in his caption that the couple is "bound together by love and strawberry pie."

Food plays a significant role in Bill Owens's portrait of a young couple barbecuing in 1972, on the patio of their new home in Livermore, California's Amador Valley subdivision. Owens visited dozens of families and couples while living in the area and compiled his photographs in his classic book, *Suburbia*, published in 1972. The caption the nameless couple supplied for their photo is, "Sunday afternoon we get together. I cook the steaks and my wife makes the salad."

Love is the overarching theme of Owens's book. Unlike photographer Robert Adams, whose photographs of America's western landscape treated subdivisions as a spreading cancer fueled by what he called "the obscenity of the speculator's greed," Owens's photos show how the people living in Amador Valley absolutely loved the place, the space, the lifestyle, and their split-level homes. Like the pudgy folks standing by the grill, they were happy to let Owens into their lives and proud to show him what they come to possess. They trusted him like a family member and you sense that he loved taking their pictures.

Owens's photos and all the others in this chapter are essentially portraits, and they do what all portraits, whether candid or posed do: memorialize their subjects for posterity. They often serve as touchstones. Like Qui, the

Chinese immigrant who Chien-Chi Chang photographed in a Chinatown apartment, we tuck a snapshot in the frame of a mirror to remind us of the people we love. Or we frame a photo and hang it proudly on the wall, like the family photo hanging in a home in Shkodra, Albania, that Guillaume Herbaut photographed and which is the cover image of this book.

We don't hang pictures of our family on the walls because they are technically brilliant or deeply revealing photographs. We hang them so every once in a while we can look at an image of someone we love. For the person who put the picture on the wall it can be a starting point, a way of re-entering the family's story, like when I look at my grandmother's photo.

For Herbaut, that can't be true. The people in the photo on the wall were not his loved ones. What he saw was a compelling visual image, a study in contrasts, an expanse of intriguing green with a black-and-white photo in a black frame smack dab in the middle. It's the kind of unselfconsciously hip, stylized look that minimalist home decorators everywhere strive to achieve.

Herbaut's picture also exemplifies the way photography has changed over the past few decades. Like his photo of the girl holding the bouquet of red roses in the In Public chapter, this is a picture that touches certain art-historical and pop-cultural chords, in this case minimalism, color field painting, old-school photographic portraiture, combined with home design and fashion magazine slickness. It is an image about an image and about image-making.

Like it or not, that is where the mainstream of contemporary photography now flows. There is a yawning, been-there-seen-that, can-you-catch-all-

my-references quality implicit in the work of many photographic artists. The pictures in their exhibitions look equally at home hawking products or attitude on a billboard, in a magazine or a Web site. What separates Herbaut's work from that of many of his peers is its warmth, humor, and mix of restrained irony and sentiment.

As with all photographs, these portraits can conceal as much as they reveal. That is particularly true when we look at them for evidence of love. We don't have the luxury of flipping the pictures over to see if there is something written on the back. There is no way of really knowing if the people we see are truly in love, unless the photographer tells us something about them through captions. Even if they are in love, their version of it may not jibe with ours. To paraphrase my grandmother's question, who are they?

We don't know. We don't know if their smiles mask some darker side of love, although something about the Lubbers and their strawberry pie makes me think they've found the real thing and it is strong enough that their tough times aren't too dark. As in the other pictures, the issue is whether what we see resonates with us.

The couples you see in this book function as archetypes. They are Everyman and Everywoman, frozen momentarily by a photographer. They serve as metaphors for love being silly or serious, physical or spiritual. Some exemplify the paradoxical sense of closeness and distance love can bring and the way the frames of life and love whirr by like film in a motor-driven camera. By placing these photos in the context of this book, their meaning is manipulated.

All photos are manipulated to a certain degree, beginning with the photographer's selection of the image to be photographed. That selection is also influenced by the cultural background of the photographer and the subject.

Physical manipulation of the photographic image is quite evident in the Taliban portrait that Thomas Dworzak found and photographed in Kandahar, Afghanistan, in 2002, while on a magazine assignment. Whoever the photographer of the original image was, he painted in the blue background and probably touched up the faces and clothing of the two men.

From an American perspective, the picture seems like it might have been taken at a Halloween party somewhere in New York City's West Village section, home to a significant gay population. The two young men are wearing make-up, they're holding hands, they are dressed in what could be considered, even by Manhattan standards, exotic garb.

But they are, in fact, Taliban fighters. When the Taliban took power in Afghanistan, Mullah Omar, its leader, banned photography of living beings because it violated his interpretation of Islamic law. But he allowed some photo studios to stay open to provide passport and ID photos.

That decree didn't sit well in Kandahar, a city of ethnic Pashtuns that became Mullah Omar's last headquarters on Afghan soil as the Taliban was being driven out in 2001. There is said to be a tradition in Kandahar of men wearing high-heeled sandals, using eyeliner and painting their fingernails. They also liked to have their pictures taken, a service that was provided by hole-in-the-wall photo shops in downtown Kandahar. After the mullah's decree, that practice continued in secret.

According to the Magnum photo agency, of which Dworzak is a member, he arrived in the days just after the Taliban had been driven out of Kandahar and found dozens of these photographs, still waiting to be picked up.

Looking at the image from a Western perspective, it seems absurd. We regard the Taliban as ruthless, hateful, religious fanatics, the kind of people who publicly execute women for deeds that wouldn't raise an eyebrow in our culture and eradicate ancient Buddha statues with explosives and cannon fire. The dolled-up young men are killers who know nothing of love.

Yet, we don't really know much about the two individuals in the picture. Their dress and appearance fall within the norms of their culture. Manipulating portraits is not unique to Afghanistan. Countless photo studios around the world pose people before fake backgrounds and touch up their faces. These men may, in fact, be killers. Or they could be clerks, doctors, or accountants. All we can really conclude from this image is that the age of irony in Western photography sometimes veers towards cultural narcissism, and that the two subjects' friendship or love for one another was such that they wanted to have their picture taken together in violation of their leader's edict.

With so much strife in our world, it is easy to forget that love is not the province of any one culture or people. It has no religion, no nationality, and

no conscience. It is ubiquitous and undiscriminating. The worst dictators in world history had mothers and fathers. Many had wives and children they loved and who loved them. No photograph can reveal or resolve that dichotomy between familial love and mass murderer. In his poem "Shorts," W. H. Auden might have been talking about 20th-century dictators' predilection to plaster photographs of themselves in public when he wrote the deceptively simple, chilling lines, "Private faces in public places/ Are wiser and nicer/ Than public faces in private places."

We don't know any more about James and Natasha Gurley than we do about Dworzak's two Pashtuns. But the faces of the young man and woman seem far more benign as they lie on the ground in Valdese, North Carolina, staring straight into Mary Ellen Mark's camera. Their wide, unblinking eyes that start this chapter seem straight from a 19th-century portrait. But Natasha's supine position, James's bare chest, and the way his cheek rests gently on her head, suggest the warmth and desire for physical closeness that can come with love.

The pair looks at the camera the way my grandmother did on that steamer, relaxed, completely trusting, and emotionally open. The viewer gets a strong sense of empathy with the subjects. That is remarkable since James and Natasha, who may be brother and sister for all I know, were not opening themselves up to us, but to Mary Ellen Mark. She got close to them, literally and psychologically. Beyond what Mark chose to show us, we know nothing about the two young people she photographed in 1990. We don't really know what they are thinking or feeling at that moment, just what they looked like when Mark took their picture.

No retouching is evident here. James and Natasha both have some blemishes on their faces and he sports a scruffy beard. Other than the grass, which is in focus, the background is a swirling riot of black and silver tones around a splotch of white sky. The kinetic tonal interplay gives the picture a kind of painterly coherence and completeness, like a black-and-white Old Masters portrait lying on its side. It becomes an object unto itself, compensating for any lack of narrative with arresting visual appeal. Whether it is a picture of love in private is for the viewer to decide.

Of all the photographers in this book, Duane Michals has done the most to expand the narrative possibilities of the medium and to explore love not as a greeting-card cliché but as a concept. He was one of the first artists to stage events for the camera, to create staged sequences of photographs, to put himself into the picture, to deliberately double-expose his prints and to paint and write on his photographs.

Michals's photograph of a man and woman sitting fully clothed on the edge of a double bed, washed in the soft light filtering through the curtained window, is a visual poem composed in the full range of tones, textures, and shadings that black-and-white photography can produce. If that was all he showed us, it would be enough to enchant our eyes for a while.

But Michals does not produce eye candy. Beneath the image of the smiling couple, the woman resting her head on the man's back, looking relaxed and happy, he wrote: "This photograph is my proof. There was that afternoon, when things were still good between us, and she embraced me, and we were so happy. It did happen. She did love me. Look, see for yourself!"

This is the visual equivalent of a short, short story contained in a single photograph. Told from the man's perspective looking back in time, we learn the relationship has ended, that he is devastated, that he believes the woman did love him and that life was good. The photograph is his proof, his evidence, the camera, which the viewer seems almost be be holding, his witness. The man/narrator uses the photograph as a touchstone, the way so many people use photographs in life. In this case, it serves as a test for determining that the woman did love him.

We don't hear from the woman. Looking at her gently smiling face doesn't let us read her thoughts. We don't know what happened to their relationship. But we read the man's pain, sadness, and desperation and it contrasts strongly with the picture. Our imaginations can supply innumerable bad endings based on those we've witnessed or read about in real life.

Through his words and picture, Michals touches both a cultural nerve—the high incidence of divorces and break-ups in Western society—a universal theme—love lost—and a plaintive personal note through the narrator's voice. That is a lot to get from any picture. Yet none of it is true.

In curator Brooks Johnson's book, *Photography Speaks—150 Photographers on their Art*, Michals commented on one of his photographs that related to his father, writing, "I really don't care what my father looked like, and I'm sure you don't very much either. What is important, however, is what did or did not transpire between us. That lack of communication, love, conflict is my legacy, my history. This is what matters to me, and this is what I want to share with you. I write with this photograph not to tell you what you can see, rather to express what is invisible. I write to express

these feelings. We are our feelings. Photography deals exquisitely with appearances, but nothing is what it appears to be."

Yet the pain and sadness conveyed by Michals' photograph are real. We feel love's absence even though we don't see it in the couple on the bed, and the break-up never really happened. Love has that power. So do photographs.

After my parents died that combination of love, loss, and photographs dogged me for months. I couldn't look at photographs of them without pain and tears. The photos brought back memories. The memories reminded me of the irreplaceable souls I had lost.

As time went by, I forced myself to look at them because the thought of not seeing how they once looked was more painful than the emotions associated with their deaths. And if I couldn't bear the memories that pictures brought into the present, how was I going to preserve those memories in the future?

I still feel a small pang sometimes when I see photos of them. But I also feel love for them and recall how they loved me and my sisters. The same feeling comes looking at the photo of my grandmother sitting on that steamer. She can't answer all the questions that have occurred to me about her marriage and her life. But I know the answer to the question she wrote on the back. I know who she was. That private picture is my proof. ❦

FOLLOWING PAGES: **JEAN GAUMY** | The photographer and his daughter, Marie

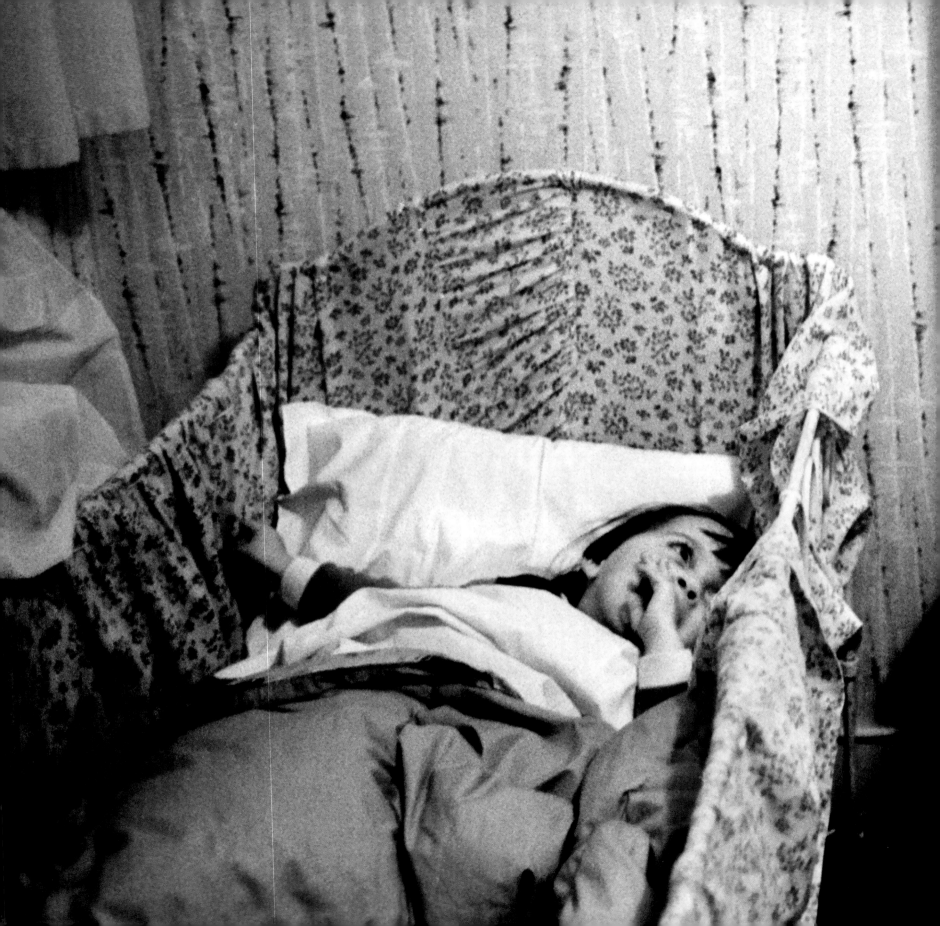

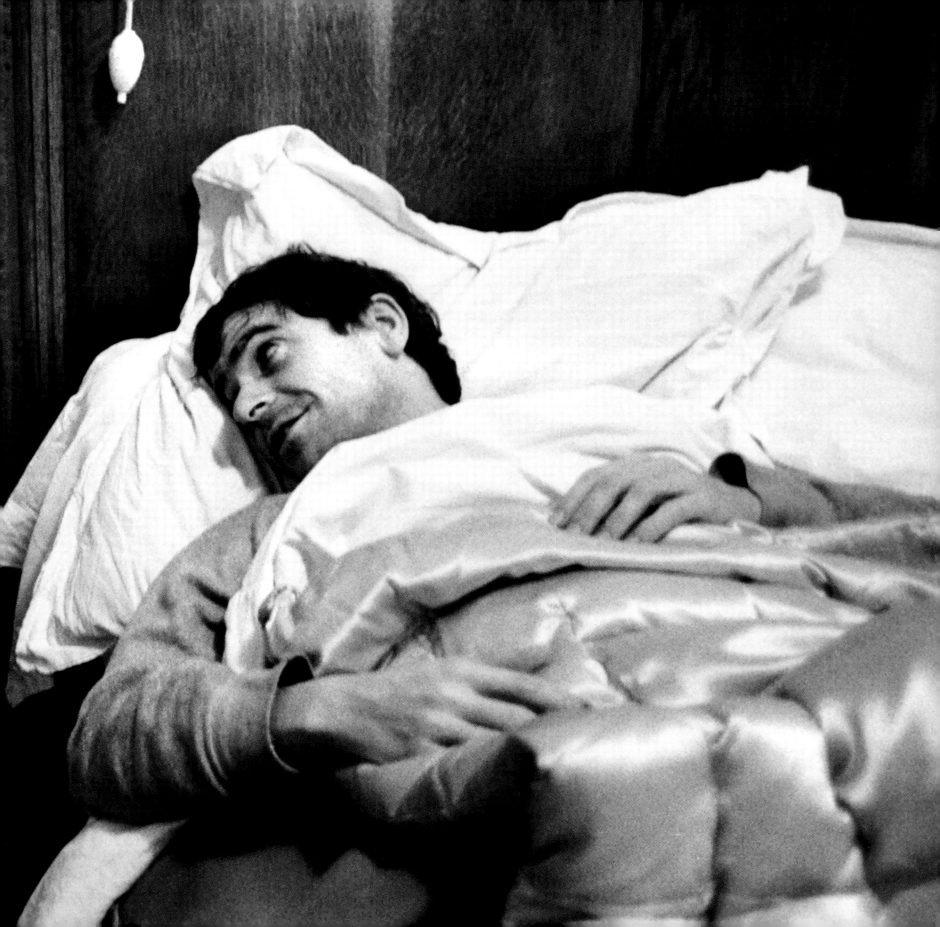

MANNY LOVES ME BUT I AM TOO STRONG

TO LOVE HIM

ELCHUCO

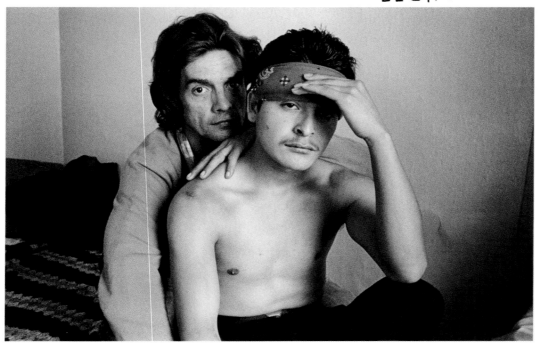

This photo makes me want to cry

Manny García
1983

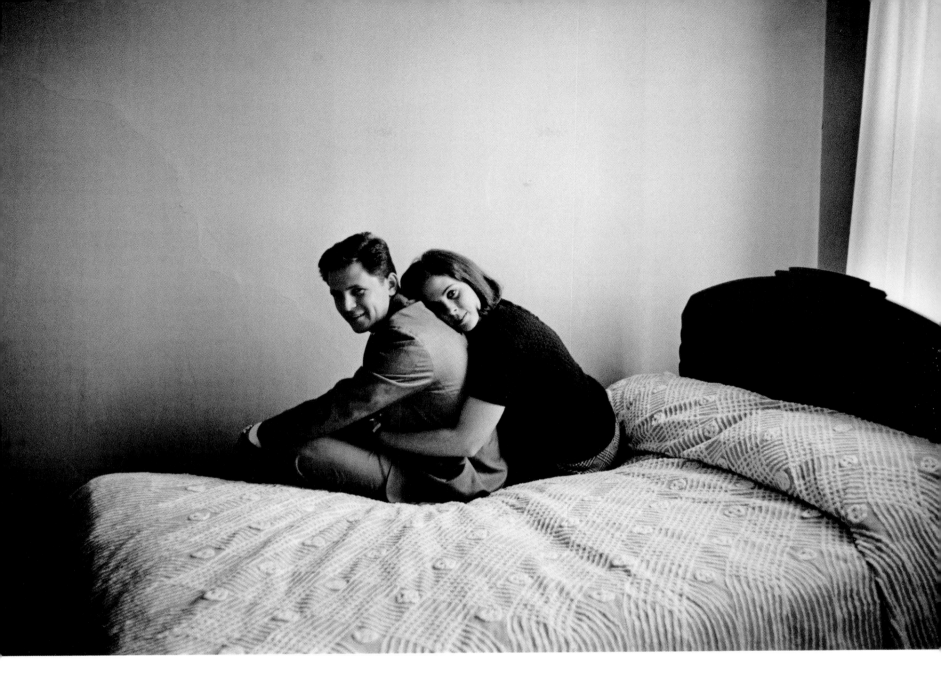

This photograph is my proof. There was that afternoon, when things were still good between us, and she embraced me, and we were so happy. It had happened. She did love me. Look, see for yourself!

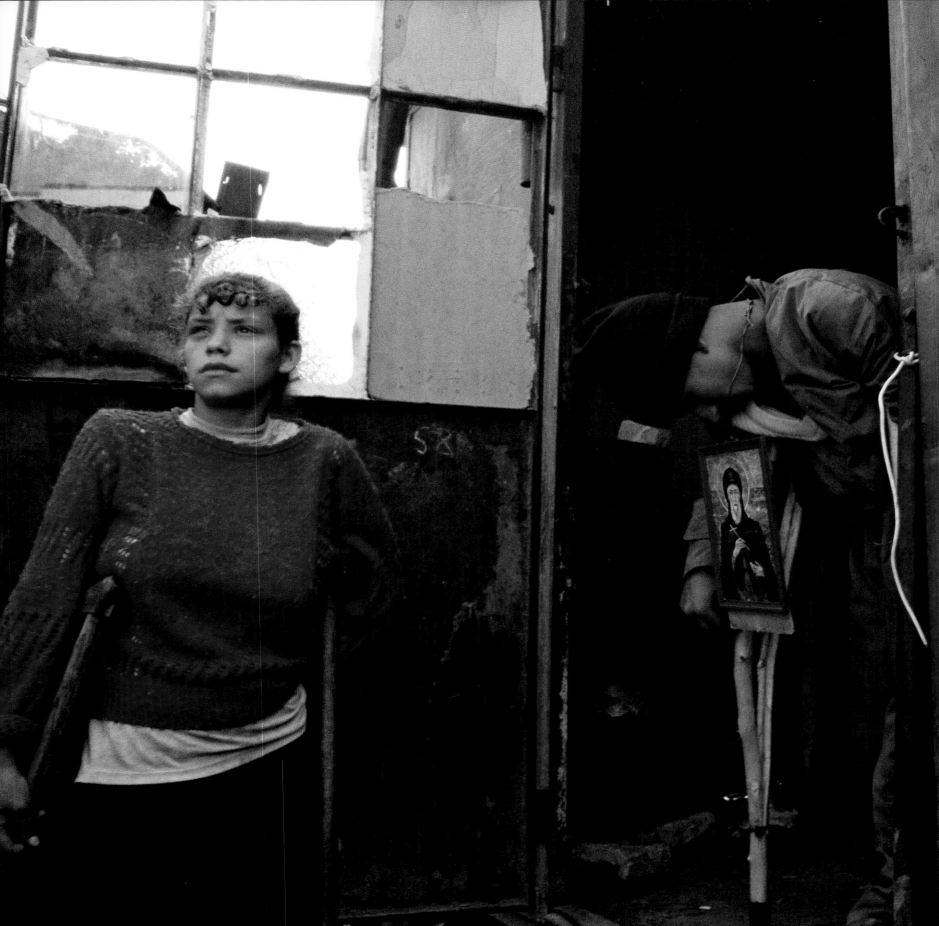

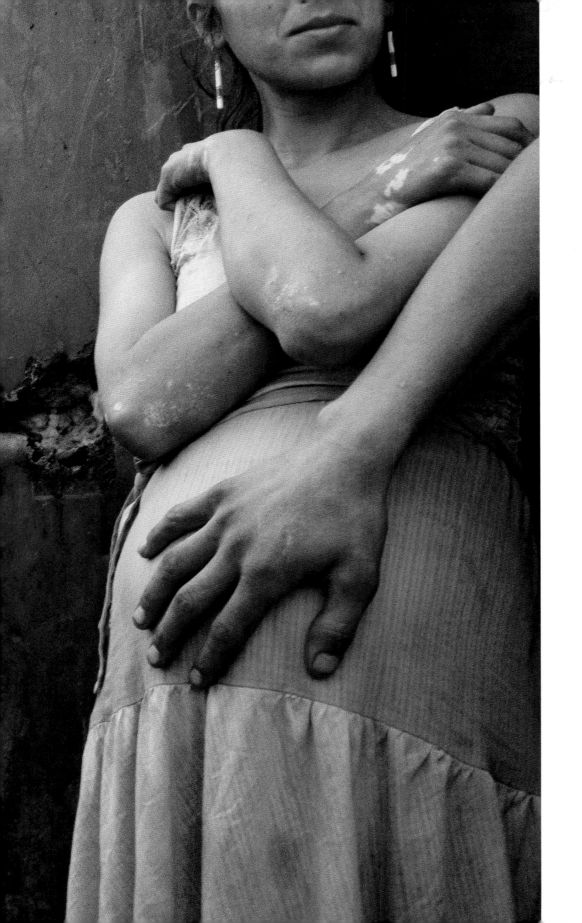

TOMASZ TOMASZEWSKI | Bucharest, Romania, 1999 | Gypsies

PRECEDING PAGE, LEFT: JIM GOLDBERG | San Francisco, 1983

RIGHT: DUANE MICHALS | "This photograph is My Proof"

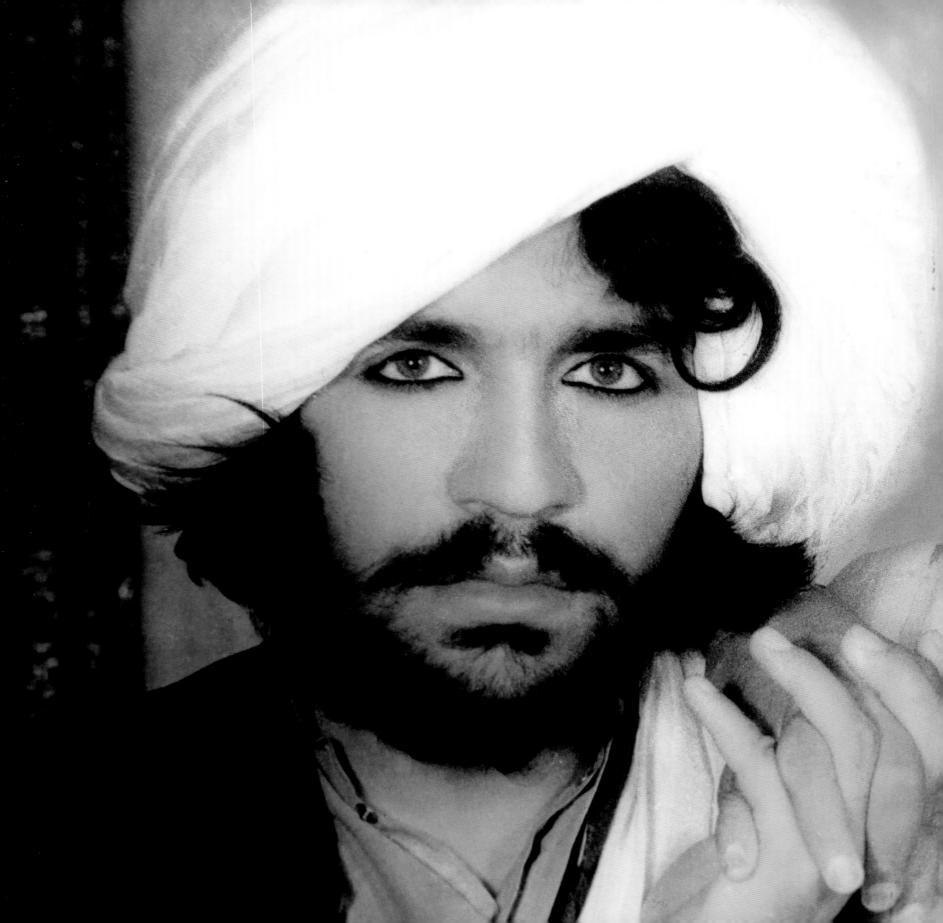

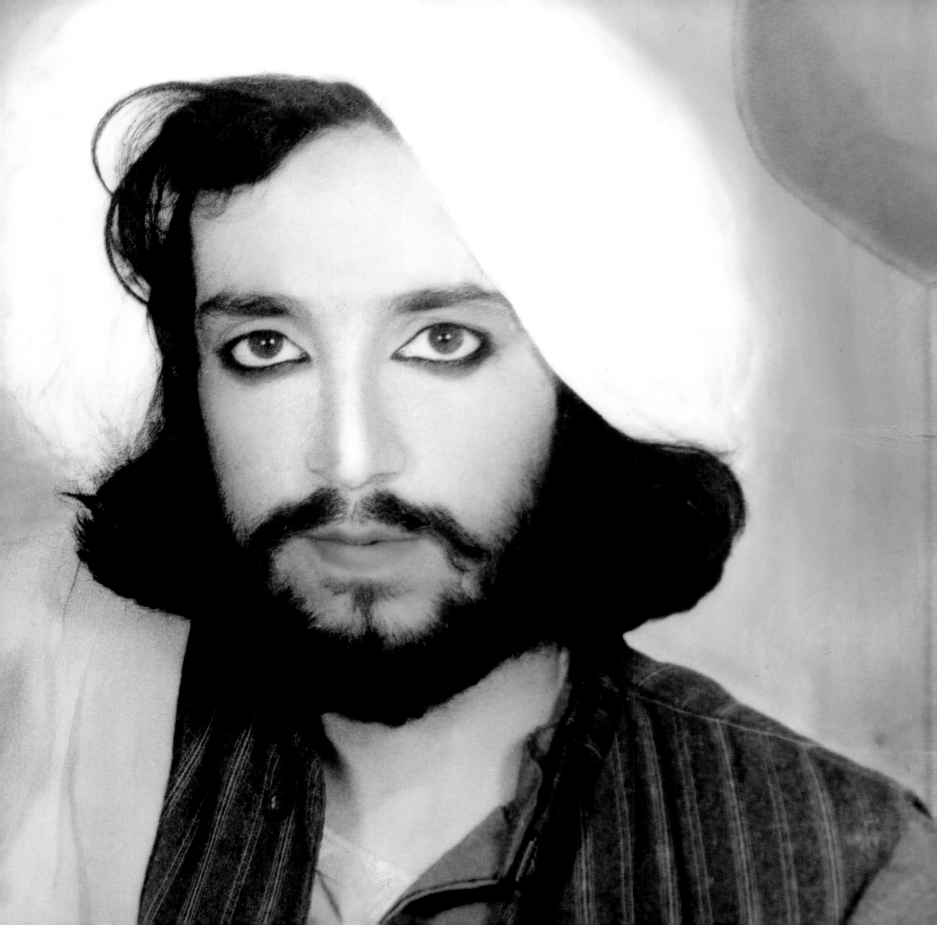

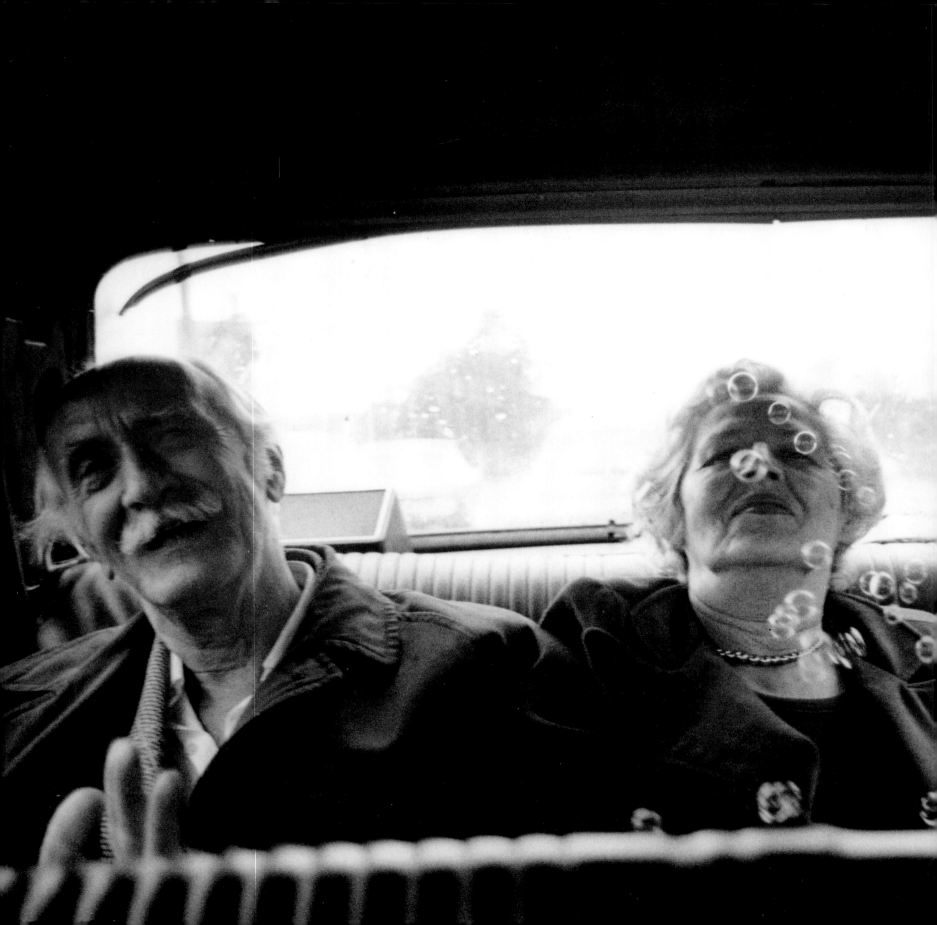

PRECEDING PAGES: **COLLECTION T. DWORZAK** I Kandahar, Afghanistan, 2002 I Taliban portrait

SYLVIA PLACHY I New York, 1979 I Grandpa and Grandma

FOLLOWING PAGES, LEFT: **WAYNE MILLER** I Chicago, 1947 I Tuesday afternoon on Halstead St.

RIGHT: **BRUCE GILDEN** I Romania, 1998 I Gypsy woman

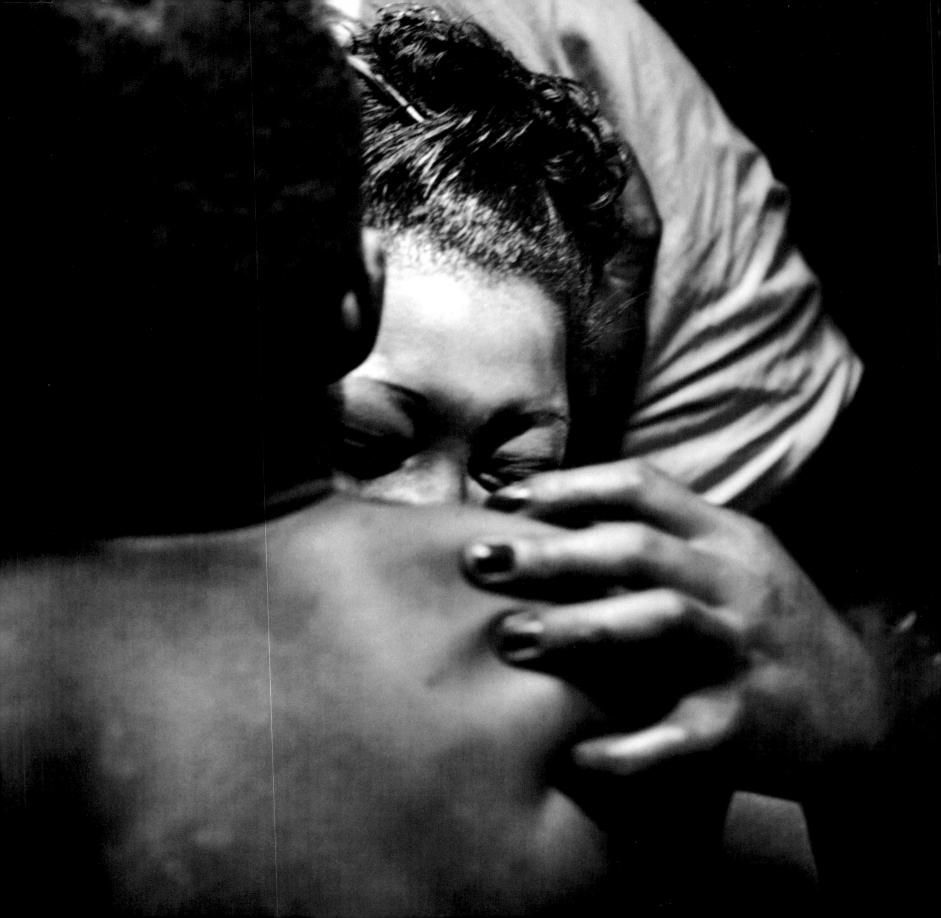

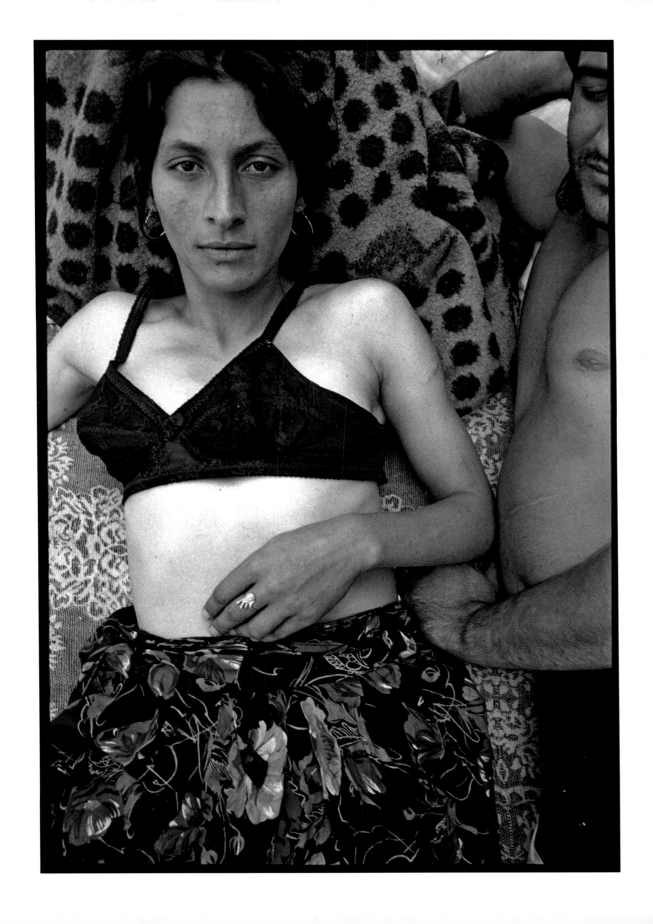

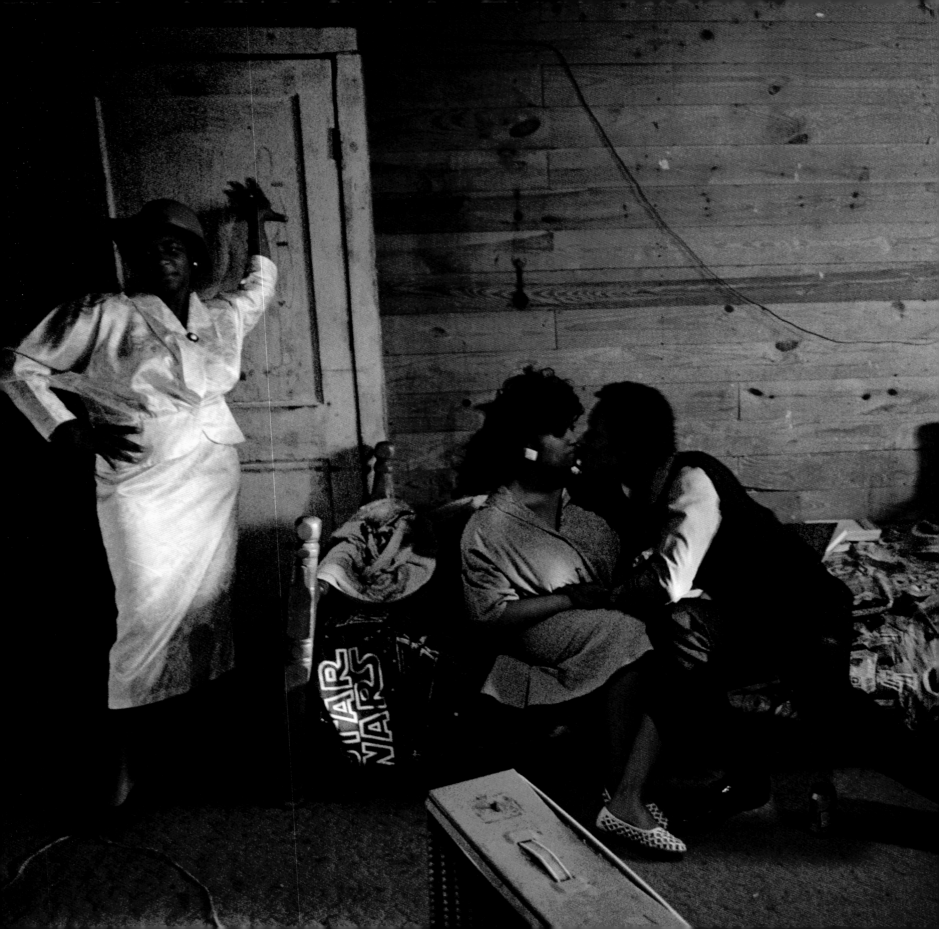

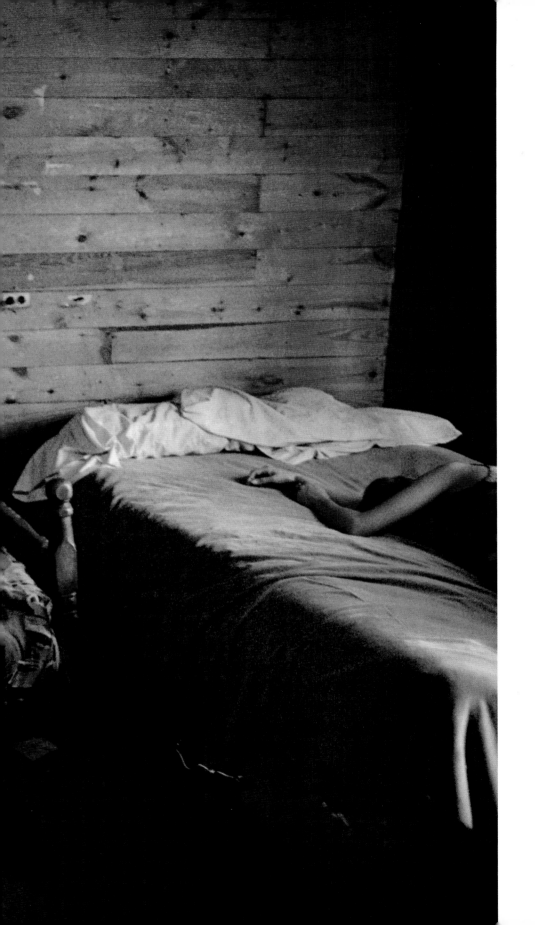

WILLIAM ALBERT ALLARD **|** Mississippi, 1987 **|** Sunday afternoon

FOLLOWING PAGES, LEFT: **JANE EVELYN ATWOOD** **|** France, 1980 **|** Blind twins

RIGHT: **BRUCE DAVIDSON** **|** New York, 1959

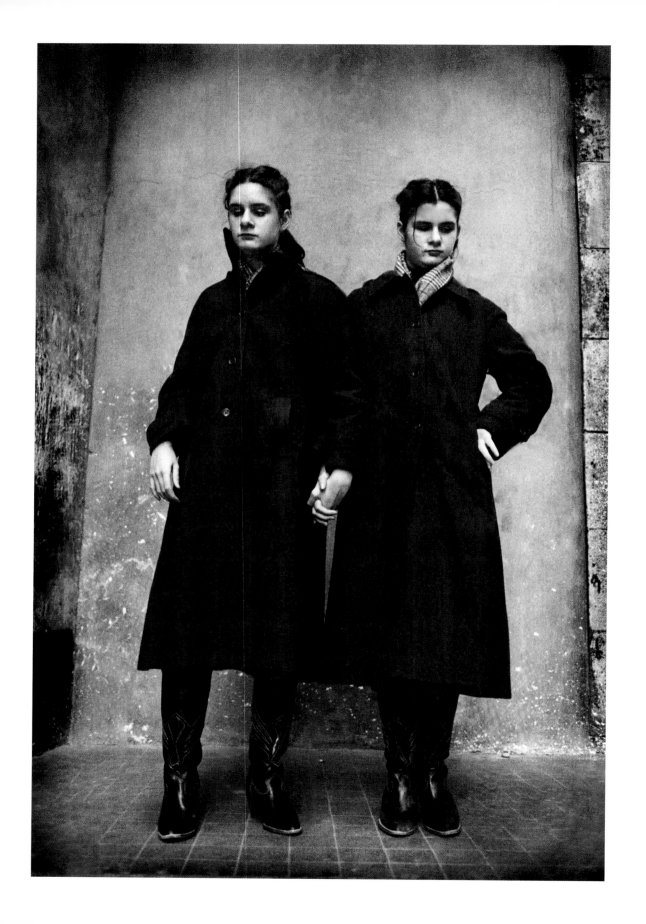

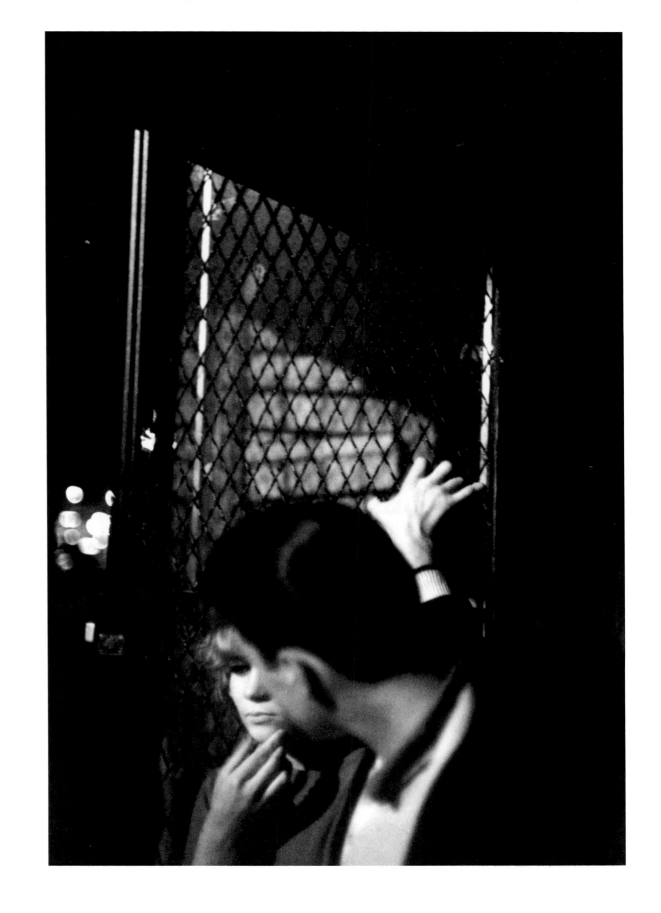

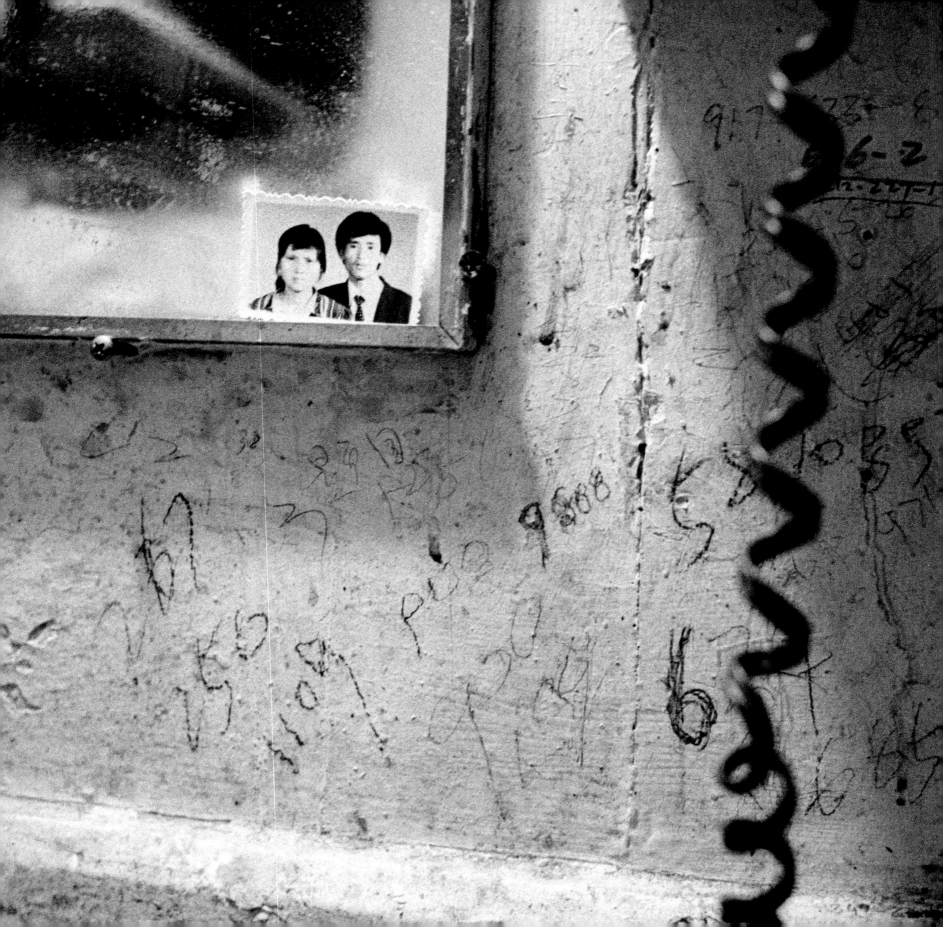

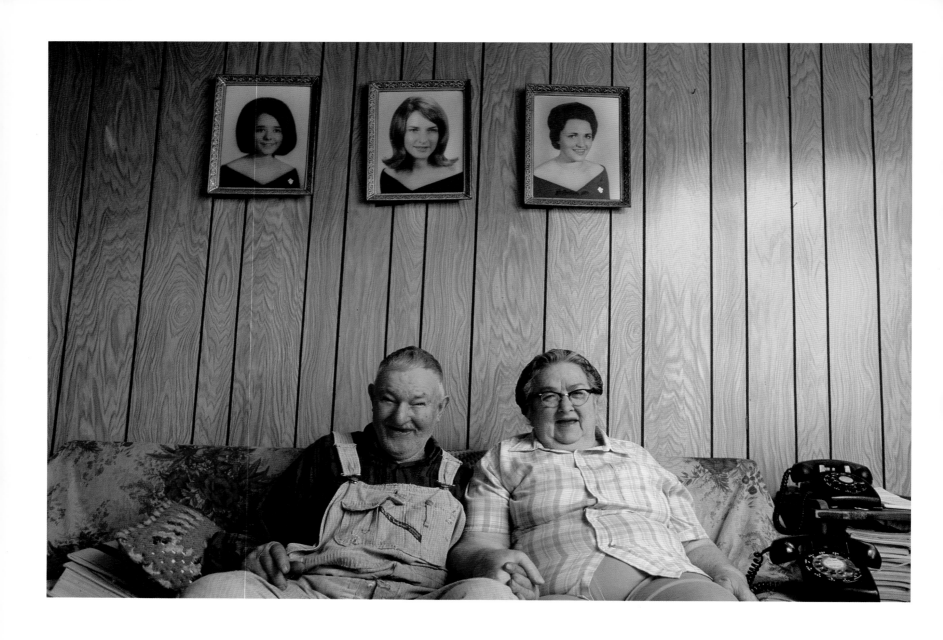

RANDY OLSON | Hasty, Arkansas, 1995 | Earl and Versie Henry, married for 57 years

PRECEDING PAGES, LEFT: **CHIEN-CHI CHANG** | New York City, 2005 | Chinese immigrants in their apartment

RIGHT: **GUILLAUME HERBAUT** | Shkodra, Albania, 2004 | Family photo in an Albanian home

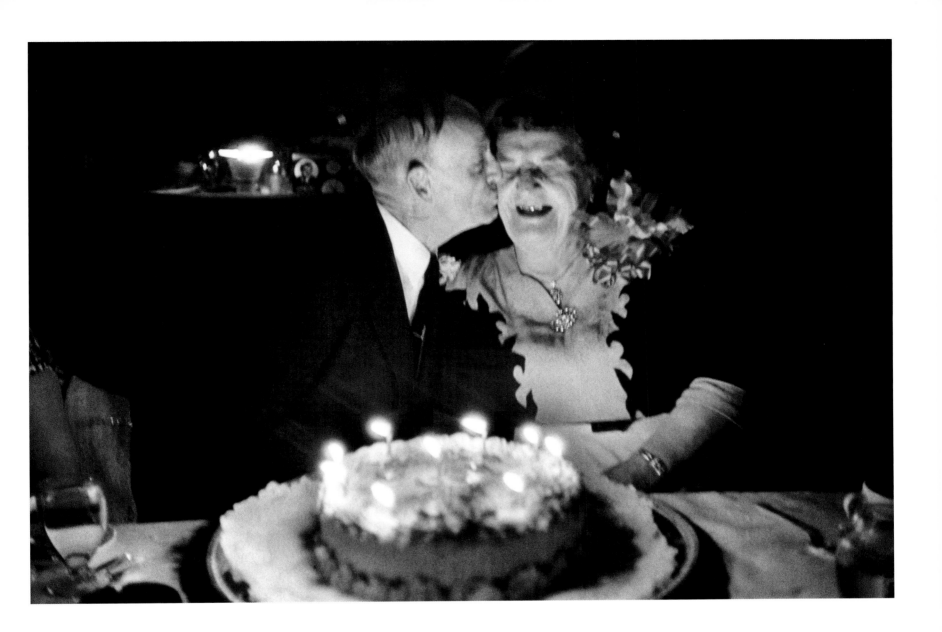

ELLIOTT ERWITT | *New York City, 1955* | *Celebration*

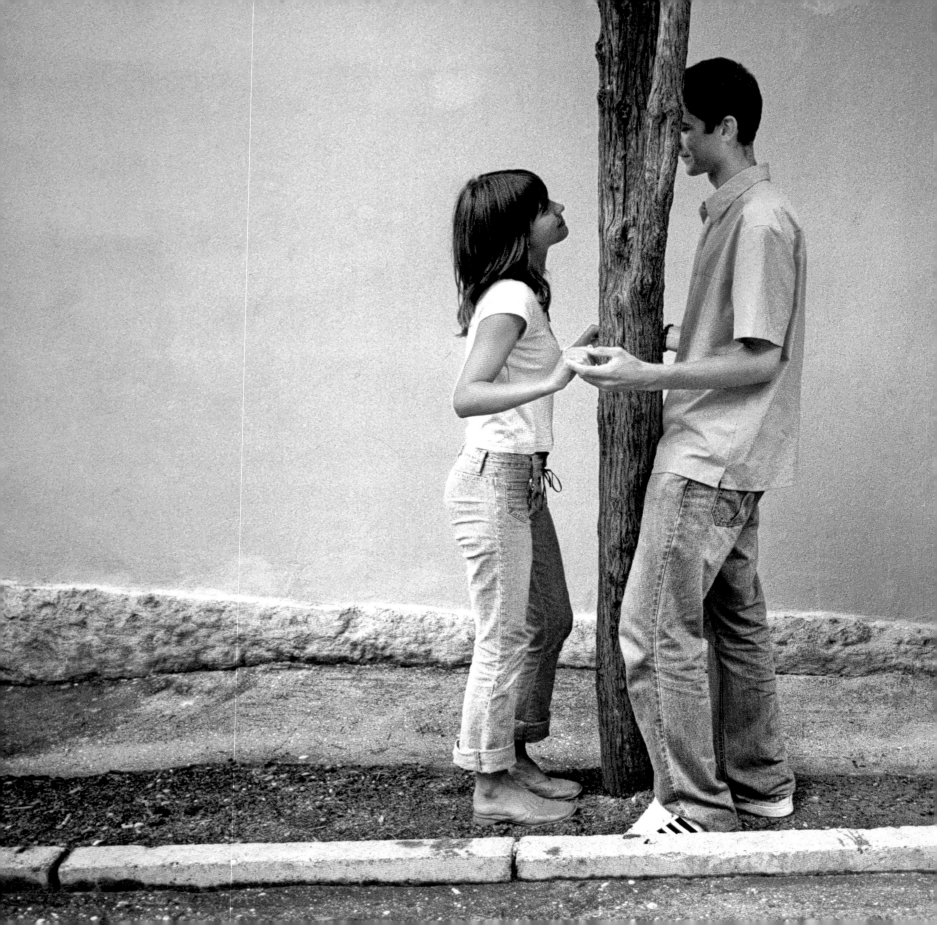

CLAUDINE DOURY I Russia, 2002 I Elisavieta and Kolia at youth camp

180

ALEX MAJOLI **|** Afghanistan, 2001 **|** Family portrait, before leaving Kabul for Pakistan

FOLLOWING PAGES, LEFT: **DAVID BURNETT** **|** Montana, 1982 **|** The pie

RIGHT: **BILL OWENS** **|** U.S.A. **|** Suburbia

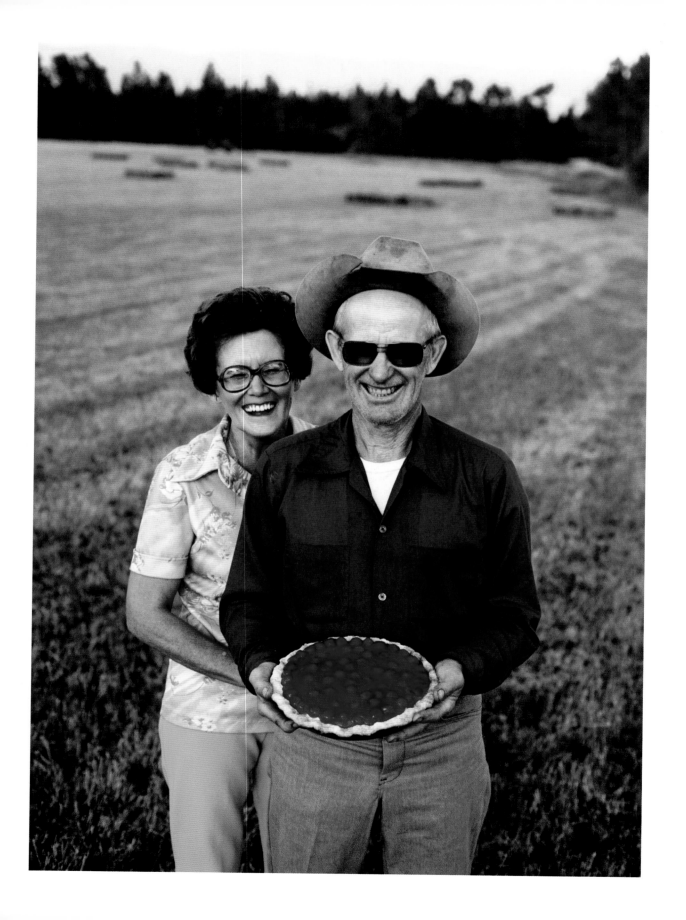

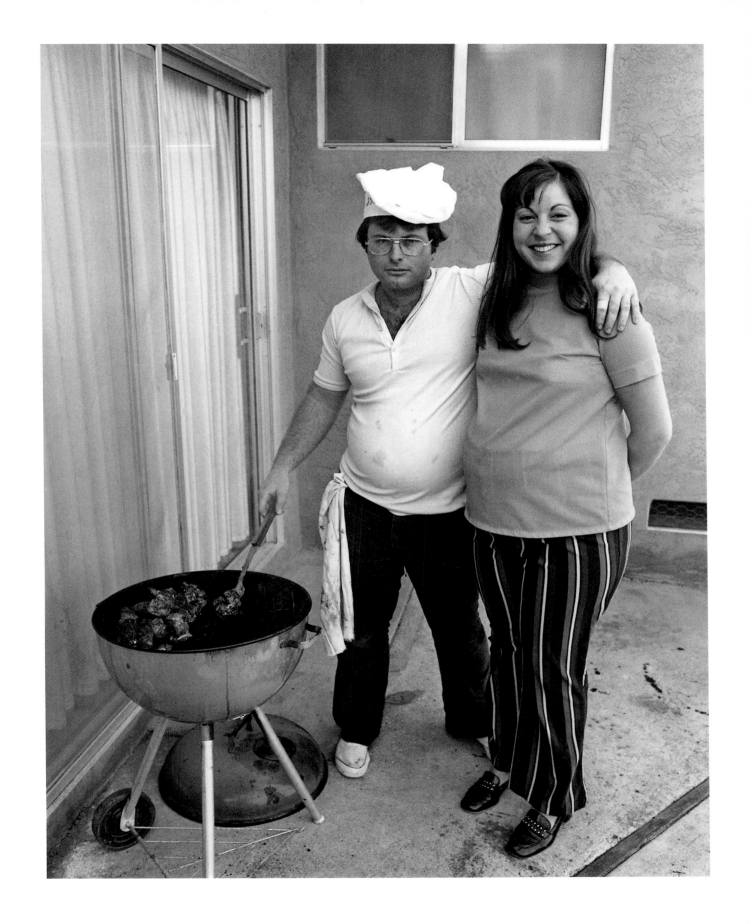

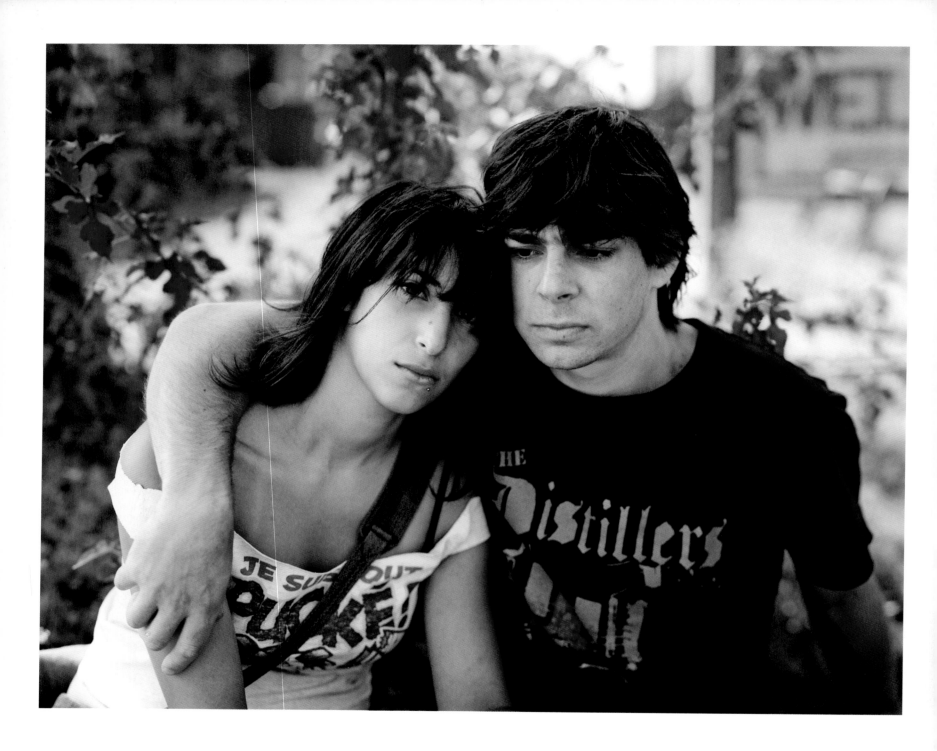

ALEC SOTH | Canada, 2004 | Martha and Anthony

OPPOSITE: **SIMON WHEATLEY** | London, 2005 | Krafty, an MC, and his girlfriend

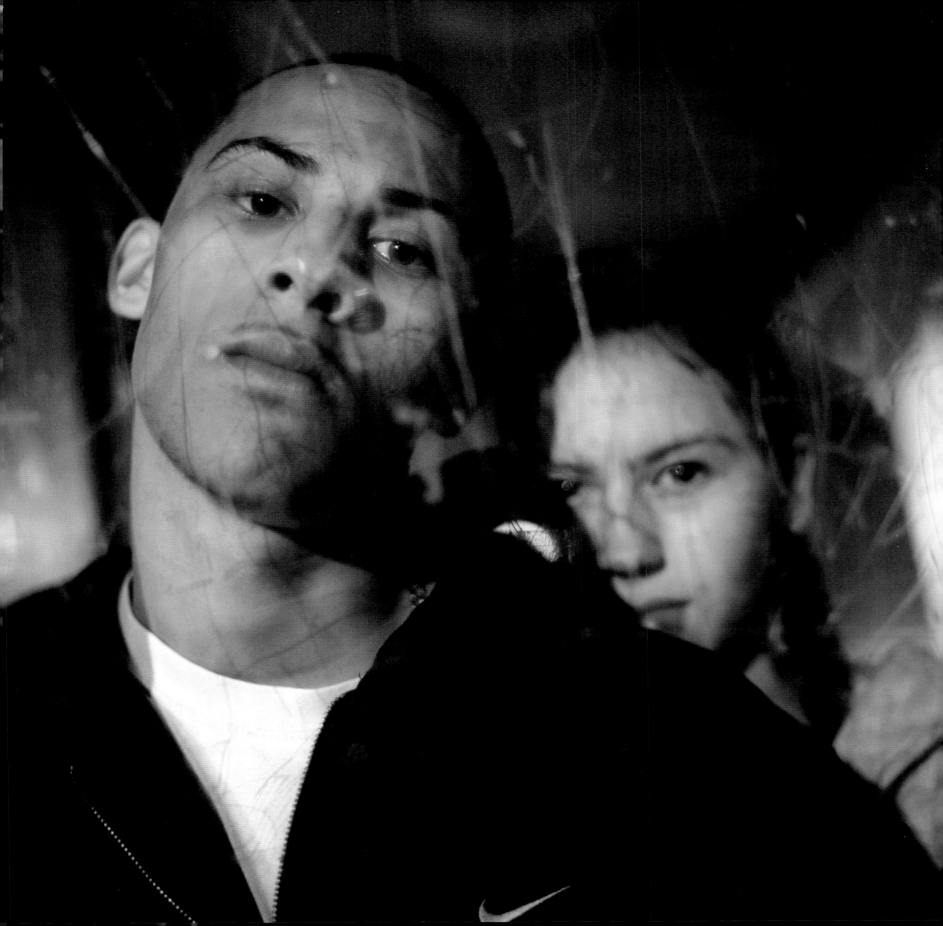

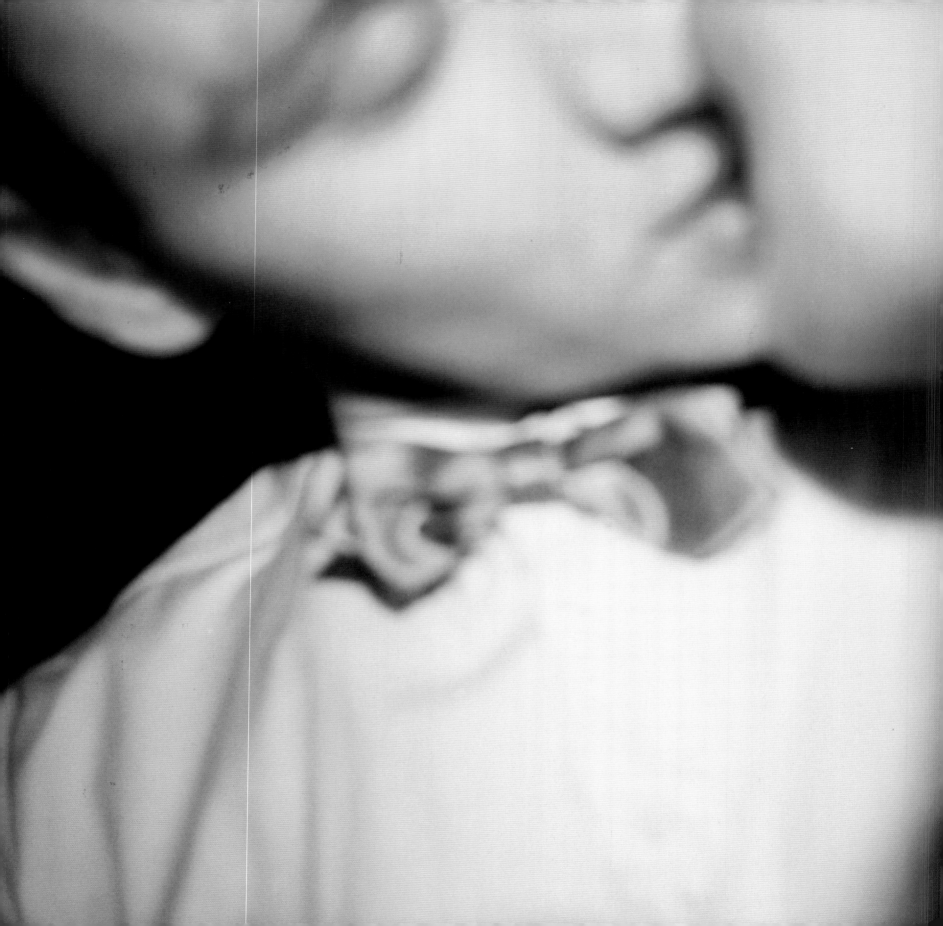

CHARLY KURZ | Frankfurt, Germany, 1994

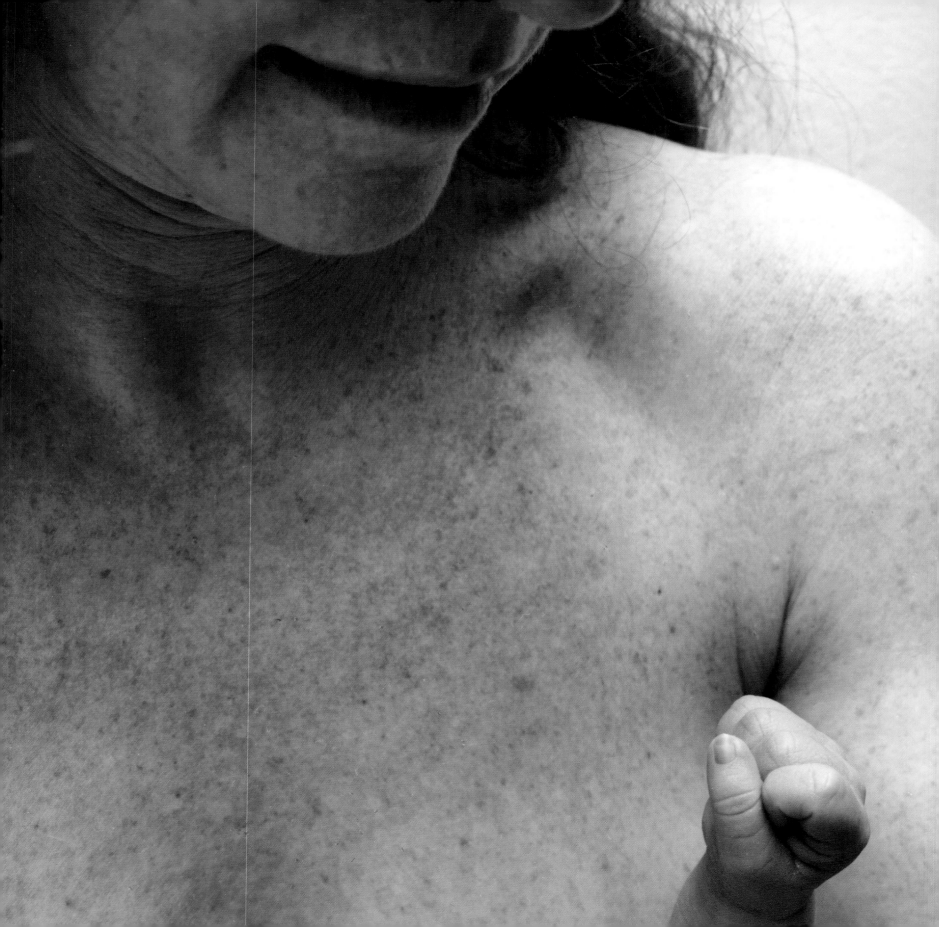

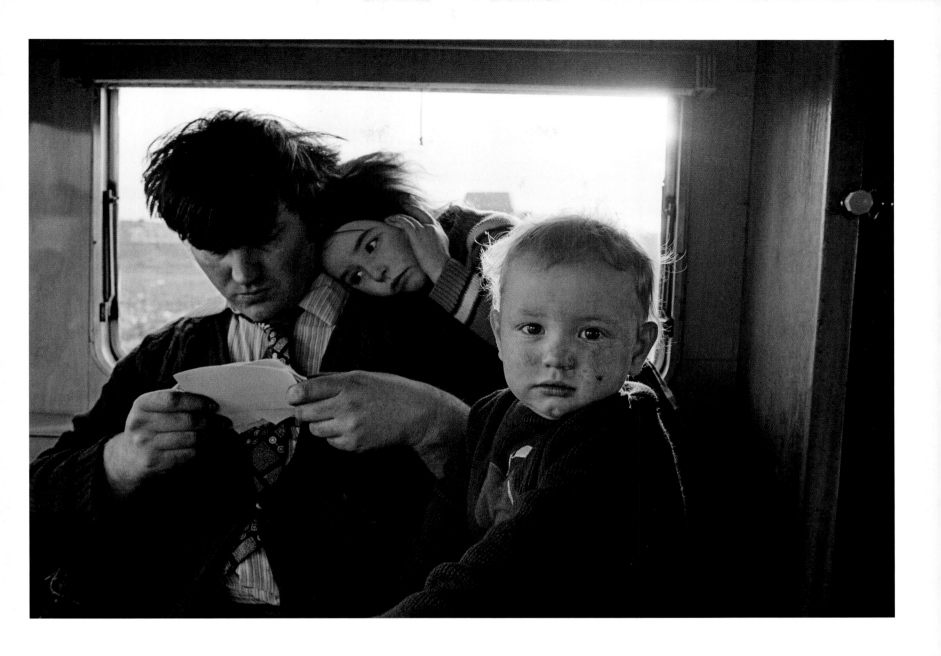

CHRIS STEELE-PERKINS | Middlesborough, England, 1975 | Family in camper
OPPOSITE: NICHOLAS NIXON | Cambridge, Massachusetts, 1985 | Bebe and Clementine

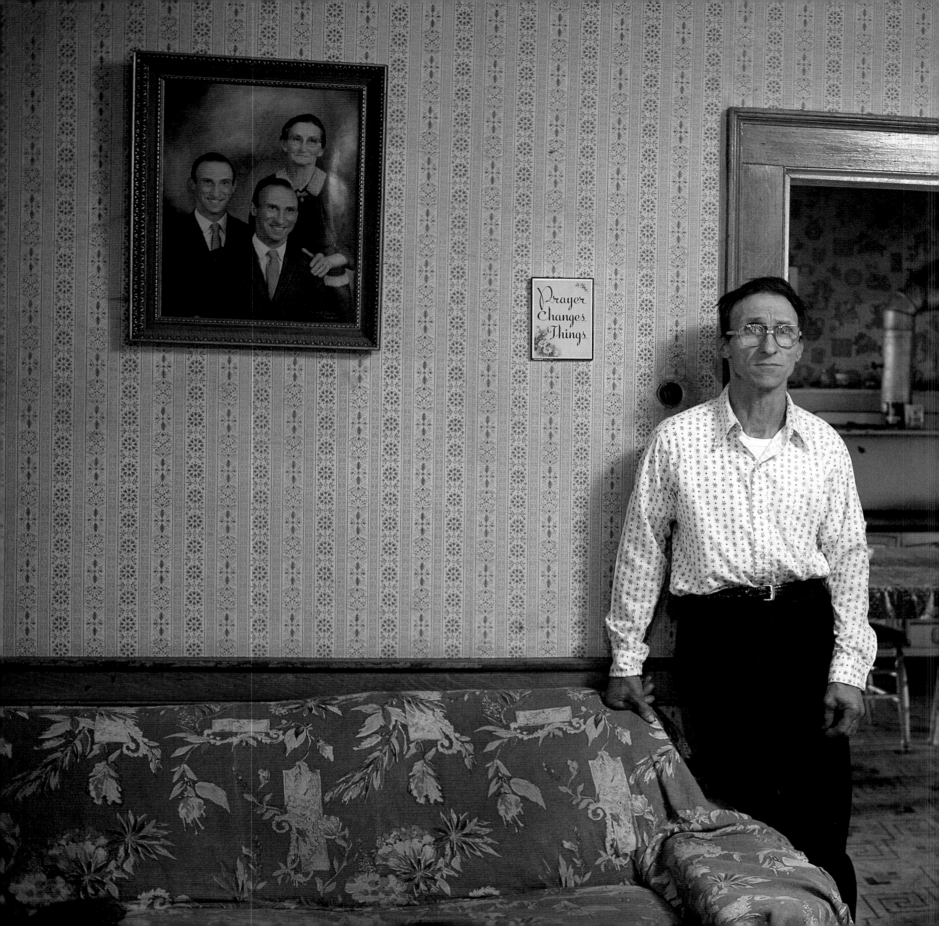

MICHAEL NICHOLS ❘ Phoenixville, Pennsylvania, 1982 ❘ Twins John and William Reiff

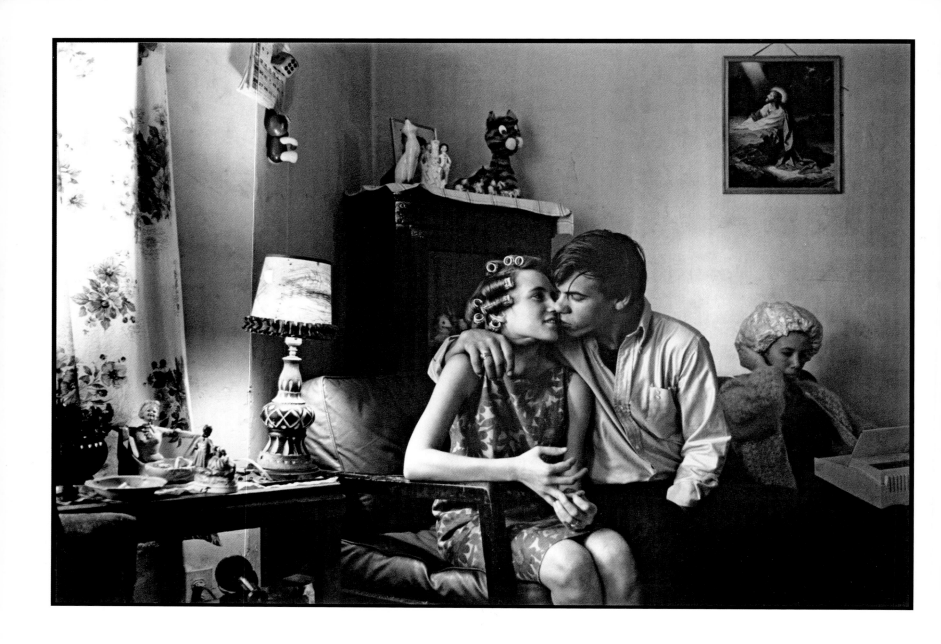

DANNY LYON I *Chicago, 1965* I *The kiss*

OPPOSITE: **HENRI CARTIER-BRESSON** I *New York, 1935* I *Jazz trumpeter Joe, with his wife, May*

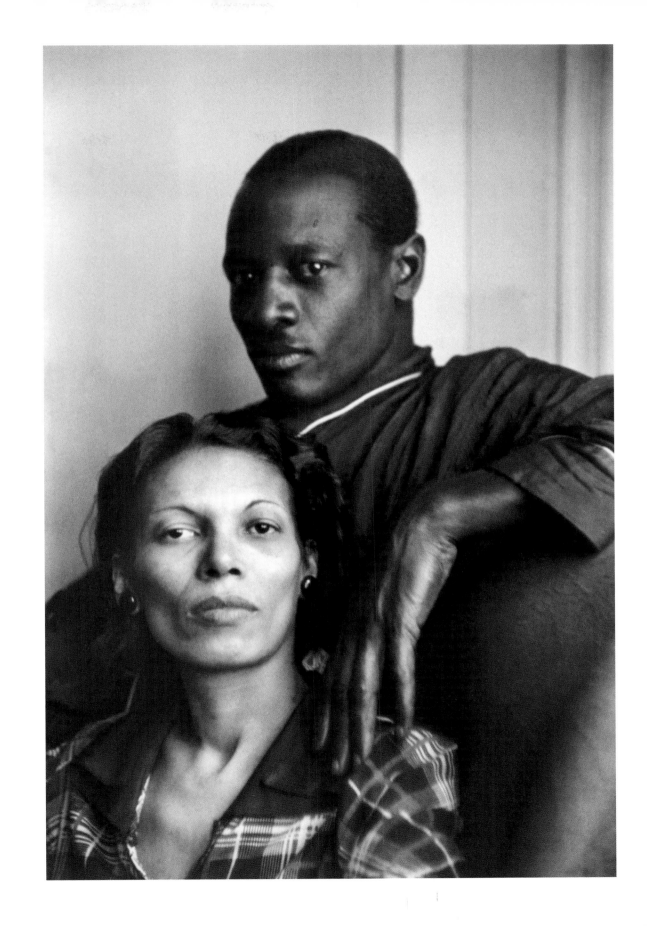

DAVID ALAN HARVEY | Costa Rica, 2001 | Chiquita Banana Company
OPPOSITE: **TRENT PARKE** | South Australia, 2006 | Backyard life

ELLIOTT ERWITT | California, 1955 | In the car

FOLLOWING PAGES, LEFT: **MARK LEONG** | China, 1998 | Rail journey

RIGHT: **SERGIO LARRAIN** | Colombia, 1964

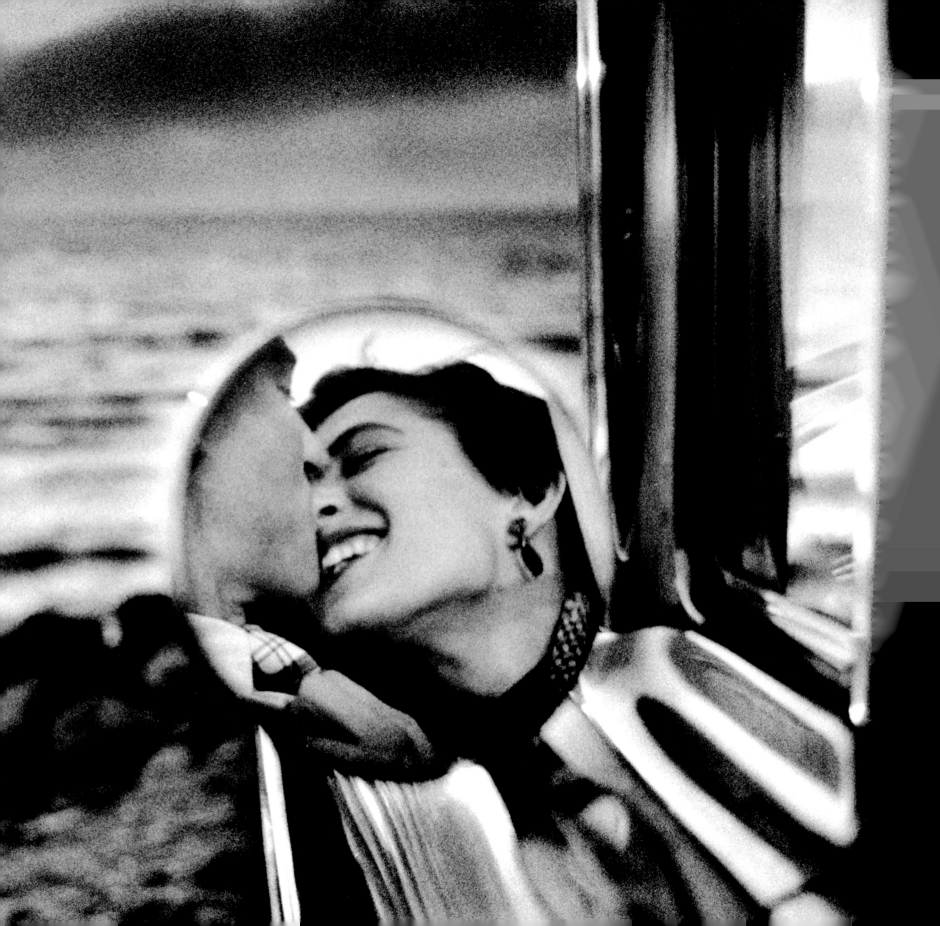

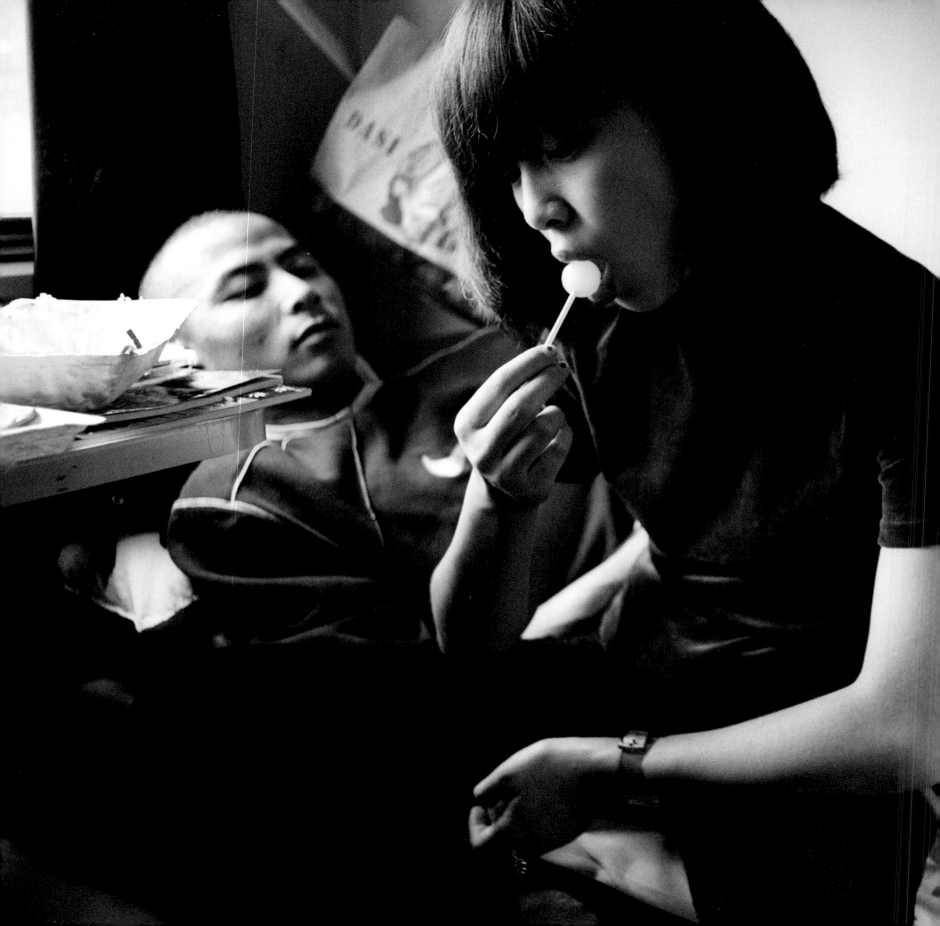

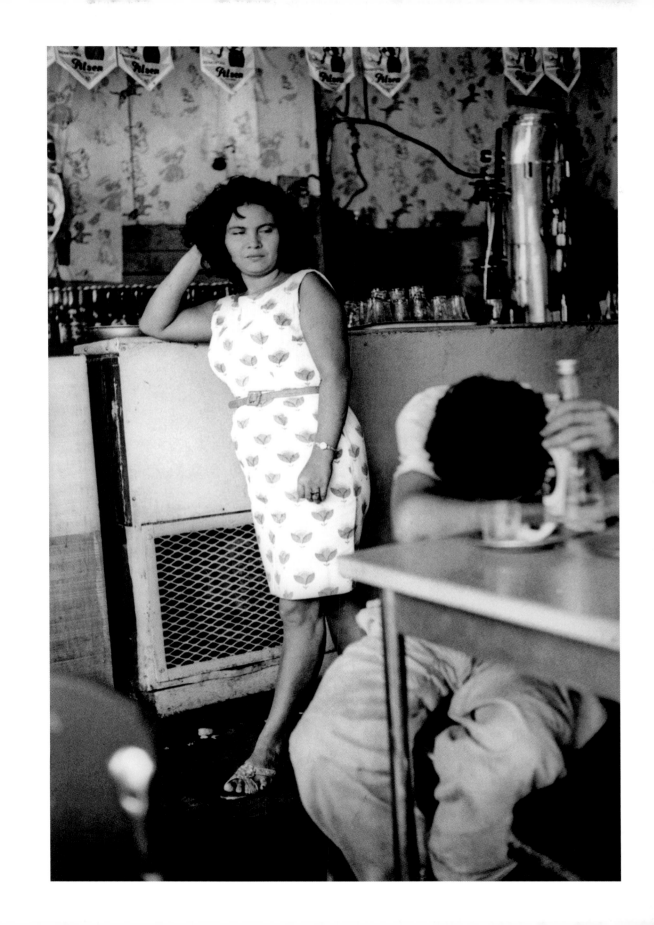

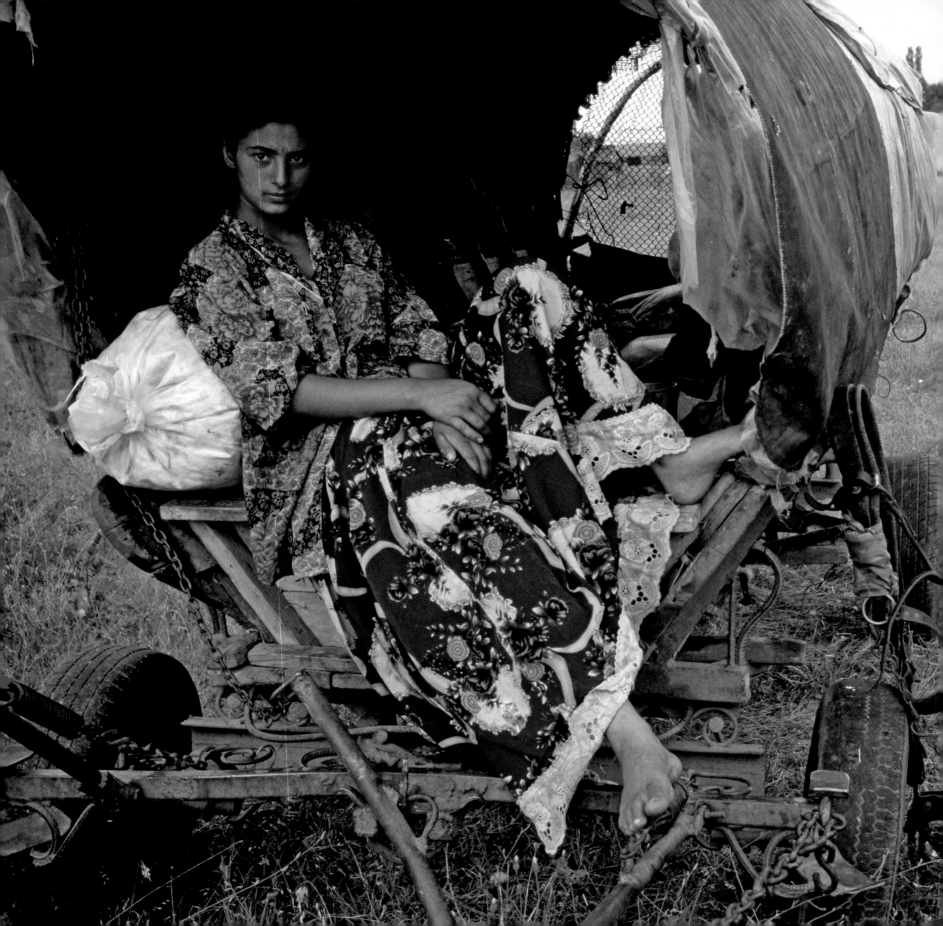

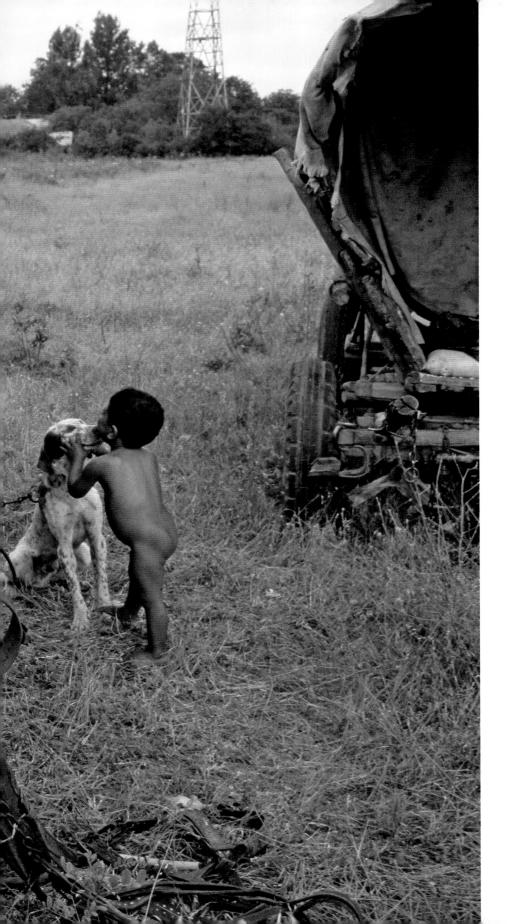

TOMASZ TOMASZEWSKI ❘ Romania, 1999 ❘ Gypsies

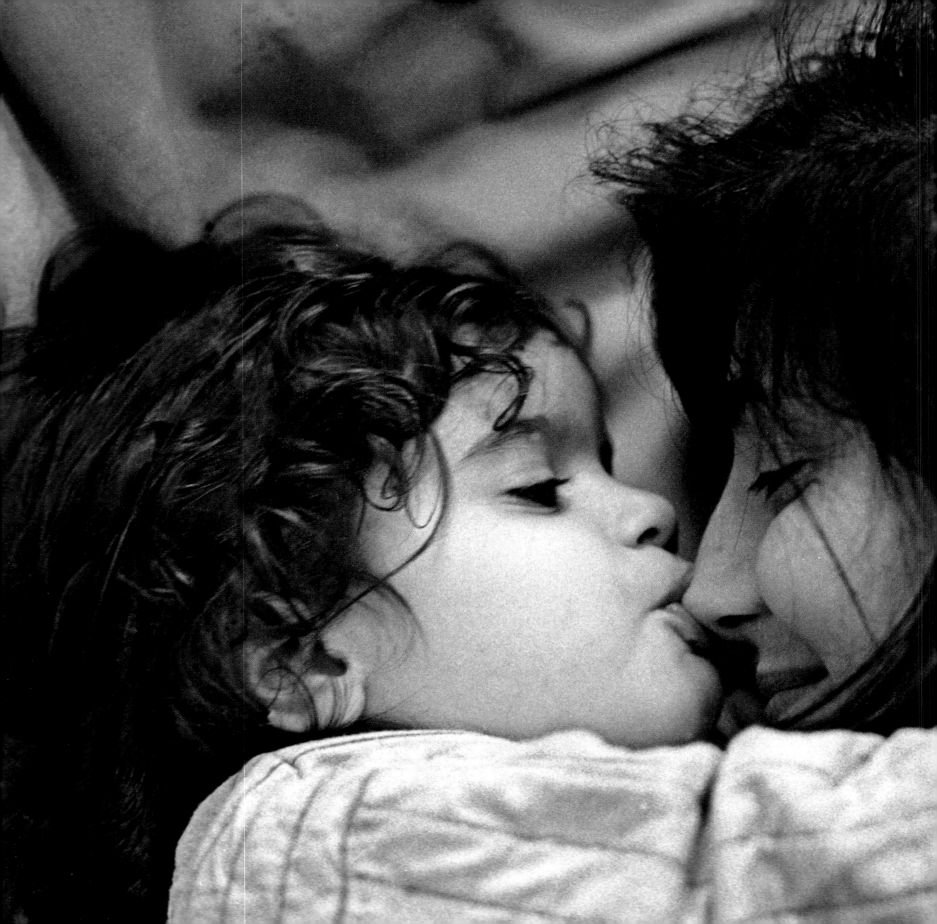

FERDINANDO SCIANNA | Milan, Italy, 1995 | Paolo and Nanà

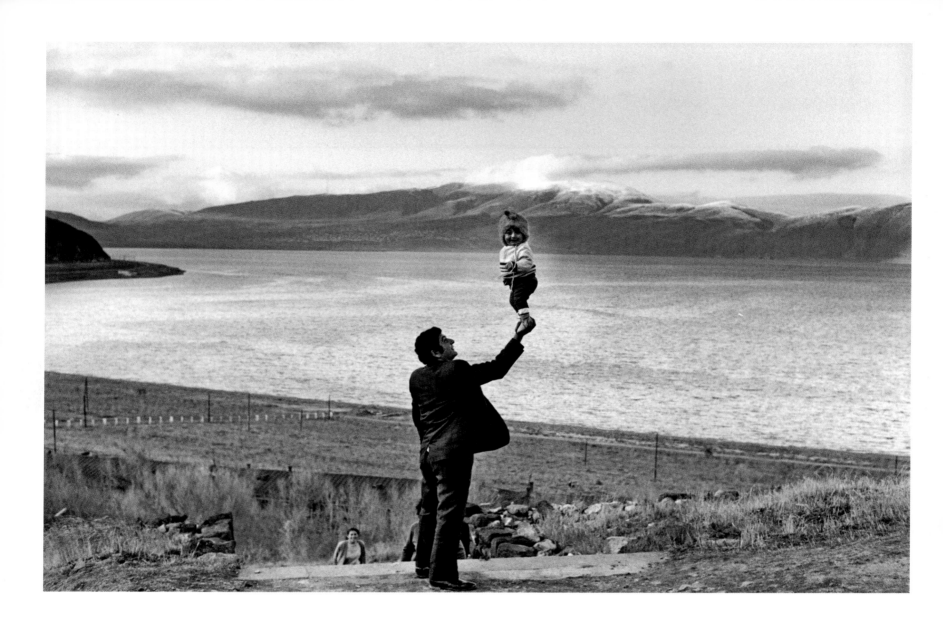

HENRI CARTIER-BRESSON | *Armenia, 1972* | Visitors at village on Lake Sevan

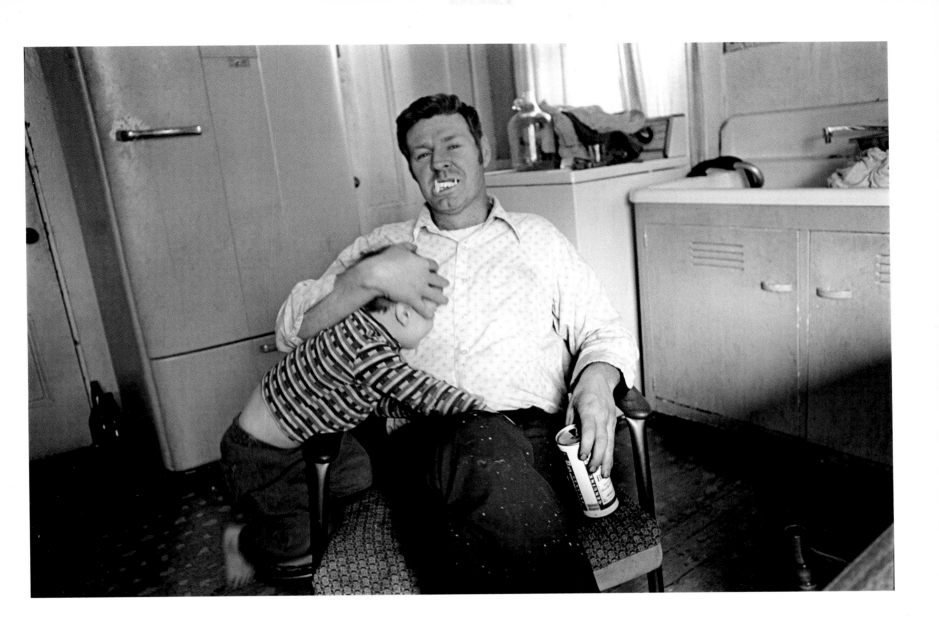

EUGENE RICHARDS | Dorchester, Massachusetts, 1978 | Freddy, wearing vampire teeth, with his son David

PETER MARLOW | London, 2004 | Royal Botanic Gardens at Kew

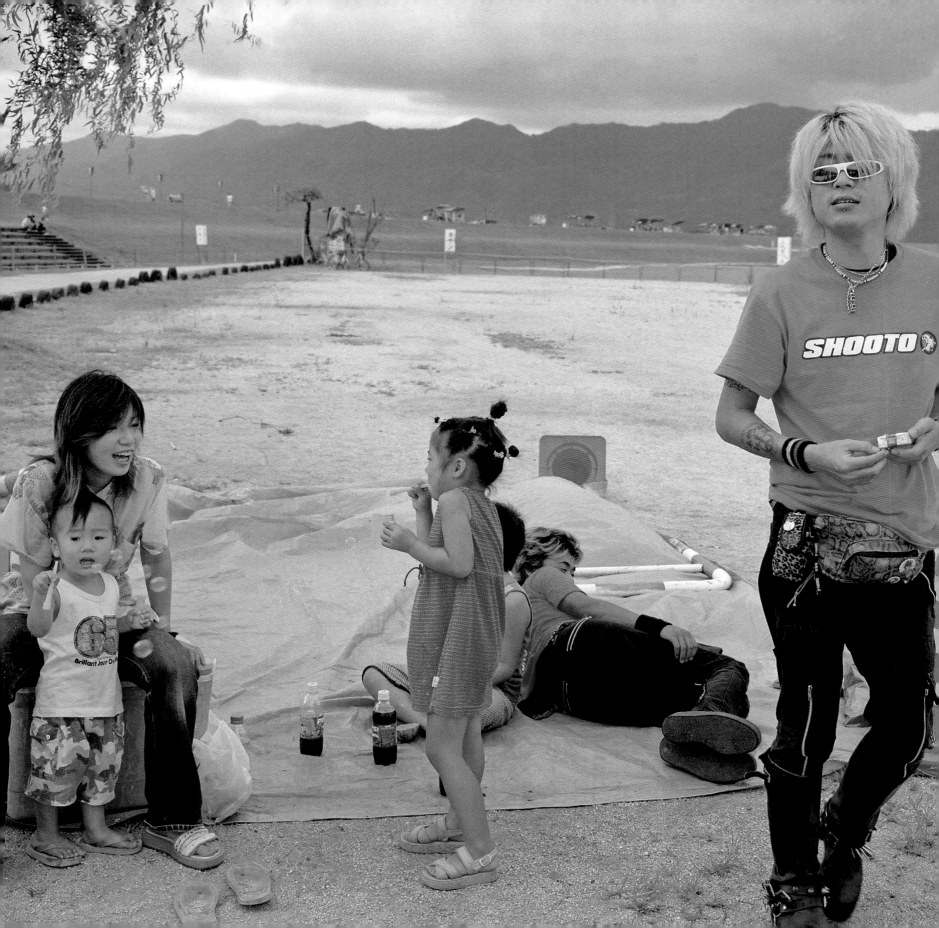

4 | TOMORROW |

There are no photos of the future for the simple reason that it hasn't happened yet. By that logic, there is no love in the future either. But logic does not prevent us from speculating that photography and love will be around when the future arrives. Tomorrow, as Little Orphan Annie sings in the musical *Annie,* is only a day away.

Exactly what tomorrow will bring is uncertain. But the odds are good it will look a lot like today, at least where photographs and love are concerned. The medium is still young, well shy of its 200th birthday, and growing fast. But even photo technology doesn't change that quickly. Love has been around much longer. It was here before the concept of time was developed and seems likely to remain one of the driving forces of human existence in the future.

Even if scientists announce tomorrow that they have unraveled the brain chemistry of love and can now see the synapses firing and the phero-mones being released as people fall for each other, love will remain a mystery. There are too many other variables affecting individuals' lives, too many stories playing out under that one title: love.

What, for example, were the odds that my father and mother, from Ohio and Pennsylvania, respectively, would end up working in a lab outside Philadelphia at the same time? Or that my dad would invite my mom to the company basketball team's season-ending banquet, where a co-worker would drink champagne from one of her shoes, and she would go home thinking her date was a great guy with a good sense of humor and wild friends? Who could have predicted they would marry, have chil-dren, and spend their lives together?

Such calculations are not impossible, but they do little to explain what love is. There is no concise definition that covers love's many facets, each of which we experience in our own way. Despite that, we'll keep trying to take its picture. The impulse to photograph love seems almost geneti-cally based now, a passion that is in us, and as the bluesman John Lee Hooker sings in "Boogie Chillen," "it got to come out."

Photography and love have a great deal in common. Both depend on the same source: sunlight. As psychologist Ada Lampert writes in her book, *The Evolution of Love,* "Love is the transfiguration of photons, eaten by plants, which are eaten by mothers who fondle their children and thus increase their blood levels of growth hormone and insulin and antibodies—all pre-requisites of survival. Evolution has made love a prerequisite, without which there is no life. Evolution has turned love into a subcontractor of the sun."

Photography, too, requires sunlight. That's why William Henry Fox Tal-bot had that now-famous oriel window installed in the South Gallery of Lacock Abbey. A look through that window today vividly illustrates how the pictures created by Talbot's "pencil of nature" have changed since he made his first, fuzzy, black-and-white image.

Thanks to the wonder of the Internet, we can see a recent photograph taken from almost the exact spot where Talbot stood. Warm sunlight

CHRIS STEELE-PERKINS **|** Japan, 2000 **|** Waiting for pop concert to begin

streams through the panes, setting an arrangement of houseplants aglow, and casting lattice shadows across the floor, giving it the appearance of a photographic negative. Outside, the trees and green lawn sloping to the River Avon look much as they must have during his lifetime. It is easy to imagine Matilda, Rosamund, and Ela, freed from the drudgery of sitting still for minutes on end in front of their father's camera, racing across the grass.

If we could somehow tell Talbot that all this is to be seen in full color, almost instantly, from just about anywhere on the planet, simply by clicking a mouse, he wouldn't know what to make of it. In his day, a mouse was a mere rodent and everyone knew they could not be clicked. After a little explanation, I think he would be thrilled, but not too surprised. Photography was already evolving rapidly during his lifetime.

In a letter written to her father on March 29, 1858, from Edinburgh, Scotland, where she was visiting with her mother and sisters, Rosamond Constance Talbot wrote of meeting a Mrs. Ross. "She and her husband have quite a passion for photography, and their room is full of views of the wildest scenes on their estate. Tilly, (Matilda Gilchrist-Clark, née Talbot) says she never saw a more perfect waterfall than one done by Mrs. Ross herself. She said to Mama, 'that they were so grateful to Mr. Talbot for his invention, as it was the delight of their existence.'"

In other words, Mr. and Mrs. Ross loved photography and used it to take pictures of a place they loved. Variations on that theme have been playing out ever since photography was invented, and you can bet your bottom dollar that they will be tomorrow.

Time is a central element in love and photography. In the latter, it is the moment being photographed, the length of the exposure, the timing of the developing and printing process, and the time spent considering the resulting image. Photography lets us seize the visual present, turn it immediately into the past, and take it into the future.

Time is also critical in love. We are the only creatures on the planet who can make and keep an appointment at a specific time with a loved one. And over time our ability to love grows and changes, as do our attitudes toward and ideas about love. As children, if we're fortunate, we come to know and feel maternal, parental, and familial love. In adolescence, we feel the stirrings of sexuality and begin experiencing the joys and heartbreaks of relationships with persons outside our families.

Then comes adulthood. Time and timing can be as important in developing love relationships as they are in photography. We talk about not having enough time for a serious relationship, or how it is time for us to find a spouse or a partner. We wonder when it will be our turn, our time, to fall in love, or if that time is ever going to come.

It usually does, often when we least expect it. As the cartoonist and humorist Lynda Barry noted, "If it is your time, love will track you down like a cruise missile. If you say, 'No, I don't want it right now,' that's when you'll get it for sure. Love will make a way out of no way. Love is an exploding cigar which we willingly smoke."

What will photographs of love look like in the future? Probably much like the portraits you see in this book and this chapter. We recognize love

most easily in faces, and we see faces most easily in portraits. While portrait photography has changed since William Henry Fox Talbot photographed Matilda and her sisters, most of it is still very much in line with Western pictorial tradition. The sitters, individuals, couples, or groups, face the camera and occupy the center of the picture plane, as in the photo Chris Steele-Perkins took in 2000 of a Japanese family—dressed in neon punk chic—waiting for a pop concert to begin in Shimane Prefecture.

In many countries, cultural and social mores have changed considerably during photography's lifespan. In modern, industrial countries there are more unmarried couples living together and, where marriage is concerned, statistics show that Barry's exploding cigar blows up about 50 percent of the time, the divorce coming on average around four years after the nuptials.

You never see divorce looming in wedding photos. Everyone looks happy. That is because an image conveyed by photons, fixed by chemicals, and printed on ground-up trees can only tell us how things looked at one point in time, and love keeps moving, shifting, evolving. It doesn't matter whether the person holding the camera is a brilliant artist or a bumbling amateur. In the future we will still be looking at couples—husbands and wives, boyfriends and girlfriends, same-sex couples, fathers and mothers—frozen for a moment in time.

Some of the pictures will be charming, some thought-provoking, some humorous. In the case of Martin Parr's photograph, taken in 1999, of a couple kissing in the town of Benidorm, Spain, as the woman holds a single red rose behind the man's back, all those elements are present.

At first glance, it looks like a classically, almost stereotypically romantic image of true love and Latin passion, fit for the greeting card hall of fame. But how true is love these days? Benidorm, on Spain's Costa Blanca about 45 kilometers northeast of Alicante, is a massively popular tourist destination, particularly for British and Irish vacationers. The place is a nature-lover's nightmare. Thickets of high-rise hotels and apartment blocks crowd the white sand beach along the Mediterranean and bars and restaurants fill the streets.

Summer in Benidorm is one big party, one big singles scene. The kissing couple looks fair-skinned and fairly sunburned, suggesting they hail from Cork or Manchester and are trying to get in as much sun and fun as they can while in Spain on a package holiday. No wedding ring is visible on the woman's right hand, where the band is usually worn in Europe. The stem of the rose, the green fuse that lights the flower, to borrow Dylan Thomas's words, explodes not into a bouquet, but a solitary blossom, suggesting passion on a budget.

Perhaps that is too cynical a take on Parr's photo. Someone else may see it as sweet, the couple as seizing the moment without shame or fear. As Shakespeare wrote in *Twelfth Night*: "What is love? 'tis not hereafter; / Present mirth hath present laughter; / What's to come is still unsure: / In Delay there lies no plenty; / Then come kiss me, sweet and twenty, / Youth's a stuff will not endure."

Love will endure, as it has through all the catastrophes and carnage the world has known. It is the force that keeps people going after horrible things befall them. In June 2002, Johann Rousselot photographed a

woman named Nerina and her boyfriend in the city of Sarajevo in Bosnia-Herzegovina. He juxtaposed the image of Nerina, smiling as she forms a peak with her hands atop her boyfriend's head, with a shot of their apartment house taken from the shell of a wasted building across the street.

Sarajevo was besieged and devastated during the ethnic clashes in the 1990s between Croats, Serbs, and Bosnian Muslims. The photograph is part of a series Rousselot did in Bosnia-Herzegovina showing young people whose sense of identity isn't tied to the country, the city, or their nationality, but to themselves. They fall in love, work to build better lives for themselves, a rising spirit he calls "beauty within the beast." By pairing the young people, such as Nerina and her boyfriend, with pictures of where they live or work, he creates a broader context and a fuller portrait of their lives and love.

Still, it is the faces of the subjects in these photos that draw us in more than the place or the background. The digital nightlife watering hole called "Remote," that Mario Tama photographed in New York City has that trendy techno look, but beneath the surface it is like any other nightspot, a place where people go to be seen and meet others. The two girls in the picture may be sending a text message or a photo. If it's a photo, most likely it is of someone's face.

Love comes through the eyes. That will be as true in the future as it is today. Human beings are drawn to beauty. But what is beauty? Defining it is almost as difficult as defining love. Each of us thinks we know beauty when we see it, but there is also a cross-cultural or universal dynamic at work. Regarding faces, scientific studies have shown that infants, when shown pictures of attractive and unattractive faces, as judged by adults, prefer the attractive ones. A ground-breaking study done in 1990, by Judith H. Langlois and Lori A. Roggman, of the Department of Psychology at the University of Texas, Austin, also showed that attractive faces are only average, meaning people judge faces to be attractive that favor characteristics—nose length, hair color, eye spacing, skin tone—close to the mean of a given population.

Do we instinctively survey the faces and calculate their mean in Olivier Cullmann's photograph from 2004, of three young people standing in front of a wall of blown-up portraits on a Friday evening in Tokyo's Shinjuku subway station? The same question applies to Jeffrey Aaronson's portraits from his project titled "Maybe It's You." His photographs are a product of the changes in social customs wrought by digital technology, an example of how people now use that technology to find love and companionship.

Aaronson began by reading personal ads on Craig's List, an online source used for posting many kinds of information, including job and classified ads. The personal ads are something like a dating or matchmaking service. He got the idea of contacting people whose ads resonated with him because the person sounded interesting or had a unique way of expressing themselves. But instead of asking them for a date, Aaronson asked the subjects if he could take their portrait and make an audio recording of them reading their ad aloud. We cannot hear the voices of these people, who come from New York City, Chicago, Las Vegas, and other American cities. But Aaronson's faces speak eloquently of the human need to connect, to find a soul mate.

That need to connect, to belong, to be part of something that goes beyond the confines of the self can be dangerous. It is the same impulse that prompts many young people in cities around the world to join gangs. These teenagers who don't have an established identity, sense of self, or calling, find comfort and security by banding together.

Simon Wheatley specializes in photographing underprivileged youth who live in council estates in London's suburbs, as well as those living in the drab suburbs of Dutch and French cities. Like Mary Ellen Mark, whose photo of James and Natasha Gurley kicked off the In Private chapter, Wheatley establishes a close relationship with his subjects. They know and trust him, as we see in the scene he caught in 2005, showing two boys banging chests in a playful ego battle in an East London council flat.

By contrast, Joachim Ladefoged's photograph of a couple kissing in a pedestrian tunnel in Shanghai, China, on December 4, 2004, falls firmly in the street-photography tradition of Cartier-Bresson and his peers. It also highlights how a society's attitude toward love can change. When Mao Zedong ruled China, public displays of affection were discouraged and rarely seen, even in crowded metropolitan areas. Now Shanghai is the epicenter of China's booming economy. Its population has swollen to over 20 million and ancient traditions are being eroded by the Western way of urban life. Couples kissing in pedestrian tunnels and subway stations are now a common sight, as they are in many countries.

That is understandable. Erotic love is a natural drive necessary to preserve and perpetuate human life. But there is also a spiritual beauty to love that is visible in the photographs in this book, particularly in the pictures of family, friends, and people worshipping.

In 1972, the National Aeronautics and Space Administration sent the Apollo 16 mission to the moon. Astronauts Charlie Duke and John Young landed on the lunar surface. Duke became the tenth man to walk on the moon. When he departed, he left something behind. It is the photograph you see, sealed in a plastic bag, lying on the moon dust. The photo shows Duke with his wife, Dottie, and their two sons.

What prompted him to do such a thing? Duke is said to be a man with a good sense of humor. But I cannot believe it was just a joke. Placing his family portrait there strikes me as an act of intense love, a way of saying you are with me and I am with you, on Earth, in heaven, now and forever.

That sort of action is what the monk/poet Thomas Merton wrote of in his essay *Love and Need*. Merton wrote, "Life curves upward to a peak of intensity, a high point of value and meaning, at which all its latent creative possibility goes into action and the person transcends himself or herself in encounter, response, and communion with another. It is for this that we came into the world—this communion and self-transcendence. We do not become fully human until we give ourselves to each other in love."

As long as human beings exist, they will be trying to find a way to give themselves to each other in love. Many will fail. Charlie Duke succeeded by taking a photograph of a photograph of the people he loved most. It is a picture of timeless, transcendent love conveyed by the light of the moon. ❧

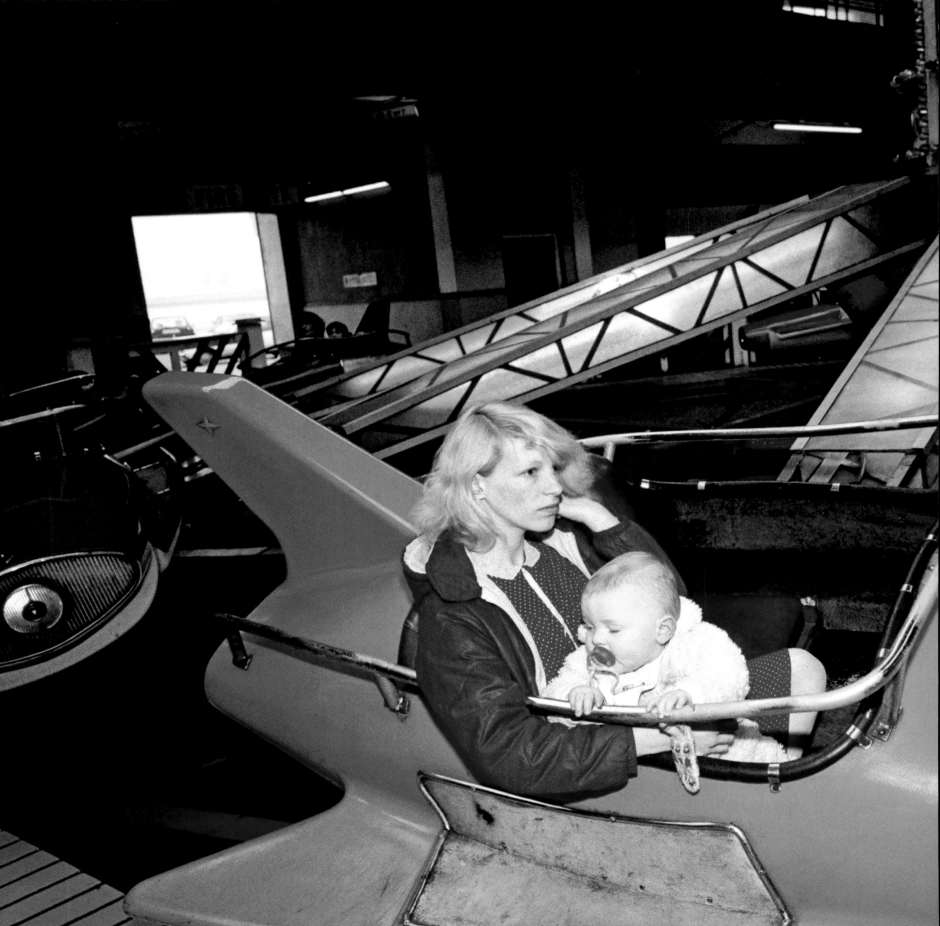

215

MARTIN PARR | New Brighton, England, 1985 | Amusement park ride

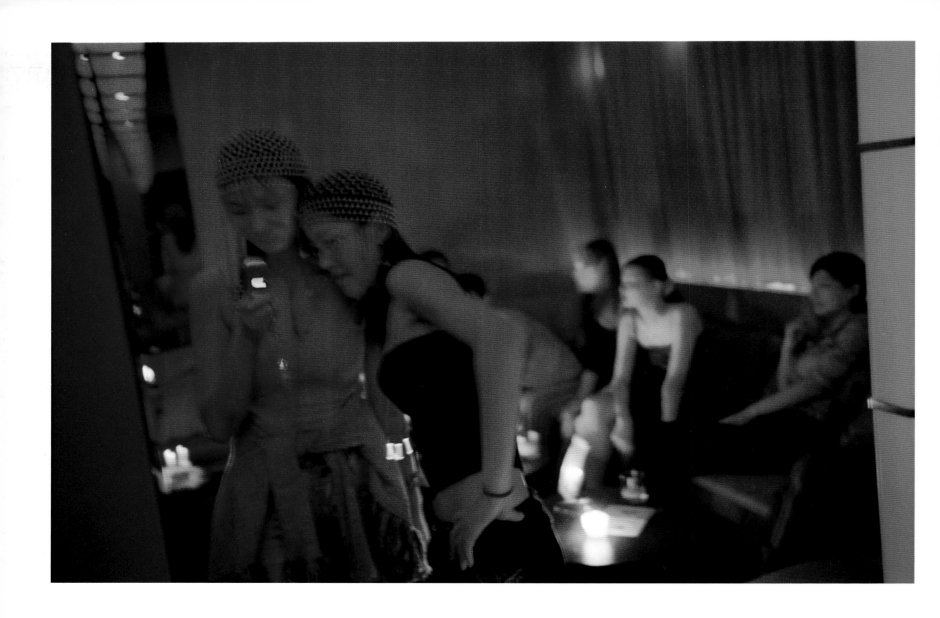

PATRICK ZACHMANN **I** Shanghai, China, 2002 **I** "California" night club

OPPOSITE: **PG I** Moscow, Russia, 1993 **I** Club for "sexual minority" groups

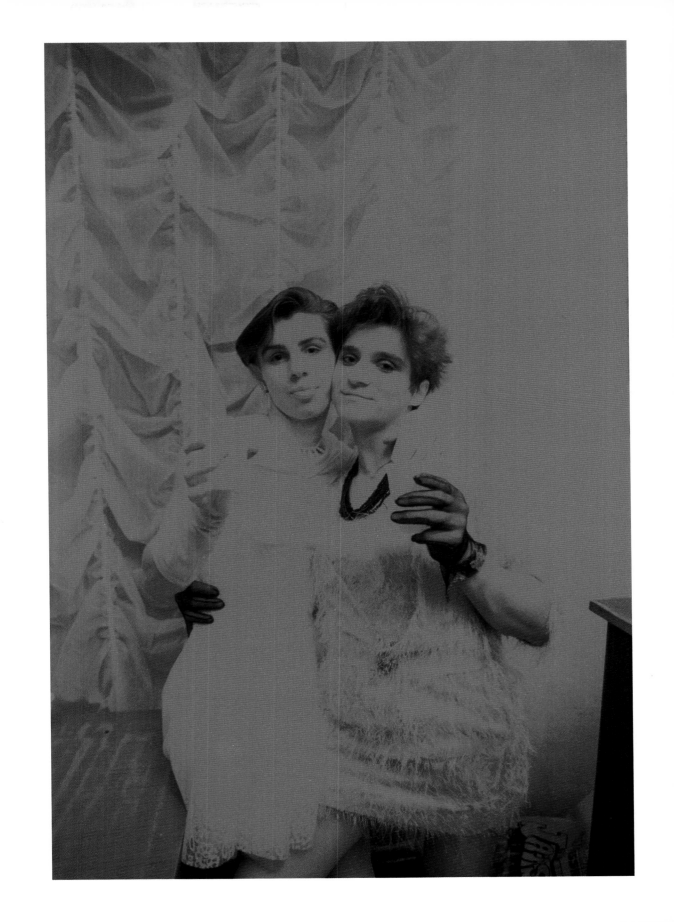

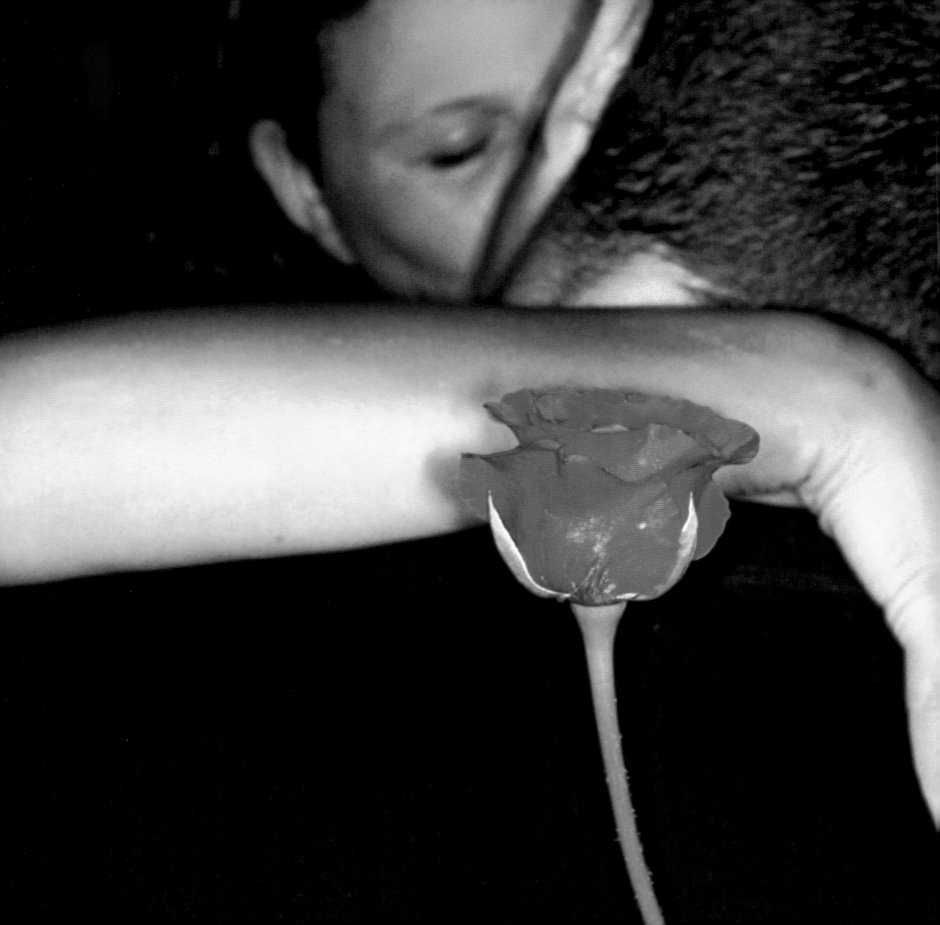

MARTIN PARR **I** Benidorm, Spain, 1999 **I** The rose
FOLLOWING PAGES: **JOHANN ROUSSELOT** **I** Sarajevo, 2002 **I** Nerina and her boyfriend

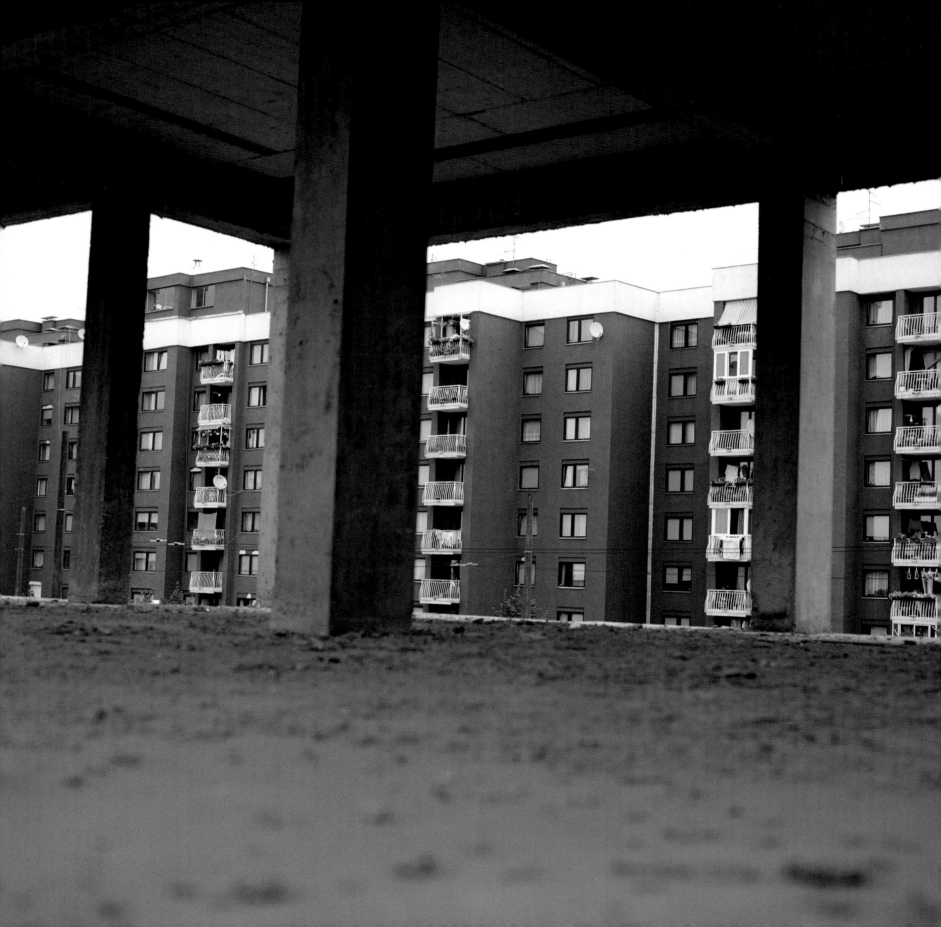

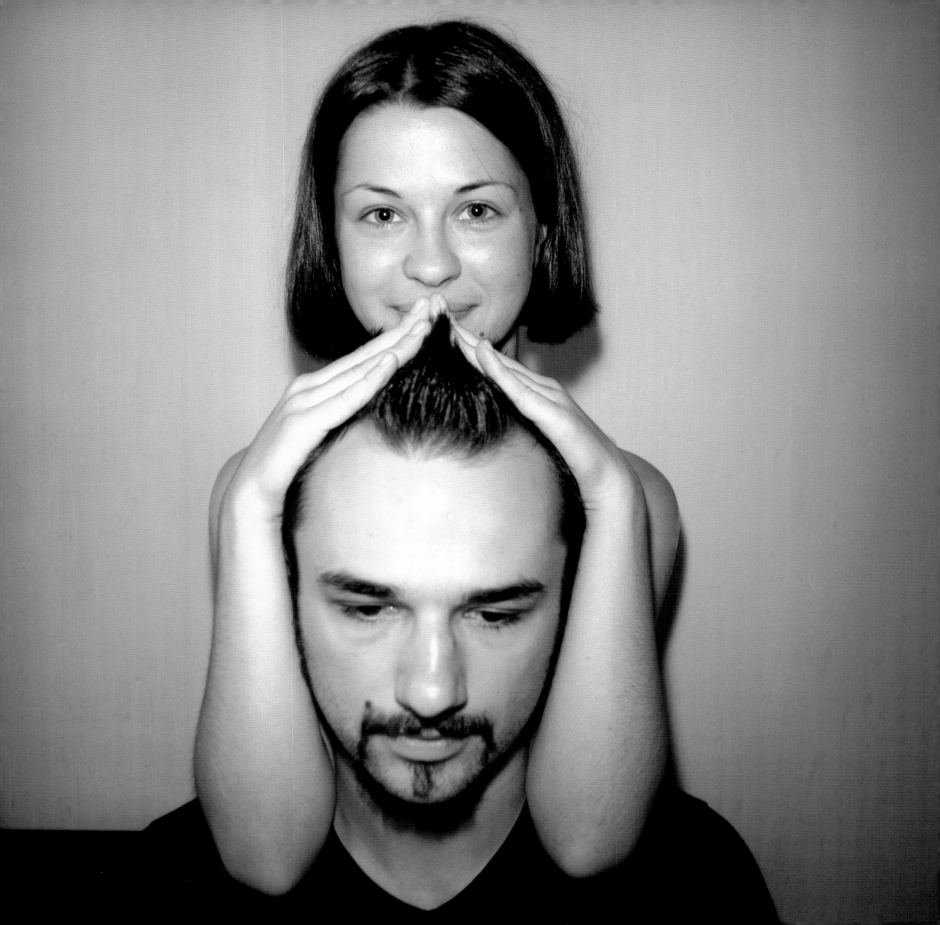

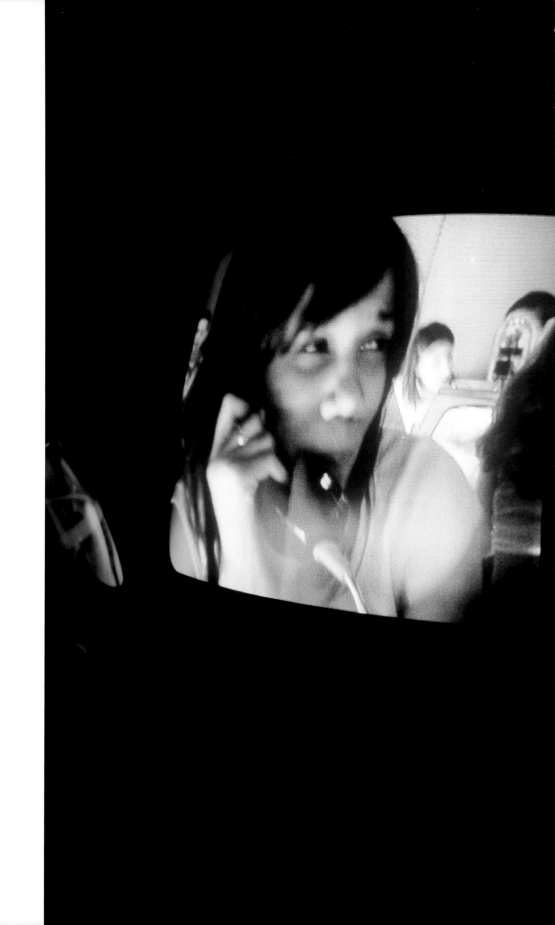

MARIO TAMA | New York City, 2002 | Digital nightlife lounge "Remote"

remote
 lounge

21 version 1.15

 A B C

 +

−

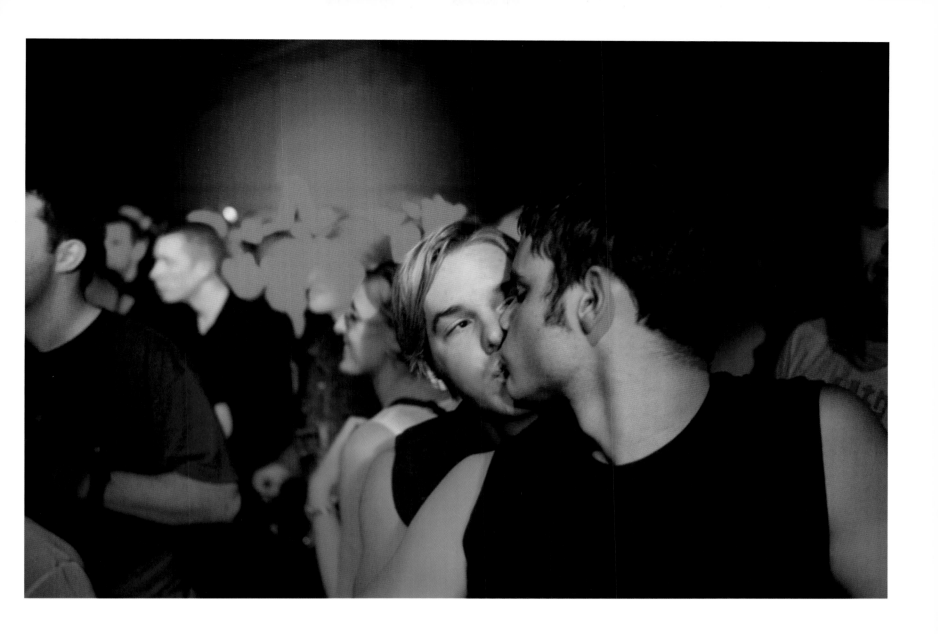

JOACHIM LADEFOGED | Shanghai, China, 2004 | Kisses in a pedestrian tunnel

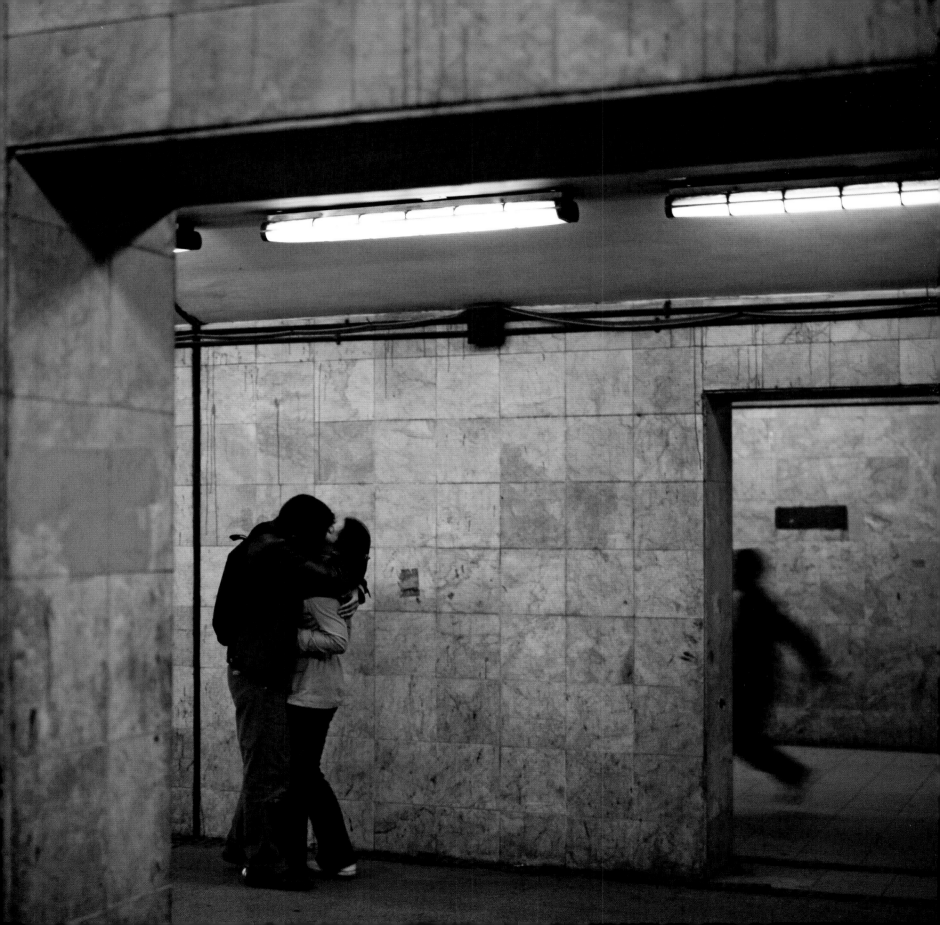

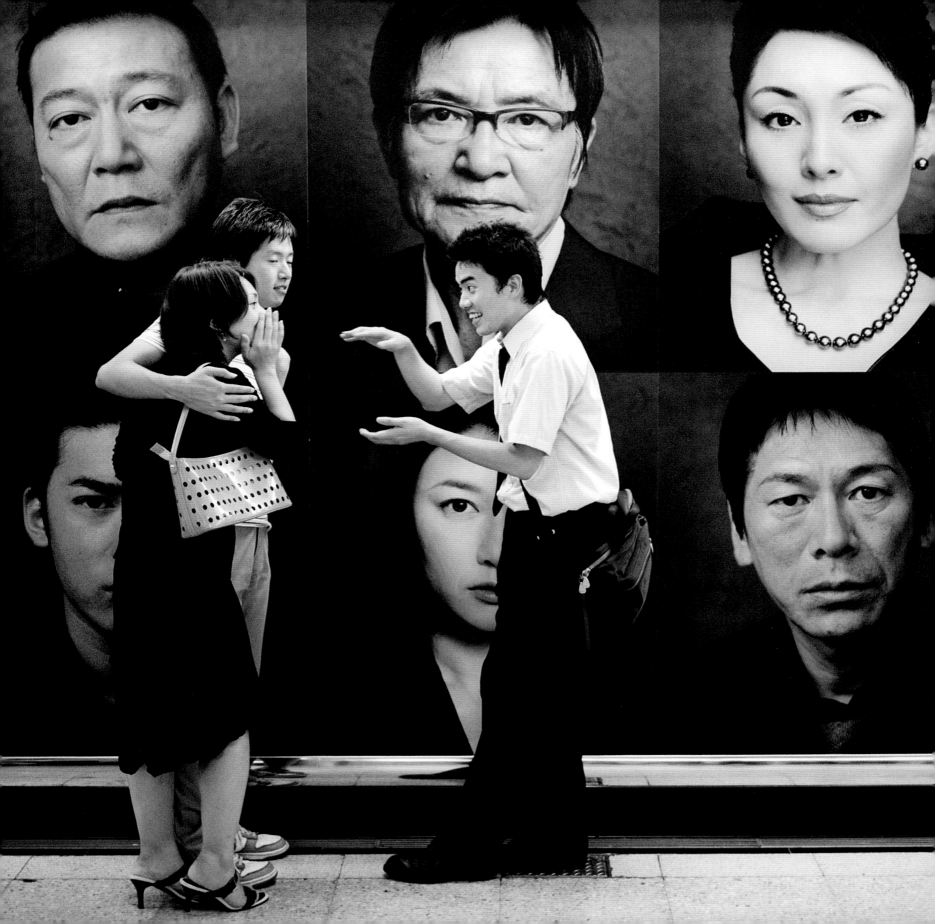

PRECEDING PAGE, LEFT: **OLIVIER CULMANN** | Tokyo, Japan, 2004 | Friday evening at Shinjuku subway station

RIGHT: **JEFFREY AARONSON** | U.S.A., 2006 | Portraits from "Maybe It's You"

NASA | The Moon, 1972 | Family portrait left on the lunar surface by Apollo 16 astronaut Charles Duke

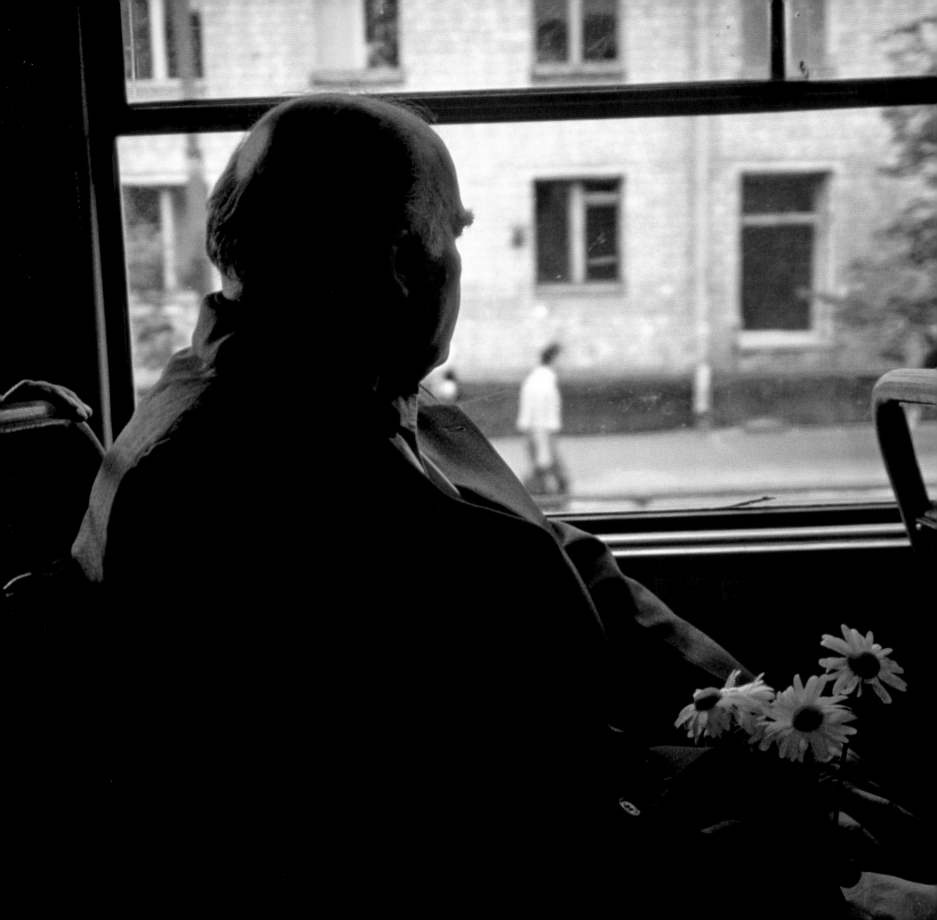

ACKNOWLEDGMENTS

In making this book, we considered the connection between love and photography and saw it everywhere, a fact that made the project both interesting and large. The team and friends who came together, in part by chance, to work on *LOVE* richly appreciated the possibilities. They put in a great deal of time and effort and also contributed to shaping the book conceptually and aesthetically in multiple ways. We extend our heartfelt thanks to Melissa Farris, Ferdinand Protzman, Bronwen Latimer, Kris Hanneman, Becky Lescaze, and Jeremy Felson for their work and their generosity. We express our special gratitude to Nora Taylor.

Leah Bendavid-Val
and Olivier Picard

SAM ABELL | Moscow, Russia | Bouquet of daisies

PHOTOGRAPHERS

JEFFREY AARONSON is an internationally recognized photojournalist who has worked on assignment for many of the world's prominent publications. His photographic project "Maybe It's You" spanned three centuries of photographic technology from camera to final print.

SAM ABELL has worked for the National Geographic Society since 1970, photographing more than 20 articles on cultural and wilderness topics for *National Geographic* magazine, and for several books. He has lectured on photography and exhibited his work to audiences throughout the world.

WILLIAM ALBERT ALLARD was born in Minneapolis in 1937. His milestone 1982 book about the West and the cowboy, *Vanishing Breed,* won awards, including the distinguished Leica Medal of Excellence for Outstanding Achievement. Allard has shot for the *National Geographic* magazine for over 35 years.

JANE EVELYN ATWOOD was born in New York in 1947, and relocated to France in 1971. She produced several published works, including *Exterieur Nuit* and *Too Much Time*, her landmark ten-year photographic study of female prisoners. In 1980 she became the first recipient of the W. Eugene Smith Award.

CARLOS BARRIA, born in Argentina in 1979, joined Reuters as a freelance photographer in 2000 and is currently a staff photographer based in Miami. Barria was awarded first prize in the 2002 World Press Photo General News category for his images of the social upheaval in Argentina in 2001.

EDOUARD BOUBAT's major photographic subject was his own city of Paris, where he was born in 1923. He became a permanent contributor to the monthly magazine *Réalités*, traveling to more than 30 countries. Each time, Boubat brought back images that were uniquely his, immediately recognizable by their elegance.

BILL BRANDT was born in Hamburg in 1904. His career began in Vienna, but he soon moved to Paris and assisted Man Ray. While freelancing in London, Brandt established his reputation as the great documentarian of British society. After the war, he returned to nudes, portraits, and landscapes.

BRASSAÏ Born in Brasso, Hungary, Gyula Halasz adopted the name Brassaï from his place of birth. After he moved to Paris, his subject of choice was the city at night. His photographic studies were published in 1933 in his famous book *Paris de nuit*.

ADAM BROOMBERG and **OLIVER CHANARIN** continue to produce work for the *Guardian*, the *Telegraph*, and *Men's Vogue*, and their long photographic partnership has won them many awards. They have produced four books displaying work from their solo exhibitions.

DAVID BURNETT became the last photojournalist from *Life* magazine to cover the Vietnam War. He also documented the coup in Chile, revolution in Iran, famine in Ethiopia, and the fall of the Berlin Wall. A regular contributor to *Time* magazine, he co-founded Contact Press Images in 1976.

DAVID BUTOW is a Los Angeles-based photojournalist who has reported from Asia, Africa, Europe, the Middle East, and South America. He has documented the unrest in Iraq and Afghanistan since 2003, and his coverage of Shanghai will be published in National Geographic *Traveler* in 2007.

ROBERT CAPA Labeled "The Greatest War Photographer in the World," Robert Capa gained international notoriety covering the Spanish Civil War. In 1947, alongside Henri Cartier-Bresson, David Seymour, George Rodger, and William Vandivert, Capa co-founded Magnum Photos, of which he became president in 1951. He fell victim to a land mine in 1954.

JULIA MARGARET CAMERON, born in Calcutta in 1815 and educated in England and France, is known for her creative effects and portraiture of notables such as Alfred Tennyson and Charles Darwin. She is considered one of the most original British photographers of the 19th century.

HENRI CARTIER-BRESSON Born in France in 1908, a young Cartier-Bresson developed visual language through painting. His concept of the "decisive moment," aided by his Leica camera, launched Cartier-Bresson's photographic career in 1932. He would later co-found Magnum Photos with Robert Capa and others in 1947.

MARTIN CHAMBI For more than 20 years, Chambi balanced his successful studio business with extensive travels outside of Cuzco to photograph archaeological sites, landscapes, and native peoples, thus combining two traditions—European art photography and documentation of his own indigenous culture.

CHIEN-CHI CHANG Alienation and connection are the subjects of much of Chang's work. His investigation of the ties that bind one person to another —and to society—draws on his own immigrant experience. Chang joined Magnum Photos in 1995. He lives and works in Taipei and New York City.

JOE CLARK's photographs of residents of historic Cumberland Gap appeared in *National Geographic* in 1943.

OLIVIER CULMANN In the 1990s, Olivier Culmann traveled the world for *Les mondes de l'école (School Worlds),* a project done in collaboration

with Mat Jacob and published in 2001. He has won awards for his post-9/11 documentation of the ruins of the World Trade Center and ghost towns in Namibia.

JULIEN DANIEL was born in 1970 and began his career in 1993. He became a member of the Oeil Public photographers' association in 1997. Daniel's freelance work has regularly been published throughout the French press, in publications such as *Liberation, Le Monde, L'Express,* and *Télerama.*

BRUCE DAVIDSON discovered photography on the streets of Oak Park, Illinois. Drafted as a soldier, he met Cartier-Bresson while stationed in Paris. Returning from military service, Davidson worked as a freelance photographer for *Life* magazine, and joined Magnum in 1959. Davidson continues to live and work in New York City.

RAYMOND DEPARDON A largely self-taught photographer from the age of 12, Depardon became co-founder and director of the Gamma photography agency. Between 1975 and 1977, Depardon's images from Chad won him a Pulitzer Prize. In 1978 he left Gamma to become a Magnum associate, becoming a full member the following year.

BERTRAND DESPREZ Desprez has been a member of Agence VU since 1999. He has worked with magazines such as *Jazz Hot, Jazz Mag,* and *Télérama,* creating series on jazz, teenagers, and Japan. While continuing to collaborate with the press, he has turned to more abstract works since 2000.

MIKE DISFARMER, born Mike Meyer, made portraits that captured the emotions of the residents of rural Heber Springs, Arkansas, in the 1930s and 1940s. His artistry has won him widespread critical acclaim.

ROBERT DOISNEAU was born in 1912 and began taking his first photos in 1929 with a camera he had borrowed from his half-brother Lucien. After WWII, he joined Rapho Agency and his photos began to be published in magazines such as *Life, Point de vue, Regards,* and *Picture Post.* Doisneau won the Kodak Prize in 1949, and the Prix Niepce in 1956.

CLAUDINE DOURY is a member of Agence VU and is represented by the gallery Camera Obscura in Paris. She is laureate of the Oscar Barnack award in 1999, of the World Press in 2000 for her work on Siberia, and of the Niepce award in 2004.

THOMAS DWORZAK Born in Germany in 1972, Dworzak began photographing Europe and the Middle East. After covering the war in the former Yugoslavia, he moved to Georgia, documenting conflicts in Chechnya, Karabakh, and Abkhazia until 1998. A Magnum member since 2004, Dworzak mainly covers conflicts following the 9/11 attacks.

WILLIAM EGGLESTON Raised in the Mississippi Delta, Eggleston began his career making black-and-white images, but soon abandoned them to experiment with color technology. The Museum of Modern Art's groundbreaking one-man show of 1976, "William Eggleston's Guide," established his reputation as the pioneer of modern color photography.

ELLIOTT ERWITT was born to Russian parents in Paris in 1928 and lived in Italy before immigrating to California. As a teenage photography enthusiast, Erwitt worked for a commercial darkroom in Hollywood. At Robert Capa's invitation, Erwitt joined Magnum in 1953, and continues to work for both journalistic and commercial outfits.

FRANK FOURNIER was born in France and began his career in 1975 in New York. Since becoming a member of Contact Press Images in 1982, he has photographed infants with AIDS in Romania, rape victims in the civil war in Bosnia, and the destruction of the World Trade Center on September 11, 2001. In 1986 he received the World Press Photo Premier Award for his portrait of a victim of the Nevada del Ruiz volcano's eruption in Colombia.

STUART FRANKLIN studied photography and film at West Surrey College of Art and Design. He also holds a B.A. and a Ph.D. in geography from the University of Oxford. During the 1980s he worked as a correspondent for Sygma Agence Presse in Paris, before joining Magnum Photos in 1985.

LEONARD FREED was born in Brooklyn, New York, to working-class Eastern European Jewish parents. Freed's work explores societal violence and racial discrimination, and his coverage of the American civil rights movement brought him initial distinction. Since joining Magnum in 1972, he has done work for the major international press.

PAUL FUSCO Born in Leominster, Massachusetts, Fusco worked as a photographer with the United States Army signal corps stationed in Korea from 1951 to 1953. After the war, he studied photojournalism at Ohio University, and worked in New York as a staff photographer with *Look* magazine. He joined Magnum Photos in 1974.

JEAN GAUMY Raised in the southwest of France, Gaumy began working as a writer and photographer for a local newspaper in Rouen while studying literature at university from 1969 to 1972. In 1973 he joined the Gamma photo agency; then, four years later, Magnum Photos.

BRUCE GILDEN With a degree in sociology and a childhood in Brooklyn, Gilden had a keen eye for observing urban behaviors and customs. After seeing Michelangelo Antonioni's film *Blow Up,* Gilden started to take night classes in photography at the New York School of Visual Arts. Gilden joined Magnum in 1998.

BURT GLINN studied literature at Harvard University, where he edited and photographed for the *Harvard Crimson* college newspaper. Later, Glinn worked for *Life* magazine before becoming a freelancer. In 1951 Glinn became one of the first Americans to enter Magnum Photos.

JIM GOLDBERG's work with various subcultures and his use of image and text are a landmark in the field. His photographs have appeared in *George, Esquire, Gear, Colours, Dazed and Confused,* and *Nest* magazines. Goldberg joined Magnum Photos in 2006.

HARRY GRUYAERT studied at the School of Cinema and Television in Brussels. He then began freelance fashion and advertising work in Paris while working as a director of photography for Flemish television. This experience sharpened his photographic sensibility, which he applied to projects around the world. He joined Magnum in 1981.

DAVID ALAN HARVEY Raised in Virginia, Harvey discovered photography at the age of 11. His 1966 book *Tell It Like It Is* documents a time during which Harvey lived with a black family in Norfolk, Virginia. Harvey went on to publish two other major books and shoot over 40 essays for *National Geographic* magazine.

GUILLAUME HERBAUT, born in 1970, is a founding member of l'Oeil Public. His work has won numerous awards, including the Kodak Critics Prize in 2001 and the Lucien Hervé Prize in 2004. He continues to photograph with the aim of revealing unseen tragedies.

BABBETTE HINES collects vernacular photography and is the author of *Photobooth,* a collection of more than 700 portraits taken in photobooths over the past 75 years.

KENNETH JARECKE joined Contact Press Images in 1986, earning a reputation as a maverick photographer with his images of student demonstrations in Tienanmen Square and his searing book from the first Gulf conflict, *Just Another War.*

CHRIS JOHNS was born in Oregon in 1951. Johns, who began his photography career as a staff member at the *Topeka Capital-Journal,* was named the National Press Photographers Association's Newspaper Photographer of the Year in 1979. He has shot numerous articles for *National Geographic,* and became the magazine's Editor-in-Chief in 2005.

KAREN KASMAUSKI is an award-winning journalist who has photographed 25 major stories for *National Geographic* magazine. Kasmauski specializes in putting a human face on scientific trends and global- change issues.

ANDRÉ KERTÉSZ was born in Budapest in 1894 and took his first photograph in 1912. In 1925 he moved to Paris to become a freelance photographer. His lyrical style garnered immediate success. After moving to New York in 1936, he spent what he termed as "lost years," but he rejuvenated his artistic career from 1962 until his death in 1985, winning widespread recognition for his role in the history of photography.

WILLIAM KLEIN was born in New York in 1928. He traveled to Paris in 1948 and has spent the past half-century in France. From 1955 to 1965 Klein shot fashion photography for *Vogue* to finance his photography projects and his work as an independent filmmaker. In 2003 Klein again published and exhibited in the United States to critical acclaim.

JOSEF KOUDELKA began in his teenage years to photograph his family and surroundings in the Czechoslovakian province of Moravia. Smuggled out of the country, his photographs were distributed by Magnum and published in the international press under the anonymous initials "P.P." Koudelka became a member of Magnum Photos in 1974.

ANTONIN KRATOCHVIL's fluid and unconventional work has been sought by many publications. His work has ranged from Mongolia's street children, shot for the Museum of Natural History's magazine, to the war in Iraq for *Fortune,* and portrait sessions with David Bowie, for *Detour,* and Deborah Harry, for the ACLU's national advertising campaign.

CHARLY KURZ is based in New York and Germany. He joined Lookat in 2003. His main interest lies in "the American way of life." Also fascinated by water and vessels, he covered the return of the former American-owned canal to Panama, moved on to "Toy City" Los Angeles, and now covers New York with his color, medium-format photography.

JOACHIM LADEFOGED In 1988, at age 17, Ladefoged got his first camera and soon became a newspaper photographer. In 2000 he published his book *Albanians,* about the turbulent life of the Albanians from 1997 to 1999. He has worked in more than 30 countries, winning international recognition for covering war, conflict, and ordinary life around the world.

SERGIO LARRAIN was born in Santiago de Chile in 1931. He studied music before taking up photography in 1949. In 1953, his first exhibition in Santiago de Chile led him to document the city's homeless children. He joined Magnum in 1959.

JOHN LAUNOIS was 17 when he began working as an assistant to *Life* magazine photographers in Paris; he was a photographer for the rest of his career. In 1972 he won the first World Understanding Award for his coverage of the Tasadays, a Stone Age tribe of Mindanao.

RUSSELL LEE Born in 1903, Lee began his career as a chemical engineer, but turned to painting and photography in 1935. After he joined the Farm Security Administration in 1936, Lee traversed the United States, documenting both rural and urban communities. Later in his career he worked for publications such as *Fortune* and the *New York Times Magazine*.

MARK LEONG first traveled to China in 1989 and has been photographing in Asia ever since. His pictures have appeared in *Time*, *Fortune*, the *New Yorker*, *Stern*, and *National Geographic*. He has received fellowships from the National Endowment for the Arts, the Lila Wallace Reader's Digest Foundation, and the Fifty Crows International Fund for Documentary Photography.

HERBERT LIST As a classically trained artist born into a prosperous merchant family in 1903, List began an apprenticeship as a Heidelberg coffee dealer in 1921 while studying literature and art history at Heidelberg University. In 1951 List met Robert Capa, who persuaded him to work as a contributor to Magnum.

DANNY LYON Self-taught in photography, Lyon documented the civil rights movement as a staff photographer for the Student Nonviolent Coordinating Committee in the 1960s. He immersed himself in and participated in the subjects he covered and won recognition as a photographer and filmmaker for his work on bikers, prison convicts, and abandoned children.

ALEX MAJOLI was born in Italy in 1971. He joined the f45 studio in Ravenna at the age of 15. In 1990 he joined Grazia Neri agency, producing photographic narrations about religions in Italy and the Balkan wars. A Magnum member since 2001, Majoli lives and works in New York and Milan.

MARY ELLEN MARK has achieved worldwide visibility through her numerous books, exhibitions, and editorial magazine work. She is a contributing photographer to the *New Yorker* and has published photo essays and portraits in such publications as *Life*, *New York Times Magazine*, *Rolling Stone*, and *Vanity Fair*. Her images of our world's diverse cultures have become landmarks in the field of documentary photography.

PETER MARLOW was born in 1952. His work in Lebanon and Northern Ireland in the 1970s brought him wide recognition and distinction as an international photojournalist. Regarded as one of the most enterprising and successful British news photographers, Marlow joined the Sygma agency in Paris in 1976, and Magnum Photos in 1981.

STEVE MCCURRY, recognized as one of the world's finest image-makers, has won many of photography's top awards. Best known for his evocative color images, McCurry endeavors to capture the essence of human struggle and joy in the finest documentary tradition. Many of his photographs have become modern icons.

JOEL MEYEROWITZ was born in New York in 1938 and began photographing in 1962. His early advocacy of color photography was influential in creating widespread acceptance for the new medium. Meyerowitz's award-winning work has appeared in over 350 exhibitions around the world.

DUANE MICHALS was born in Pennsylvania in 1932. During the 1960s he developed a unique visual style, using sequences of images with handwritten notes to tell narrative stories. While balancing fragility and strength, gravity and humor, Michals explores universal themes such as love, desire, memory, death, and immortality.

WAYNE MILLER Born in Chicago in 1918, Miller worked part-time as a photographer while studying banking at the University of Illinois. After serving as a lieutenant in the U.S. Navy, Miller won two consecutive Guggenheim Fellowships. His renowned work includes *Chicago's South Side, 1946-1948*. Miller joined Magnum Photos in 1958.

GEORGE F. MOBLEY's assignments for National Geographic have taken him to the Arctic, China, Africa, and the Amazon. While a staff photographer for NGS, he made the first authorized photograph of the U.S. Senate in session. His pictures illustrate the books *The Great Southwest* and *Alaska*.

MICHAEL NICHOLS was born in Alabama in 1952. His first exposure to photography came when he was assigned to the photography unit as an Army draftee in the early 1970s. Nichols later studied his craft at the University of North Alabama. His work has appeared in such publications as *National Geographic*, *Rolling Stone*, *Life*, *American Photographer*, *Stern*, and the *New York Times Magazine*.

NASA Charles M. Duke, Jr., put a snapshot of his family on the lunar surface and took a photograph of it during the Apollo 16 mission in 1972.

NICHOLAS NIXON, born in 1947, is known for the ease and intimacy of his large-format photography. Nixon has photographed porch life in the rural South, schools in and around Boston, cityscapes, sick and dying people, the intimacy of couples, and the ongoing annual portrait of his wife, Bebe, and her three sisters (which he began in 1975).

RANDY OLSON, Magazine Photographer of the Year for 2003 in the Pictures of the Year International competition, has spent the past dozen years working for National Geographic in places such as the Siberian Arctic, Africa, Iraq, Pakistan, India, Thailand, Newfoundland, Guyana, American Samoa, Turkey, Republic of Georgia, Australia, and the South Pacific.

BILL OWENS Born in 1938, Owens is a photographer known for his classic 1972 book *Suburbia*. Owens's images have been published in *Life* and *Newsweek*. He continues to work on digital movies and new book projects.

TRENT PARKE was raised in Newcastle, New South Wales, Australia. At 12 years old Parke started photographing with his mother's Pentax Spotmatic and using the family laundry room as a darkroom. Parke has one of the most vivid visual signatures in Australian photojournalism. He is the only Australian photographer represented by Magnum.

MARTIN PARR was born in Epsom, Surrey, in 1952. Encouraged by his grandfather, Parr studied photography at Manchester Polytechnic. He has since worked on numerous photographic projects that showcase his provocative photographic style. He became a member of Magnum in 1994.

ADM. ROBERT E. PEARY Born in Pennsylvania in 1856, Peary joined the U.S. Navy in 1881. He became fascinated with the Arctic, making multiple expeditions to Greenland and the North Pole. He studied the Inuit people he encountered and photographed their way of life.

PAOLO PELLEGRIN Known for his ability to traverse distinct subjects and themes within photography, Pellegrin studied architecture before discovering his passion lay in photography. He maintains an eye for images that are both spare and dramatic. Pellegrin joined Magnum in 2001.

DARIO PIGNATELLI was born in 1977 and lived in Brussels until age 18. He moved to Italy to study political science, but decided instead to follow his passion for photography. Since 2003 Pignatelli has lived in Rome, collaborating with publications such as *The Messenger*. Pignatelli seeks and finds the human side of every situation he photographs.

GUEORGUI PINKHASSOV A young photography enthusiast, Pinkhassov studied cinematography at the Superior Institute of Cinematography in Moscow. After serving in the military, he worked in a camera crew and later as a still photographer for the film studio Mosfilm. Pinkhassov moved to Paris in 1985 and joined Magnum in 1988.

SYLVIA PLACHY was born in Budapest and lives in New York. Her photographs have been published in numerous magazines. She is a Guggenheim fellow and the recipient of the Lucie Award. Her most recent books are *Self Portrait with Cows Going Home* and *Goings On About Town*.

JUAN MANUEL CASTRO PRIETO Born in 1958 in Madrid, Prieto studied science and has always been a lover of photography. He reconciled his two passions by becoming one of the most subtle and skillful European photographic printers. But any time he is not in the darkroom, he explores different approaches and techniques to photographic projects including landscapes, people, and untouched cultures.

TONY RAY-JONES, born in 1941, was one of the foremost observers of British life. In the mid to late 1960s he created a sardonic and surreal portrayal of the seaside resorts, customs, and festivals of England. Although he died prematurely, his work was a major influence on the independent photography movement in Britain that followed.

EUGENE RICHARDS studied photography with Minor White at MIT. He is best known for his books and photo essays on such diverse topics as breast cancer, drug addiction, poverty, emergency medicine, pediatric HIV and AIDS, the meat-packing industry, the plight of the world's mentally disabled, and aging and death in America.

JOHANN ROUSSELOT Born in Brussels in 1971, Rousselot studied photography at the "75" (High School of Imaging). Rousselot has been a member of l'Oeil Public agency since 2001 and has won awards including the 2003 French Kodak Photography Award for his coverage of youth in the Balkans region and grants for his projects on the new economic face of India and the dazzling worldwide expansion of American evangelicals.

AUGUST SANDER Born in Germany in 1876, Sander developed an interest in photography as a young man. His work covered a broad range of subjects, encompassing portrait, architectural, landscape, industrial, and still-life photography. Sander established a studio in Cologne and embarked on the photographic work in the Westerwald that yielded important material for his landmark opus, *People of the 20th Century*.

FERDINANDO SCIANNA started taking photographs while studying literature, philosophy, and art history at the University of Palermo. He began to systematically photograph the Sicilian people and their festivities using dramatic light and dark shadows, similar to the Italian neo-realist film movement. Scianna joined Magnum Photos in 1982.

DAVID SEYMOUR David Szymin (later Seymour) was born in Warsaw in 1911 to a family of publishers. Adopting the nickname "Chim," Szymin began working as a freelance photographer. His work began to appear regularly in the newspaper *Paris-Soir* and in *Regards*, one of the first illustrated magazines. Szymin was one of the founding members of Magnum.

ALEC SOTH became a nominee of Magnum Photos in 2004. Based in Minneapolis, Minnesota, he has received fellowships from the McKnight

and Jerome Foundations and was the recipient of the 2003 Santa Fe Prize for Photography.

CHRIS STEELE-PERKINS was born in Rangoon in 1947 and moved to London with his family at the age of two. At the University of Newcastle-upon-Tyne, he studied psychology and worked for the student newspaper. In 1971 Steele-Perkins moved on to freelance photography in London. He joined Magnum in 1979.

DENNIS STOCK was born in New York City in 1928. Evoking the spirit of America through his memorable and iconic portraits of Hollywood stars, Stock is also known for his portraits of jazz musicians and California in the 1960s. Joining Magnum in 1951, Stock has lectured, conducted workshops, and produced and displayed work almost every year since the 1950s.

TOM STODDART has photographed many of the world's major events throughout his distinguished career. From the fighting around the Palestinian refugee camps in Beirut during the 1980s to his documentation of the siege of Sarajevo between 1992 and 1995 to his most recent work covering the AIDS pandemic in sub-Saharan Africa, he has consistently created images that take the viewer close to the heart of the matter.

WILLIAM HENRY FOX TALBOT was born in England in 1800. His research in the mid 1830s led to the positive-negative processes, the basis of most photography of the 19th and 20th centuries. His work in the 1850s in photomechanical reproduction led to the photogravure and halftone printing processes.

MARIO TAMA studied photojournalism at Rochester Institute of Technology, graduating in 1993. He has covered President Clinton's impeachment, the 2000 presidential campaign, a grant project on land mine victims in Cambodia, and humanitarian issues in Mexico and Cuba. In 2001 he joined Getty Images as a staff photographer. His photographs have appeared in *Time*, *Newsweek*, *U.S. News & World Report*, the *New York Times*, the *International Herald Tribune*, the *Guardian*, and *Le Monde*.

TOMASZ TOMASZEWSKI, a freelance photographer, was born in Poland in 1953. He started his photographic career with Polish magazines and worked with *Solidarity Weekly*, as well as the underground press. His pictures have appeared in *Stern*, *Paris Match*, *Geo*, *Time*, *U.S. News & World Report*, and the *New York Times*. Tomaszewski is a regular contributor to *National Geographic*.

PATRICK TOURNEBOEUF portrays men by photographing the traces they leave behind them, the places they bring to life, and, sometimes,

the places they abandon. Using a large-format camera, he has documented the everyday life of French naval recruits, seaside resorts out of season, and historic monuments such as the Chateau de Versailles and remnants of the Berlin Wall.

PEKKA TURUNEN A native of Finland, award-winning photographer Turunen has had solo exhibitions in Canada, Denmark, Sweden, Russia, Germany, France, and his homeland since 1991.

ALEX WEBB was born in San Francisco and became interested in photography in high school. His work, especially from Latin America and the Caribbean, has been displayed at the Whitney Museum of American Art, the High Museum of Art, and the Museum of Contemporary Art, San Diego. He joined Magnum Photos in 1979.

WEEGEE, born Arthur Fellig, is known primarily for his tabloid photographs of New York crime scenes and urban grit. Weegee began his career with Acme Newspictures in the mid 1920s. He was the first photographer to be granted a permit for a shortwave radio to listen to police and fire frequencies. He later worked in Hollywood and experimented with abstract images.

SIMON WHEATLEY Born in Singapore in 1970, Wheatley was raised in the U.K., graduating from Manchester University in 1993. Wheatley has focused on marginalized urban areas and issues of youth and urban regeneration. Wheatley joined Magnum in 2005 and is still based in the United Kingdom.

GARRY WINOGRAND was born in New York in 1928, where he lived and worked during much of his life. Winogrand photographed the visual cacophony of city streets, people, rodeos, airports, and animals in zoos. Winogrand was the recipient of numerous grants, and his work has been the subject of many museum and gallery exhibits and published monographs.

PATRICK ZACHMANN A freelance photographer since 1976 and member of Magnum Photos since 1990, Zachmann has dedicated himself to long-term projects that bring to light the complexity of the identity and culture of the communities he investigates. His work explores themes of immigration and cultural and social fragmentation.

GUILLAUME ZUILI has dedicated himself the past few years to the exploration of urban landscapes. Using double exposures in black and white, he has created portraits of Paris, Berlin, and Moscow that reveal the history of these cities. His color work reflects the mood of today with an impressionistic use of light.

LOVE

Ferdinand Protzman

Published by the National Geographic Society

John M. Fahey, Jr., *President and Chief Executive Officer*

Gilbert M. Grosvenor, *Chairman of the Board*

Nina D. Hoffman, *Executive Vice President;*
President, Book Publishing Group

Prepared by the Book Division

Kevin Mulroy, *Senior Vice President and Publisher*

Leah Bendavid-Val, *Director of Photography Publishing*
and Illustrations

Marianne R. Koszorus, *Director of Design*

Barbara Brownell Grogan, *Executive Editor*

Elizabeth Newhouse, *Director of Travel Publishing*

Carl Mehler, *Director of Maps*

Staff for This Book

Leah Bendavid-Val and Olivier Picard, *Editors*

Olivier Picard, *Illustrations Editor*

Melissa Farris, *Art Director*

Rebecca Lescaze, *Text Editor*

Kristin Hanneman, *Contributing Illustrations Editor*

Mike Horenstein, *Production Manager*

Jeremy Felson, *Intern*

Jennifer A. Thornton, *Managing Editor*

Gary Colbert, *Production Director*

Meredith C. Wilcox, *Administrative Director, Illustrations*

Manufacturing and Quality Management

Christopher A. Liedel, *Chief Financial Officer*

Phillip L. Schlosser, *Vice President*

John T. Dunn, *Technical Director*

Chris Brown, *Director*

Maryclare Tracy, *Manager*

Nicole Elliott, *Manager*

Founded in 1888, the National Geographic Society is one of the largest nonprofit scientific and educational organizations in the world. It reaches more than 285 million people worldwide each month through its official journal, NATIONAL GEOGRAPHIC, and its four other magazines; the National Geographic Channel; television documentaries; radio programs; films; books; videos and DVDs; maps; and interactive media. National Geographic has funded more than 8,000 scientific research projects and supports an education program combating geographic illiteracy.

For more information, please call 1-800-NGS LINE (647-5463) or write to the following address:

National Geographic Society
1145 17th Street N.W.
Washington, D.C. 20036-4688 U.S.A.

Visit us online at www.nationalgeographic.com/books

For information about special discounts for bulk purchases, please contact National Geographic Books Special Sales: ngspecsales@ngs.org

For rights or permissions inquiries, please contact National Geographic Books Subsidiary Rights: ngbookrights@ngs.org

Library of Congress Cataloging-in-Publication Data
Protzman, Ferdinand.
 Love / by Ferdinand Protzman
 p. cm.
 ISBN 978-1-4262-0115-8
 1. Portrait photography. 2. Love—Pictorial works. 3. Love in art. I. Title
 TR680.P76 2008
 779--dc22
 2007027739

ISBN: 978-14262-0115-8

Printed in Italy

Illustrations

VII: pp. 96; 205; 226-227. **AGENCE VU**: pp. 115; 120; 148-149; 178-179. **ART RESOURCE, NEW YORK/CNAC/MNAM/Dist. Réunion des Musées Nationaux**: pp. 41; 49. **BEINECKE RARE BOOK AND MANUSCRIPT LIBRARY, YALE UNIVERSITY**: p. 32. **BRITISH LIBRARY**: p. 33. **STEPHEN BULGER GALLERY**: p. 99. **BILL CHARLES, INC.**: pp. 138-139. **CONTACT PRESS IMAGES**: pp. 95; 126-127; 172; 182. **EGGLESTON ARTISTIC TRUST**: p. 16 © 2008, courtesy Cheim & Read, New York. Used with permission. All rights reserved. **FRAENKEL GALLERY, SAN FRANCISCO**: pp. 64 © The Estate of Garry Winogrand/The Metropolitan Museum of Art, Purchase, The Horace W. Goldsmith Foundation Gift, 1992 (1992.5107) Photograph © 1995 The Metropolitan Museum of Art; 188 Yossi Milo Gallery, New York. **GALLERY STOCK**: pp. 74-75; 129; 183. **GETTY IMAGES**: pp. 8-9; 109 (Arthur Fellig)/International Centre of Photography; 135 Picture Post; 222-223. **HOWARD GREENBERG GALLERY, NYC**: pp. 45 © Peter Miller/Mike Disfarmer; 82-83. **HIGHER PICTURES**: p. 48 The Estate of André Kertész. **LIBRARY OF CONGRESS**: pp. 50-51 Prints & Photographs Division, FSA/OWI Collection (LC-USF34-T01-039623-D). **LOOKATONLINE**: pp. 186-187. **MAGNUM PHOTOS**: pp. 2-3; 4-5; 6-7; 10-11; 34-35 © 2001 by Cornell Capa; 36; 38-39; 40; 42-43; 46-47; 66-67; 68-69; 70-71; 78; 79; 80-81; 84; 85; 86-87; 90; 91; 94; 97; 98; 100-101; 102-103; 104; 105; 108; 110-111; 112-113; 114; 116-117; 118-119; 121; 122-123; 124; 125; 130-131; 132-133; 134; 140; 142-143; 144-145; 158-159; 160; 164-165; 168; 169; 173; 174; 177; 180-181; 184; 185; 189; 192; 193; 194; 195; 196-197; 199; 202-203; 204; 206-207; 208; 214-215; 216; 217; 218-219; 224; 225; Back Cover. **NATIONAL GEOGRAPHIC IMAGE COLLECTION**: pp. 14-15; 37; 52-53 Three Lions; 72-73; 106-107; 128; 136-137; 141; 146-147; 162-163; 170-171; 176; 190-191; 200-201; 232. **OEIL PUBLIC**: Cover; pp. 54; 62-63; 175; 220-221. **PACE/MACGILL GALLERY, NEW YORK**: p. 161. **POLARIS**: p. 18. **RAPHO/EYEDEA**: pp. 12-13; 30. **REDUX PICTURES**: pp. 76-77; 198. **REUTERS**: pp. 92-93. **AUGUST SANDER**: p. 44 © Die Photographische Sammlung/SK Stiftung Kultur – August Sander Archive, Cologne; ARS New York 2007. **SCIENCE & SOCIETY PICTURE LIBRARY**: pp. 24; 65. **TENDANCE FLOUE**: pp. 88-89; 228.